Finding Purpose
Through Spirituality

# becoming
# a kamala

## DR. KAMALA K.
## MADDALI

FREILING
PUBLISHING

Published by Freiling Publishing,
a division of Freiling Agency, LLC.

P.O. Box 1264,
Warrenton, VA 20188

www.FreilingPublishing.com

ISBN: 978-1-950948-87-1

*Printed in the United States of America*

# kamala's dedication and gratitude

You, your unique self, are the inspiration for this book. It is a book dedicated to YOU, unique as you are. The unity of who you are in diversity will make a world filled with love, gratitude, and peace.

My deepest gratitude goes out to Sai, Swaminiji, my parents, Venky, my grandparents, my spouse and my in-laws, my extended family, and my friends, as well as Mother Universe.

# *table of contents*

# *note to the reader*

My attempt to chronicle my life experiences was influenced by the fact that I did not want to forget what I had faced, whether it was a triumph or a low point for me, because each experience has helped me to become who I am today. These failures and successes have all contributed to my transformation, making me who I am today. As I began to record the past events of my life as well as such present ones, I realized how much I have accomplished, what an extreme dreamer I have always been, and what a remarkably strong human being I am today. Whenever I proclaim the above, I am not being pompous; rather, I am being graciously thankful for my achievements.

I have faced the challenges of life straight on, facing them all squarely and obtaining all I achieved. Life has thrown me curve balls (sometimes even dung balls!) but I have faced them bravely to reach my successes. During the course of life, in reflection on my life, I learned who I have been by my own yardstick, not by what the rest of the world believes success is.

As long as my experiences and learnings can help even some of those who are out there in the fight of their lives, I consider this book a success. No one ever gets things handed to them—I know that for a fact! But we all need to make the most of what is given to us so we can cook with gratitude what we desire.

Almost everyone has a problem, but there is usually a universal solution. I dreamt of being a medical doctor, and instead became a veterinarian. I faced two extremes of life—a career that kept soaring and health that kept pulling me down.

But, today, as the head of an AI firm, member of a family that I love, and the mother of a bright eleven year old, and also the embraced victim of a debilitating condition, I can tell you, my story involves many rebirths in one life. I have navigated my way out of many debacles with sheer willpower and hope.

If you are someone aspiring for bigger things in life, or someone fighting a desperate situation, or even someone just bored of your ordinary life, I am sure my journey will inspire you.

## "KAMALA BECOMES ME WHEN I BECOME KAMALA"

Kamala is a synonym in Sanskrit, meaning lotus flower. This is my own name, which has always inspired me to be what I am now. I apologize for the brevity, but this flower symbolizes an important secret to your success and purpose.

In Hinduism, Kamala is the seat of mighty gods and goddesses such as Brahma, Vishnu, Ganesha, Lakshmi, and Saraswathi. Most other deities are depicted holding a lotus in one of their hands. Here are three popular references to this flower in the Hindu sacred texts:

1) Goddess Lakshmi, the giver of wealth, emerged from the churning of the oceans sitting on a pink lotus while also holding one.
2) Goddess Saraswathi, the giver of knowledge, sits on an immaculate white lotus.
3) Lord Brahma, the creator of the universe according to Hinduism, comes into being on the stem of a lotus attached to Lord Vishnu's navel.

The lotus has long been associated with Asian traditions, particularly Hinduism and Buddhism. In Jainism and

Buddhism, the lotus is a symbol of purity of heart, speech, and action. In Egypt, the lotus is a symbol of completion.

In my childhood I sometimes wondered why this flower had such a celebrity status. I was compelled by the natural researcher in me to investigate the significance of this seemingly fragile yet surprisingly resilient flower. Each time I recognize its beauty, I am awed!

A lotus blooms right in the middle of muddy waters. If you follow the rhythm of the sun to live your life, it keeps blossoming each day and sleeps beneath the waves at night. Over the years, I have found many symbolisms associated with a Kamala—that of purity (it does remain pristinely beautiful despite the muddy surroundings) revival and enlightenment (it does submerge into the same murky waters every night only to bloom beautifully the next morning).

The symbolism that appealed to me the most was that a lotus is a symbol of transformation. Despite being surrounded by nothing much but dark and dirty mud, a lotus transforms itself to something so pristine. This is what keeps me going each time the going gets tough, when people and circumstances challenge me, I have to "become" a Kamala—survive and transform myself and my surroundings despite what envelops me. Keep my peace and calm amidst all the noise and clutter of life.

Kamala also symbolizes many other things to me.

First, the lotus embodies many lives within one life, with its petals opening in the sun and closing in the dark. Makes me wonder if it shouldn't apply to us humans too. Shouldn't we, too, show the resilience to bloom anew each time we wilt?

Second, it also appears to me as though this pretty little thing challenges the mud to taint its beauty! I have adopted this into my life. I try to look at adversities straight in the eye and emerge as unscathed as I can.

Furthermore, since I've had time to build a protective layer around myself that keeps all unreasonable things and all unnecessary emotions out, I have developed a lotus-like protective barrier around me.

I've come to realize that I am the embodiment of Kamala, which you will understand if you read my life story. I have relinquished defeat. I have placed my faith in my own abilities as well as in the universe.

Goldie Hawn has stated, "A lotus is the most beautiful flower in the world, whose petals open one by one. People who strive to acquire more wisdom, kindness, and compassion must have the intention to grow as a lotus and open each petal one by one."

I couldn't agree more! I have always wanted to change the world for the better. A lofty goal, but I have remained true to it. I have altered my paths along the way but never my goal.

# *preface*

## *by Kamala's Parents*

We as parents are pleased and humbled that our only daughter is writing a memoir of her life. Having been born with high myopia, she couldn't see what her teacher wrote on the blackboard at the age of three. She now writes a book based on her *own name, Kamala a Lotus*.

As parents, if we don't mention our blessed child in this preface, we don't fulfill our duty.

For every week in her childhood until her 10th grade, as a dad I remember the school vehicle in which all my kids and my brother's kids rode together. As a token of appreciation, they are given a delicious gourmet candy treat halfway to their commute to school every Wednesday. Kamala was a young girl with thick eyeglasses and a pair of ponytails in her school outfit as I recall her. As a token of appreciation, she would wave her little hands in delight whenever she was given her favorite candy, "Cadbury's dairy milk fruit and nut". It is an experience Kamala still relishes whenever she visits us.

A fearless and brave young girl, she bravely confronted each new situation and, despite her deformity, earned unanimous ratification as the institution's pupil leader, which demonstrated her leadership abilities at the time. It is not surprising that, as a child, she was called a tiger or a lion by her peers.

As parents, we vividly recall the most heart-wrenching moment for any student, when our little girl came home crying being denied a school seat and asked to stand outside

the doorways of school. It was because her daddy could not afford to pay school fees in the right period, yet she could become a "School pupil leader" in her middle school and highschool education and rise as an outstanding student.

Regardless of what she did, she was the best at anything she aspired to, from school debates to provincial competitions.

So daring and visionary that she took biological sciences in her pre-university, despite her deformity in her eyes, as per her mother's wish to become a medical doctor. Given the tough educational selection criteria with EAMCET mimicking SAT and ACT, she instead became a veterinary doctor; again the old theory as said in the past her daddy could not afford to pay tuition fees in private medical schools then.

Her hidden strengths revealed themselves during times of childhood challenges as she's been said to be one of a kind.

During her 12th grade, we remember her telling us, "If we could succeed as pharmacy entrepreneurs in human and veterinary medicine with no medical background and receive blessings from patients and farmers, I will indeed leave a lasting legacy." The timing will be right this time since it won't be just sons, but daughters too. The very daughter we adore, Kamala Kalyani Maddali.

Love for all and standing up for justice is her passion, we do say it's a divine gift—love all, stand for all, and stand by justice even when it costs her, and sometimes brings heart-wrenching situations in subsequent phases of her life.

Occasionally, I, as a dad, believe she is a symbolism of Vasudaika Kutumbam, a phrase used by Sri Narendra Modi, India's Prime Minister in a speech at the World Culture Festival, organized by Art of Living. In India, it is considered the most important moral value in the Indian society. It is a Sanskrit phrase found in Hindu texts such as the *Maha Upanishad*, which means "the world is one family".

At times, the above virtues make her conflicted with herself. Yet, she challenged herself and stood up irrespective of the losing of an academic year. Graduating as a topper in her undergraduate, she expressed the fact that this was only the very beginning of what she would learn in her path to knowledge. As I have known her, she has blossomed into a unique Kamala through transcending her challenges, accepting everything with gratitude in every aspect of her life.

Lastly we put our pen like this.

She is truly what Kamala means in our mother language, though she is risen from muddy water and blooming into a magnificent lotus blossom, nevertheless, there isn't any muck or muddy water on her leaves and flower itself.

As her parents, we have only ever taught her to fly high, never to push herself for higher altitudes. She, nevertheless, gave herself to her passion, persevered and endured, much like the Greater American Eagle and the Indian Garuda, god of the sky, who have always been a magnificent sight.

As she endeavors to bring this book to the universe, it is our blessing that she become the "Sahasra Kamala," the thousand-petaled lotus which is eternally held in the palms of Goddess Lakshmi—the personification of all "treasures of knowledge" in Hindu mythology.

Kamala will always be in our hearts.

Daddy and Mummy
Ramakrishna and Sita Lakshmi.

# *foreword*

## *by my mentor Swamini Shraddananda on Spirituality*

As much as we each wish to be heard in this life, we also wish to know about others. That is why we are so deeply called to share our stories with each other. Stories of joy and sorrow, tales of love and loss, chronicles of strength and struggles, help us connect to each other in a world that is often unfriendly and which sometimes seems to lack meaning. Our stories are our inroad. They are the means to bridge our divides, to inspire our dreams, and to show alternate perspectives and paths that exist. Stories give us meaning. All in all, sharing our stories empowers us to more deeply appreciate the diversity and the potential that exists. Stories are where our sense of unity and solidarity come from.

Dr. Kamala Maddali has chosen to share her stories with us in this inspiring collection of reflections. She narrates not only her unique human experience, but she also teaches us much about her Hindu culture, religion, and spirituality. A life so rich in love, loss, struggle, and strength should be shared. Largely because there is something here for every reader to embrace and for every human heart to connect to.

The colorful and delightful ways in which Kamala shares her stories and her heritage offers us perspectives on our own life. With each page we are empowered to draw parallel lines relating our experiences with her words, our hopes with hers, and our fears and concerns with hers. Perhaps, along the way,

we shall discover new and meaningful ways to interpret life's circumstances.

Kamala has shared with us her rich past. She has shown us in this writing that she carries, within and of herself, a treasure trove of passionate experiences. Her words encourage the reader to begin telling their own stories. Together, our stories, our lives, and our being create the most beautiful mosaic...

~ Swamini Shraddhananda Saraswati

# the human mosaic

A mosaic is made of hundreds of sherds of broken porcelain and pottery. Each sherd is unique in color, shape, and design. They even differ in chemical composition. Each is born of a unique combination of raw materials. As such each has a unique story of creation, use, and destruction, thereby contributing a unique part of itself to the completed artistic rendering. Particular characteristics of certain sherds may catch your eye. Some possess appealing qualities in color, texture, and composition that add to the subjective beauty of the object. Some are less appealing, being dull, discolored, or jagged. You can ask yourself, "Why is that one there? It takes so much away from the beauty of the object. What was the artist thinking?" However, should someone remove those less-preferred pieces from the overall rendering, the true and inherent beauty of the object would be forever lost. True beauty resides in the compilation of all parts and not in one or two subjectively attractive sherds near the outer edge.

Humans are mosaics. We each possess qualities that are ambient, strong, and attractive, and often insist that our true self is defined by only those positive qualities. However, we also possess qualities that are darker, weaker, and less attractive. We ask ourselves, "Why is that there, in me? It takes so much away from the true beauty of the object (me). What was the artist (I/God) thinking?" However, should we simply dissect the less-preferred pieces from the overall rendering of the self, the true and inherent beauty of the object (you) would be forever lost. True beauty resides in the compilation

of our parts and not in one or two subjectively qualified characteristics that only exist near our outer edges.

Instead of dissecting or denying the existence of the less-ambient parts of the self, accept, embrace, and transform. Allow each part to coexist peacefully within the entirety of the unique spirit that is you. You may find that through time, attention, and experience, what was once weak or less attractive will be transformed into a quality that supports truly honorable action and intentional being.

Excerpt From: Swamini Shraddhananda Saraswati, aka Sharon Allitt. "Thru the Mud Toward the Sun." 2008.

# chapter "devi"

I cut my wrists severely in a moment of despair, feeling woozy after hours, and collapsed on the floor. What a terrible mistake I had made in the darkest moments of my thinking and confusion of life's problems.

My memories of how I came to be in an emergency room after how many hours are fuzzy. My vision was blurry, I could barely see without myopic spectacles, and I couldn't see clearly with my naked eyes. Further to this, I was a total puzzle as to why I was doing this to myself. I've never felt like this since I was born—depressed, angry, devalued.

My life hadn't even been a quarter of a century when I felt like the worst human to ever exist! I don't know what happened to me and I wasn't listening to myself.

I couldn't help thinking about questions ever since I opened my eyes, surrounded by tubes placed into my throat to drain poison I consumed to die along with the deeply inflicted knife wounds. The question being:

*Who am I?*

After my two days in the ER, I was moved to another facility, so I wasn't quite sure where I would be going. It became apparent that it was a psychiatric facility that monitored a suicidal patient's recovery and behavioral health.

At this psychiatric facility I was tethered to an observation ward I shared with other patients with the same kind of suicidal trauma. I was in constant pain and tears, incapable of speaking to anyone for two days. I was under constant

scrutiny if I would try to commit suicide again and as I used the bathroom, I was naked—in fear I might renege on my promise to abstain from suicide again. I remember my shower in the bathroom made me feel like a dried seed in my shell. It reminded me so much of being hard-shelled without any sense. Whenever I touched a drop of water, I felt motionless and lifeless, which is quite unusual for an aquarius-born human being like me.

In those two days, I overheard stories from people who I'm in the same boat with, but their stories were heartbreaking, from homeless to sexually abused.

In the midst of this, a divine-looking angel was visible far away in the room I was in; she had a smile as my mother, Sita, did.

An old me would probably have jumped up and greeted her and told how similar her smile was to my mother's. However, I was barely motivated in speaking with anyone around me.

At the end of the second day, early in the evening, I heard a voice ask, "Would it bother you if I helped you, Kamala Kalyani?" The gesture sounded like my mother and maternal grandmother contacting me from overseas, thousands of miles away, out of love!

The enigmatic young woman in front of me held a book with an orange back cover. Despite my eyes being hazily swollen from tears, as I read the title, it stated, "The Bhagavad Gita" in English.

I was stunned seeing that picture as I saw a beautiful Caucasian woman holding a holy book of the oldest religion of mankind, Hinduism. I opened my eyes like the stars in the darkest of nights, shining heavenly powers. I found her inspirational radiance and appearance similar to a Devi, a female deity found in various comic books where Hindu mythology is depicted.

The Bhagavad Gita, the main Hindu sacred text, does not include angels in the same sense that Islam, Judaism, or Christianity do. In Hinduism, such angelic beings include gods like Lord Krishna, the Bhagavad Gita's author. "Devas" and "Devis" are terms used in reference to male and female deities, respectively. Human gurus (spiritual teachers who developed divinity in their core) and ancestors who passed away. You may have discovered that Vice President Kamala Harris has a middle name called Devi, which symbolizes her true calling as the first female Vice President in American history.

There are not many people in the United States who remember my first and middle names back then. When I viewed Devi, that young Caucasian female who had been described as divine, I felt I saw a person of authority with divine intention. Her so deeply committing her speech to my name had a purpose.

Devi took an old note out of her book and read out the words:

"I hate you, Kamala Kalyani."

I couldn't stop staring at the note's four petal, Lotus-like origami fold, which reminds me of a Kamala. It touched me deeply and began to awaken my inner core.

I was holding a book magazine with a cover of mighty elephants, which are one of my most favorite of nature's creations. It was apparent she was very curious about my connection to elephants. I told her there are several reasons but also one of the main reasons being it represents the mighty Lord Ganesha, the obstacle-remover God who is a human with an elephant's head we pray to in India. Hence, I am holding this magazine to my chest and would like to connect better with the Ganesha to better understand who I am.

We talked for hours, I didn't even get to ask her name and she talked for hours about her acquaintance with India, her friends, and then finally she said, "You know the meaning of your names right?" I said I would love to hear her perspective. Devi said that Kalyani is named after the Goddess of Knowledge who sits on the Lotus, a symbol for the Kamala.

I told her my life story from my childhood until my arrival in the United States. You will find it documented in the first few chapters. In the end, she said, "Kamala, your story thus far reminds me of the great Indian prayer, the story of Gajendra Moksha."

"Gajendra Moksha," a prayer addressed by the king elephant, Gajendra to Lord Vishnu, who is the preserver god as per Hindu religion. In Hindu mythology, that means he keeps the universe going strong and saved from destruction.

The story runs as follows.

A nice garden belonged to Varuna, the Lord of the Oceans, which was located in one of the secluded valleys on Mount Trikota, surrounded by the Ocean of Milk and intersected by lakes and rivers of various sizes and shapes.

Gajendra, the herculean elephant king lived in the forest on the mountain. A happy creature in his strength and power, he harbored pride for his success and power.

Once, Gajendra led his elephant family into the garden to drink water and relax in a big lake. They were playing and having fun disturbing the peace of the lake. As he was so proud of everything he did, Gajendra was engrossed in playing, as the rest of the army climbed the bank.

Makara, a crocodile living in the lake, was upset by Gajendra's disturbance of the peace, so he grabbed at his foot and started dragging him into the water. He resorted to releasing the crocodile by turning and tossing the body.

Despite a thousand years having passed since their battle began, the noble King elephant and the crocodile were still fighting on, tugging and pulling each other, to the amazement of even the celestials.

The terrible struggle left Gajendra exhausted and in pain. Suffering in body and spirit, he turned his thoughts to the Lord Vishnu at the last second. He started singing the praises of the lord in the form of a prayer, "Gajendra Moksha". Lord Vishnu with his Garuda Vahana, in his eagle-humanoid form who is revered as the god of the sky with a magnificent sight, spotted Gajendra who was holding a Lotus, plucked from the pond, waving to surrender, unmindful of the terrible pain. "Garuda" is the Sanskrit word for "Eagle." In no time, Lord Vishnu severed the head of the crocodile with his discus and liberated Gajendra from suffering. The mighty king Gajendra kneeled at the Lord's feet with gratitude and sought for liberation from the suffering and humbly surrendered to him.

Devi's last phrase was, "Find your purpose, Kamala, the world needs you. You are just beginning Gajendra's journey. Keep going by always being humble with gratitude and cultivating your success. With all your drive and vigor, you will bloom as many petals as you can and help others bloom as many Kamalas in the pond of this lovely life.

"Bloom your petals of passion and perseverance, Kamala." Her last act was to tuck me in bed and give a gentle pat on my head.

Is this real or is it just my imagination telling me that I am waking up to the blessing of "Gajendra Moksha" in America, which has graciously selected the Bald Eagle as its national emblem. The purpose of Gajendra Moksha in my life will become apparent halfway through this book.

This is a special chapter dedicated to a "Devi" that I met around that time and one that we all encounter in the form

of a "man" or a "woman" that awakens life in the hard-shelled seeds.

# chapter 1

My childhood was quite unique. I lived with twenty-one family members for most of it. We were a joint family where my father's five brothers and their families lived together with me and my grandparents. This may seem surprising to someone from a nuclear family, but we were able to form a great bond while living together. In truth, we did not have our own rooms, cots, or even desks, but we had company. Someone to talk to, play with, fight with, and share joys and sorrows with.

Despite the many people in our large family, it worked beautifully because of the amazing people in it. I feel extremely fortunate to have been raised in a home that discussed every difference of opinion peacefully and swiftly. My father and my uncles ran a large pharmaceutical business together, as well as lived together. There were no fights, no anger, and no bitterness. This made a very powerful first impression on my subconscious: there really is no insurmountable conflict when people are reasonable, decent, and loving.

It requires a village to raise a child, said Hillary Clinton, and I couldn't agree more. Now, decades later, I recognize how living in a joint family shaped me into who I am today. The implicit lessons you learn when you live in a large family are innumerable. Without batting an eyelid I can say that I am capable of selfless love, but I will add this in the same breath—it is because I was enveloped in an abundance of it while growing up. No adult differentiated between their children and the others. In essence, every child in the family had five sets of parents. If one of my aunts cooked a special dish,

it was distributed evenly. If my mother taught me, she also taught all the other children with equal diligence. If one of my uncles bought a toy, then it was for all of us to share.

Sharing is caring, no doubt, but children from joint families also know that sharing brings with it a bouquet of benefits. For one, thanks to the pooled resources, you always have an abundance of things—be it clothes, toys, or food. If your red t-shirt for the sports day is soiled, all you need is to ask a cousin. If you don't want to wear the same old boring dress for a party, just borrow. If your textbook has a tear, there is always a spare! Diwali was the best—nobody in the neighbourhood had as much as we did! With five families pooling in, both the numbers and varieties were unbelievably large. While children in nuclear families have to be taught to share, the ones from joint families assimilate this effortlessly.

I learned early on that sharing went beyond material things. As the adage goes, the joy that is shared is joy doubled and sorrow halved. Each time we celebrated a festival, went on a holiday, or even had a simple evening at a movie or a restaurant, the laughter and chatter were unstoppable. If I am feeling low and out, I try to summon memories that have made me happy and invariably most of them are from my childhood.

Another valuable and yet a rather difficult habit to inculcate in both adults and children is the discipline with time. However, for those in large families, this trait becomes second nature. We had to get up at around the same time because we ate all the meals together. Mothers served everyone and then had their food, which meant we could not delay the process. But those mealtimes were such fun times! Ideas were shared, jokes were cracked, legs got pulled—I am smiling as I even write this! And the same with bathing. We could not bathe when the mood struck us. Water was heated once in

the morning and that was that! And everyone had a slot since we only had two bathrooms between all of us. Nobody could stay up insanely late since we had a moderately big house and the lights in the common areas disturbed others. This again meant we could not procrastinate our work inordinately. We were always cautious of the lights being out by eleven, so we would finish the school and college work as early as we could. None of us struggled with late submissions and last-minute panic—like most of our classmates. The habit of doing work on time got into our systems without even trying. Now when I look at people struggling to manage time, I am truly grateful for the way I was raised. I know how to manage my twenty-four hours wisely!

Then there is inbuilt teamwork in large families and children learn the trait merely by watching adults. Every day I saw women in the house cook meals together by sharing tasks. Our house worked with the precision of a factory. One shopped, one chopped, one ground, but the meals were always ready on time. And men assumed duties and got them done—from paying bills to getting repairs done. We children, too, had chores, simple ones like washing our plates and folding our own clothes, which we did ungrudgingly because we saw every adult around us do the same.

The amount of love we received at home was unmatched. If someone was sad, there were a dozen people to console. If someone was happy, the whole house cheered. My grandmother was more like a mother to all her daughters-in-law. She was a pillar of strength who held the family together not through power play but with love and affection. Such magnanimity is very contagious. Since there was no pettiness from the heads of the household, there was not a mean bone in anyone.

We hardly find large joint families anymore in India. But those who lived in one are truly the blessed ones, especially the

children. The invaluable life lessons of love, respect, sharing, and discipline that came from everyone made us stronger individuals. The abundant companionship and acceptance at home made us confident adults. The good news is, more and more youngsters are choosing to live with their parents, especially in cities. This could be for various reasons—mounting costs of good housing or for the lack of reliable childcare. Whatever the reason, this is a good trend since research shows that when children grow up with grandparents, they do become empathetic and emotionally stable individuals.

My experience to be born and raised in this beautiful joint family planted the beautiful attributes of Vasudhaiva Kutumbakam ("vasudha", the earth; "iva", is; and "kutumbakam", family) is a Sanskrit phrase that means that the whole world is one single family. The concept originates in the Vedic scripture Maha Upanishad (Chapter 6, Verse 72):

*"Ayam bandhurayam neti ganana laghuchetasam udaracharitanam tu vasudhaiva kutumbakam," meaning:*

*Only small men discriminate, saying: One is a relative; the other is a stranger. For those who live magnanimously, the entire world constitutes but a family.*

This concept is also mentioned in another Vedic text, Hitopadesha: "Udāracharitānām tu vasudhaiva kutumbakam", meaning, "'This is my own relative and that is a stranger—is the reasoning of the narrow-minded; for the noble hearts, however, the entire earth is but one family", and is considered an integral part of the Hindu Philosophy.

The statement is not just about peace and harmony among the societies in the world, but also about a truth that somehow the whole world has to live by some rules like a family, set by

an unknowable source. Just by contemplating this idea and by at least trying to live by it and practice it in our lives, we could make this world a better place.

# chapter 2

My story cannot begin without me talking about those who had a role in shaping me to who I am. Based on my memory, I might narrate at length about some and in short about others, but they all have been equally important to me.

Most of my childhood positive influences came from my universal family of my parents and my father's brothers and their families.

Let me start with my grandfather. From the time I could remember, he was bed-ridden. He had had a paralytic attack when he was in his early fifties, which had taken away the motility from his entire right side of the body. How shocking it must have been for a man out and about to be bedridden overnight? How distressing, after fifty years of normal life, not to be able to stir out of position without help? How melancholic to live in that vegetative state knowing there was no cure for the condition? But my grandfather, despite his condition, was the epitome of calmness and composure. Not a single day did I see him complain about his fate or lose his temper. He had gracefully accepted what life had doled out to him.

He had retired as the headmaster of a renowned school in Kurnool. Even after two decades, many of his older students came home to seek his blessings. This always made me wonder what kind of a great teacher he was if those highly accomplished students still sought his blessings. My grandmother did tell me stories of how my grandfather was a very well-respected head of the institution. He was responsible for changing many archaic educational policies. Though his

income was far from adequate to support the large family, he helped many students with their fees and living. Not a surprise that many still revered him.

When it comes to my memory of him, he was one of the few people who called me "Kalyan," like I was a boy! Whenever I heard him call my name, I dropped everything I was doing and rushed. Not that he spoke much to me but just being around him felt positive. He had a very unique energy around him. When things bogged me down, I simply sat next to him and that was enough to give me a fresh bout of energy.

I truly was in awe of him because, every waking hour, he wrote Rama Koti from his left hand. After being paralyzed he had trained his left hand to write. Rama Koti is a Hindu tradition where the spiritual aspirants write the name of God Sri Rama as many times as they can in a day. The final goal is to write the name of the Lord one crore times (Ten Million Times.) This is a form of meditation, where the practitioner would write the name each time with mindfulness and with thoughts of any of their favorite lords' names. Once a devotee completes writing it, then the book can be sent to temples where they are buried during new constructions or used in Homas (fire rituals.) In some temples, it is simply stored in the meditation room. It is believed that the positive energy from those Rama Kotis aids the fellow spiritual seekers.

I recently got curious about what we did with the Ramakotis my grandfather had written. My father said all five brothers together took him to the Bhadrachala temple of Lord Rama and submitted the script. According to my father, despite the journey of five-hundred kilometres being uneasy for him, my grandfather had coped with it pleasantly.

My paralysed grandfather, with his shaky left hand, wrote "Jai Shri Rama" ten million times! And traveled to the land of the lord to submit his work of devotion. That is grit. That

is self-discipline. That is strength. When you grow up around someone of that calibre, it is hard not to imbibe some of those qualities! When I was around him, my problems did not seem too large. When I observed his calmness, I calmed down too. If someone who had led an active and energetic life for four-and-half decades had accepted his current paralyzed state with dispassion, so could I with any of my problems. When things go wrong for me, even today I remember him to feel positive.

Then there was my grandmother, always smiling and never uttering a harsh word. Her daughters-in-law loved her like their own mothers. Just to give an example, my eldest uncle passed away while in his late forties. My aunt, instead of moving to her hometown, decided to stay with my grand-mother. It was impossible not to love my grandmother. The way she took care of my grandfather was exemplary. Never a complaint, never a why-me or why-my-husband. She fed him, bathed him, changed him—all with a smile. Today, if compassion runs through me, it probably comes from her. I get energized when I get an opportunity to help someone. I probably even dawn the same smile as my granny when I do!

Values systems imbibed in childhood carry into adulthood. In ancient India, the princes were sent to Gurukuls (humble homes of Gurus, mostly in secluded forests) so that they were part of a holy and selfless way of living during their formative years. The princes lived as meagerly as students from common families. This goes to show how important it is to build a good value system early in a child's life. Today's research supports with ample data that children learn from models around them. The term today is "observational learning," a process where children learn by watching others and later replicate the same. This makes it so much more important for parents in nuclear families to be good role models for children.

# chapter 3

Every girl hero-worships her father and I was no different. Throughout this book I will keep talking about my parents, but let me first talk about how impressed I was with my parents as a child. When I think of my father and my childhood, the most vivid memory is how I loved watching him take charge as a leader. As I mentioned earlier, my father and his brothers ran a rather large pharmaceutical distribution business in partnership. They were renowned distributors of medicines throughout the district of Kurnool.

My father was also the president of the Pharmacists Association of the district of Kurnool. Often people came home to talk to him and I witnessed them seek his advice on various matters regarding the trade. I stuck around watching how he handled questions and concerns. Every time I did so, I was impressed with his vast knowledge of medicines and the pharma industry. His quiet efficiency, the respect he claimed from his fellow men, and how he went out of his way to help those in need—it was highly inspiring to observe him at work. I remember people calling him up at all hours of the day for advice on medicines. He was also a phone-in doctor to many! Many times, he would go out of his way to source medicines for people. That was not just for business but that was out of his concern for people. Each time someone thanked him for his help and advice, I imagined myself as him—an achiever, a leader, someone popular, and in a position of power!

My father was a man of very few words. I haven't met another soul who was quite like him. When I was young, I wondered why he was so silent. What was the benefit of that

silence? I observed him since his quietness intrigued me and also concerned me. Was he quiet because he is unhappy? But I soon realized that his silence was not a concern. He was happy being silent. Now I understand that he was a doer and not a talker. His name was Rama and he was godly like Lord Rama from Ramayana. He was devoted to his family, was highly respectful of his parents, never spoke a foul word, and never once boasted of his achievements.

Now in my forties, I am modeling him and my mother in my approaches to parenting. I don't allow myself to fly off the handle and I try to be as positive and supportive of my son as I can be. I am also trying to be quieter since it brings in peace and makes me think and reflect. I still have a long way to go before I can be called a silent person, but I know I'm headed there and I like my journey.

He was kind and gentle as a father and seldom expected anything out of us. He believed in letting children self-motivate themselves rather than push them. This was in stark contrast to my mother! She was someone who would have nothing less than perfection when it came to our studies! My maternal grandparents tell me stories of my mother's academic excellence and how she topped every single grade, including college. My mother had preserved all her practical laboratory records and showed them to us often when she emphasized on perfection. She had a perfect ten of ten on every page! And, her drawings were spectacularly picture-perfect, especially in her Biology records.

"Your mother wanted to be a doctor. She even got admission into medical college, but her grandmother wouldn't allow her to leave town." My grandmother would tell us wistfully. Since there was no medical college in her hometown, the only way was for my mother to move to another town to study medicine. But my mother's maternal grandmother, Kamala

(you guessed it! I was named after her), was so emotion-
ally attached to my mother, she couldn't bear the thought
of sending her away from home. Consequently, my mother
gave up her dream of being a doctor and graduated with a
degree in Bachelor's of Science. However, anyone could tell
she was not happy about it. And, quite naturally so. Now,
looking back, I do understand her pressuring us to succeed.
She wanted us to achieve what she couldn't. I was too young
to empathize with her frustration, which saddens me today.
I wish I had asked her about her aspirations, I wish I had at
least let her vent her angst.

If I were to describe my mother, I would say she was highly
energetic, extremely determined, very emotional, and bent on
having her way! None of this was negative. She used all her
traits positively. You could call her stubborn or highly deter-
mined. Yes, she was high-strung but that also made her very
caring and sympathetic. She was bent on having her way, but
that was because she was so sure of what she wanted!

Talking about her energy, she never wasted a minute. Even
when she taught us in the evenings, we would find her knit-
ting, or sewing, or doing some artwork. She was meticulous
about her looks and attire. If she bought a sari, she prettied it
up with embroidery or mirror-work or something to make it
look unique. And she would put in any number of hours to
achieve the effects she had in mind. It is a pity that someone
of her calibre, so very precise, diligent, and intelligent, had to
bury her career dreams and be a homemaker. Looking back, I
can recollect her moments of frustration. What a toll it must
have taken on her.

To some extent, she tried to overcompensate for her lack
of a career. She spent all her evenings educating every child
at home. That was good for all of us (though I hated it at
that time!). But she was also very restless. When I began to

understand the goings-on around me, she scared me with her pursuits. Even her spirituality seemed like a pursuit of perfection to me—for her devotion was how many mantras she could chant. Worship was counting how many different kinds of flowers she could find to decorate the Gods. Festivals were an altogether different kind of mania—for each deity she had a different set of ornaments.

I wished someone would stop her but nobody objected to her because she was adored and respected by everyone at home. My aunts respected my mother immensely because she was the only one educated among them and they were almost grateful to her for helping the children with school work. Being distant relatives, my grandmother had seen my mother as a young child this made my mother a favoured daughter-in-law. Thus, nobody minded my mother's excessive tendencies. But it bothered me. It did not feel right even at that young age. But she would just silence me with a stare if I objected. Now, I think she was expending her high mental energy wherever and in whichever way she could. Probably, someone should have pushed her to pursue higher studies and take up a fulfilling job.

As one can see, my father and mother were too different from each other. But, it was also the case of opposites attracting! I remember my mother fighting with my father constantly over one or the other thing. But he was also the only one capable of calming her down and convincing her why something could not go her way. Maybe, it was her love for him that made her accept her life. The more I observed them, the more I knew how much good compromise went into accommodating the ones we love. Both my parents adjusted and adapted to each other: my mother rebelliously and my father silently.

One beautiful memory is the synergy that my mother and father had in choosing my name. I was named "Kamala Kalyani". I was named Kamala after my mother's paternal grandmother who raised her and Kalyani means "Saraswati, Goddess of Education and Knowledge" as per Hindu mythology. They decided that they would name their baby girl during their honeymoon in KanyaKumari. What a coincidence that the place abbreviation is KK and my first name and middle name is abbreviated KK.

Kanyakumari Temple is located in the city of Kanyakumari, the southernmost city of India. It is a popular tourist destination and also a holy pilgrimage site since it is believed to be a Shakti-Peeth, a divine form of Goddess Parvati in Indian Mythology.

According to another legend, it is said that a huge chunk of rock fell out of the hill carrying Mrita Sanjivani when Lord Hanuman carried it over his shoulders to revive Lord Laxman during the Ram and Ravana war. The piece of rock is called Marunthuvazl Malai, and it is said that is the reason why the region has an abundance of medicinal plants and herbs. There is also a nearby village here named after the sage Agastya, who was considered to be an expert with herbs and medicines, another reason why it is said that the region has so many of them.

On the other hand, Kanyakumari is also the site of the Vivekananda Rock, named so after Swami Vivekananda swam out into the sea and performed meditation here till he gained enlightenment and chose to become an active Monk and perform his duty for the people.

No wonder all these magical forces from this beautiful place have had a tremendous influence on my spiritual growth. A place I must one day visit as a pilgrim like Swami Vivekananda did. No wonder I unknowingly got attracted to

his preachings. If any of you have time, please do research about Swami Vivekananda. One of his most favorite quotes that touched my heart is, "The earth is enjoyed by heroes". This is the unfailing truth. Be a hero. Always say, "I have no fear." Tell this to everybody, "Have no fear." Fear is death, fear is sin, fear is hell, fear is unrighteousness, fear is wrong life.

Apart from being a holy site for the pilgrims, the tourists come to Kanyakumari to spend a relaxing time by the beach. The city is located at the confluence of the three oceans of the Indian Ocean, the Bay of Bengal, and the Arabian Sea and it is quite an experience to be here. There are lush green landscapes a little way off the main city and the laid-back lifestyle here is perfect for a holiday.

# chapter 4

In my extended family, I was the closest to my eldest uncle (father's eldest brother) and his wife. I liked to call him, a fiery lion! He always spoke his mind and let his instincts take over. Haven't met anyone who lives in the moment like he did. He grabbed life with both hands and lived it as best as he could! There are a few incidents that are etched in my memory about him.

Kurnool is one of the hottest regions in India. It is one of the four districts of Rayalaseema, where the terrain is extremely dry and rocky. Summer begins in March and lasts till June. In May and June, temperatures reach the late thirties and get so hot and humid, it is nearly impossible to step out of the house during the day. In that sweltering heat, fans turn useless. Only those few lucky ones with air conditioners have a grand time. My uncle decided one such summer that he was going to buy an AC. We envied him. He was going to lounge in a cool room! But when he returned we were in for a huge surprise! Instead of one for his room, he had bought three! Two of them were for the common areas in the house. We were not rich enough to afford three units of ACs but that was his largesse and love for the family.

"Why did you buy three? Isn't it very expensive?" I asked, basking in the cool air.

"Are you enjoying the AC?" He questioned me back.

"I am, of course." I grinned happily.

"Well then. It is money well spent. I would rather see all of you happy today than leaving a bit more of inheritance after I die."

That was his philosophy of life. When you have enough to make a living, then do live a little. He was the one who had struggled the most in his youth. With my grandfather being paralyzed in his fifties, the onus of supporting the large family had fallen on his young shoulders. He had cut short his education and joined a pharmacy as a representative. He had five younger brothers, a sister, and parents to support on his single income. I still cannot fathom what makes some like my uncle so committed to the family? He was young and his income was more than enough to support himself. Why did he stick around to support the rest? Well, that is probably what is called "Samskara," in Hinduism or ethics. It is a term that cannot be explained but Hindus do believe that most of the Samskaras are carried through births.

But he compensated for his years of hardship later by living a life of luxury. But now, as an adult, I can understand why he wanted a better life for himself rather than save more. He spent liberally on both his wants and needs. But it was not all materialistic. He helped those in need, be it employees of the company or total strangers. He donated large sums ungrudgingly. Given his way of living, I don't know if he had saved enough for his old age. But one thing was for sure—he had done so much for his family, he didn't have to worry about his retirement. His brothers would have supported him to eternity if need be!

My uncle never lived long enough to be an old man. Much to our deep chagrin, he died when he was only a little above forty. I sure am glad he treated himself to a good life after the hardships he endured as a youth. However, his life often made me think about whether one should live for today or save for later. The pendulum swings both ways in this debate. Lately, we do see more and more youngsters who display quite an aversion to saving for later. They would much rather spend

the money when they are young and healthy than think about old age. Live large today more than defer happiness.

On the contrary, what happens if you spend all of your income today but end up living a long life? Inflation even at a conservative estimate is 6 percent. Which means if your expenses today are 35,000 rupees per month, thirty years from now you will need close to two Lakh rupees. Twenty years from now, you will need a lakh and twenty thousand to lead the same lifestyle as the one you have now. Once these numbers are kept in mind and investing is done accordingly, living it up isn't a bad idea! Warren Buffet says, "If you buy things you don't need, soon you will have to sell things you do need." So as long as we are mindful of our expenses, spending is not the enemy.

Each one of these incidents at home has made me think deeply and formulate a life plan for myself.

Another time, I witnessed my father and my uncle having a heated debate. Strangely, I even remember that they stood by the front gate and argued! My brain does store a lot of information! Anyway, this is how their conversation went.

My father: We have to invest more into the business and expand it.

My father was an ambitious businessman. He believed neither in spending nor in saving, but in investing the money back into the business.

My uncle: When the business is large enough to get us all a decent income, what is the need to expand? Let us have a good life for a change!

My father: How the business is doing today is no indication of how it will be a decade from now. If we don't adapt to the market changes, we will cease to exist!

This went back and forth for a while before they both came inside smiling to have their evening tea! In my opinion, that

was the biggest positive of their partnership, they perfectly complemented each other. While one spelt ambition, the other advocated contentment. I wish I had someone who complemented me so perfectly! When I expressed these precise sentiments, my father quoted a verse from "Bhagavadgita" that says a man must elevate himself with his mind! I have taken upon his advice and am learning to be the yin to my yang! If I am too worked up, I coach myself to relax. If I am too miserly, I tell myself to loosen the purse strings! But all the while, I do wish I had someone who helped me balance my emotions!

There are many more incidents that I remember vividly about my uncle and they will all surface in different chapters of this book. But one more thing I want to mention here is the relationship between my father and his brothers. I was often highly curious about how all the five brothers came to work together. And roughly, this is how it was. My eldest uncle was still working at a pharmacy when my father completed his Master's in Organic Chemistry. My father then worked at different chemical plants but he was too eager to be an entrepreneur. That was when my uncle suggested that they could start their pharmacy. My father jumped in and before long, with his keen business acumen, he had built a chain of pharmacies. Then, he suggested they take up the distribution of drugs rather than just be retailers. By then, my other uncles had completed their education and they too joined the business that was flourishing.

Each brother brought a different skill set to the organization. If one was good at sales and marketing, another was great at logistics—so on and so forth. They all worked hard and never complained. I always witnessed in them a respect for each other and an abnormally high degree of affection! No wonder the five brothers were called the "Pandavas" by everyone! Not just because they were five in number but because of how

they were. The Pandavas, the famous brothers from the epic *Mahabharata*, were so united they were often described as one soul in five bodies. They always worked toward the common good rather than individual glories. And, they all unquestioningly obeyed their eldest brother, Yudhishtira. My father and his brothers were no different! Truly.

It may seem like I paint my family in too good a light, but that is the reality. We were and still are just as perfect as a family. I could spend hours sitting inside the house and never get bored, not only as a child but also as a teenager and beyond. I wonder how many can say that. In the next chapter, let me talk about the rest of my faultless family—my uncles, aunts, and cousins!

# chapter 5

I grew up with eight cousins including my brother. But four of us were in a clique. My brother Raghu, and my eldest uncle's children, Tulasi and Ravi, and I were very close. That was because we were the closest in age. For a few years, we did everything together—commuting to school to playing highly competitive board games to running errands. The good thing about the boys was that they never left me and Tulasi out of anything even though we were girls. They were quite broad-minded for that age, I must say. All their friends were also our friends and we played what they played and did what they did.

But many things changed quite early with Tulasi. Though she was only two years older than me, she grew very serious about her studies by the time she was in seventh grade. After that, we hardly had any time to while away. Till date, we regret not having spent more fun times together. We lived in the same house but lived our separate lives. To make up for that lost time, we do make it a point to get together as often as we can now though we live across continents! We do want our children to grow up closely.

Yet another incident from childhood, which meant very little then, weighs heavy on my heart now. My maternal grandparents were in a town called Nellore. Every summer it was a matter of great joy to pack our suitcases, sit on a big bus, and go to Nellore for two months. However, I remember Tulasi getting extremely sad to see us leave—not because she missed us but because she didn't have an out-of-town relative to visit! Her maternal grandparents lived in Kurnool, only a few kilometres away from us. She, as I learned later, cried

such bitter tears once we left home, my aunt would make her notionally pack a suitcase and leave it on the front porch. I feel a twinge of guilt pass through me when I think about it. Why didn't I invite her to go with me to Nellore? Did I completely lack empathy?

Recently when I spoke to her (she is now in Finland) I voiced how I feel. She, being the mature, reflective one as always, calmed me down. "You were too young for empathy and sympathy, Kamala. Look, it did not cause me any great damage, did it? We all grew tougher with each disappointment we faced. Don't worry about it."

She may be right but it continues to bother me nonetheless. Now I am a different sort of person. I am consciously more sympathetic toward others. I try to put myself in others' shoes before I judge them for their actions. Wish I was this wise when I was young! But, as the adage goes, better late than never.

Besides being homemakers, the women in our family were also quite talented and unique. I would like to mention my dad's sisters who are both unique pillars of my family's music talent. My family's nightingale was my father's eldest sister, Kanaka Lakshmi, whose outstanding traditional singing would melt our hearts. Her first name, Kanaka, means "Gold" and I always felt like she had a golden voice. Her passion for education is evident in how she raised her sons. I would like to acknowledge Uncle Raghupathi, the husband of my aunt, who was regarded as one of the best professors in the area of the physical and mathematical sciences. Their four sons pursued highest degrees in elite institutions with hard work and dedication which always was one of the unique driving forces for my passion for education. I am truly inspired by all my aunt's sons' competitive spirits. The right one to compete for.

Then comes my youngest aunt, Prasuna. She was the most bubbly and vivacious character I have met till date. She was the last of my father's siblings and was naturally highly pampered. And she was quite awe-inspiring, to my young self at least. She was a great Bharatanatyam dancer and a highly intellectual lady who did her Master's in Economics. This is an aside, but I still remember her teaching maths to Tulasi, which was quite a comical scene. Every time Tulasi did something wrong, Prasuna would tap her head and say, "Think, Tulasi. Think." It became quite a pastime for us to count how many times it happened in an hour of tutoring!

My aunt, so talented and educated, turned into someone very different after she was married. She not only gave up her job but also her dancing. In front of my own eyes, a girl so full of life turned into a docile, yet happy, and pious housewife. She continues to intrigue me, which makes me wonder why so many women let their talents deteriorate so drastically after marriage. What happens to their ambitions? My grandfather, though bed-ridden, would urge my mother and my aunts to pursue higher studies. But none of them did, including my mother. Do women need to change so much for marriage? Is it because the family subtly compels them into domesticity? Or is it because once they stay away from cognitive work, they lose the will to get back to it? Is it the love for their children that makes mothers give up having a life of their own? I am not judging anyone, but I am merely puzzled by this, based on events in my own childhood. These were my naive thoughts back then.

# chapter 6

Three people who made me realize the value of celebrating small things in life are my last three uncles. Without them in my life, I probably wouldn't have known how to pull myself out of despair. It takes very little to be cheerful actually. But when we are agitated or sad, we don't have the energy to make an effort to be happy. But once you know what makes you happy and by practicing it repeatedly, you automatically know what to do when the chips are down!

One of my uncles, my father's third and fourth brothers, was the most passionate when it came to fruits and sweets! Yes—fruits and sweets! You may chuckle at it, smile condescendingly, or even roll your eyes when I say this, but their passion was highly contagious. The third one is Jagan who is a lover of sweets or desserts but was also so committed to staying fit physically which always amazed me.

My dad's fourth brother, Srinu, the way he chose and judged fruits were no less than the Masterchef jury! And he took his time to peel them, cut them, and eat them, and made us do the same. Watching him enthuse over it so gleefully, we did the same!

Also, both brothers made a tradition out of bringing home the most delicious sweets—chocolates, cakes, fruits, or even something simple and local. When they traveled out of town, we waited for them to come back because we knew one of them would bring with them a treasure chest of unique fruits or sweets! They never explicitly taught me to enjoy food but I did so by merely watching them. Now when I am stressed, I may not go hunting for delicacies all over the town like him,

but I do take my time to cook a wholesome meal and eat it with my family.

Now, even research shows that eating slowly improves digestion and aids in weight loss. Researchers in Japan have found that when you mindfully eat or drink, you consume less. Eating slowly gives your brain the time to receive signals from the hormones that indicate fullness. When you eat quickly, the brain doesn't get these signals and it keeps prompting you to eat more. It takes about twenty minutes for the brain to receive the fullness signal, so the next time you gulp your breakfast bar in the car in five minutes, know that you are adding unnecessary inches to your waist!

Enjoying food with mindful eating bodes well with your emotional well-being as well. Slowing down life a notch to enjoy things you love, be it a cup of morning coffee or an evening snack, brings in a calm. There was a movement a few years ago that originated from Italy called the Slow Food movement. The idea was to educate people to source, cook, and eat food slowly. Much of that happened ironically during the recent Covid lockdowns! People learned the joys of staying home and cooking what pleased them rather than ordering in or eating out.

Having dinner at the table with family and friends helps eat slowly rather than eat in front of the television. When you sit down to eat with someone, you cannot just keep shoveling food into your mouth. You will take the time to talk, listen, and sip. While growing up, eating together was the norm and not a novelty. But today, with the busy lives we lead, I have to force myself to bring back the tradition of family mealtimes but it is well worth the effort.

My youngest uncle was Sridhar, my father's youngest brother. He was enthusiastic and the most gifted in my view. If one of us scored well in maths, party time. If one of us got

selected for something, party time. If the family clocked in good business that month, of course, party time! The celebrations could be as simple and quick as going for ice cream in the neighborhood or as elaborate as going on a vacation. But he showed us that life needs to be celebrated—not just the birthdays, anniversaries, and big achievements but also every little triumph.

Now, as an overworked adult, I understand the tremendous mental energy it takes to go out and celebrate. After a long day at work, all I want some nights is to curl in bed and read. However, if there is any accomplishment to be lauded, especially my son's, I put myself into the party mood. I know from my childhood how wonderful it felt when I was acknowledged for my hard work.

Studies show that people who focused only on the end goal failed a lot more compared to those who focused on daily progress. One way to motivate yourself, your loved ones, or those who work for you, is to reward and celebrate small wins. An extensive Harvard research showed that 76 percent of the participants in their survey made good progress at work on the days when they received words of encouragement and praise from a colleague! So, building a culture of appreciating small victories helps boost happy hormones and thereby productivity, conclude the researchers.

# *chapter 7*

I am told that I was sent to school at two years of age, a year earlier than other children. According to my mother, it was for two reasons. First, I was unbearably naughty. I apparently mercilessly bullied the boys—my brother, Raghu, and my cousin, Ravi. I wondered often how a two-year-old could bully one-year-olds! But multiple adults in the family have confirmed that my favorite pastime at home used to make the two boys bawl by banging their heads together, or snatching their glasses of milk, or pushing them to topple—anything that took to make them cry. Well, can't blame my mother for packing me off to school after hearing this!

The second reason, again taking my mom's word for it, was that I was too bright to be kept idling at home. That was my mom. Time was too valuable a commodity to waste. The good thing was, I had no problem going to school. On the contrary, I am told that I quite fell in love with the whole idea of school—getting dressed in the morning, taking that short walk, sitting in my favorite spot by the window, reciting rhymes. I do vaguely remember.

School at the age of two was quite unheard of in the late seventies since there was no concept of preschool at that time in India. Children began with the nursery classes at the age of three, if they went to an English-medium school. Those who went to a vernacular school began their schooling at age five from first grade (or as it is called the first standard in India). Consequently, I was made to attend nursery classes. The idea was for me to repeat the same class the year after as well.

I hardly remember that first year at school. Two is too young to remember anything. But what I do remember quite vividly was repeating the same class the next year. I can recollect that year being highly monotonous making me quite restless since I already knew most of what was being taught. Days seemed to drag since the novelty of going to school had begun to fade.

Early schooling, as we know today, has both advantages and disadvantages. The advantages being, children get into a routine fast. They learn the art of socializing without much effort. They are exposed to adults other than their parents. Statistically, children who start school early also happen to achieve greater academic successes. But at the same time, early schooling can also be detrimental to a child's growth. Children are deprived of the freedom to play and think freely too early. From getting one-on-one attention from parents, they are sharing a teacher with multiple others. Given their lack of immunity, they tend to fall sick more often.

On the above lines, I fell more into the category of children who benefited from early schooling. Except for the boredom, there were no other problems. But, parents in the eighties did not worry so much about schooling or a child's emotional well-being! It was taken for granted. My case was no different either. My mother put me into school because it seemed like the right thing to do for her!

Coming back to my classroom experience, I began to feel that not everything was all right with me. I had an unease in me that I was not experiencing what the other kids were. Soon I knew it was my eyes. The previous year, since I was the youngest in the class, I was made to sit in the front row. But this year, being a tall child, I was almost at the back of the classroom and except for a few faces immediately around me, the world was a blur.

While the rest of the kids wrote what the teacher scribbled on the blackboard, I only saw foggy images on a hazy black surface. All I could see of the teacher was only a silhouetted image. I tried to cope the best I could. I copied what the kid next to me wrote in his book. Letters, pictures, numbers— thanks to my mother and an extra year of schooling, I already knew them all. This torture continued for probably a month or so before the teacher caught it. With most young children, weak eyes are first detected at school.

As it turned out, I was a born myopic. Now, as an adult, I thank my luck for early schooling. Whether or not it bene-fited me academically and socially, it helped diagnose my condition early on. The teacher caught my condition early on because she had already seen me for a year. She was puzzled that I suddenly was struggling to copy the blackboard when I had been doing that effortlessly the previous year.

My parents were appalled that I could not see much of anything clearly, including my own mother's face. The first visit was to the best ophthalmologist in town who diagnosed that my power was already a whopping -4 D and it was too high for a three-year-old. Then the panic started. My mother blamed herself for ignoring my condition. Everyone consoled her that such conditions seldom came to light in children younger than three. My father began hunting for the best ophthalmologist in town and out of town, finally finding one in Chennai, the then Madras.

As far as I was concerned, I was not worried about my eyes but those eye tests horrified me. I hated them. It was torturous to have the nurse administer the eye drops that burned the eyes. It was even more grueling having to sit with my eyes shut for half an hour for the pupils to dilate. So when my father decided to take me to Chennai, my reaction was

that of horror. Children don't understand that hardships must be endured for a better life.

When I fussed and cried that I didn't want any more eye tests, my father put it cleverly, "We are going to Chennai because I want to take you to the beach. I am thinking, when you play with the waves, you can also have ice cream. What do you say?"

That sounded like pure joy! I loved the sea. Watching the waves chase one another, playing with the water, and all that while slurping ice-cream! "What about the eye test?" I asked, being the precocious kid that I was.

"Oh, that will be just a few minutes. We will hit the beach right after your test," my father thoroughly downplayed the test part. And, because I was so excited about the beach, I didn't mind it either. It didn't lessen the torture in any way but the reward at the end of it made it bearable. Later, my father turned my eye tests at Chennai into an annual ritual for the four of us.

Looking back, I smile at how brilliant my father was! He knew it was futile to explain to a young child why that eye test was important. Instead, he gave me a coping mechanism by promising a reward at the end of an unpleasant task. At the eye clinic, it was hours of waiting for our turn (as it happens with any doctor's visits, despite appointments). An anonymous quote says, "Patience is not simply the ability to wait. It is how we behave while we are waiting." While I waited at the ophthalmologist, I would get angry and restless. The wait was miserable. There were no mobile phones or gaming consoles to keep me engaged. But my father never left my side nor lost his patience with me. He sat there calmly answering all my myriad questions. His calmness sobered me up.

Children are inherently impatient and it is a tough challenge for parents and teachers to instil patience in them.

"Patience is bitter but its fruit is sweet," says Aristotle. Many studies have shown that patient children are better at handling careers and relationships later in life. When an adult role model is calm, kind, and patient, children pick up these traits automatically. Also, the most common mistake parents make is to go back on a promise made to a child. If my father hadn't taken me every year to the beach after the visit to the eye clinic, I probably would have resented him and my condition a lot more. Being a parent is a tough job, having to walk the talk, always!

As I already mentioned, my father was a very silent man. Except for a smile or a nod, he had no expressions. Sometimes I even doubted if he had any emotions at all. But two incidents proved me wrong. One, when he talked to my ophthalmologist. The fear and the concern in his voice was so palpable, it showed how scared he was about my eyes. I have never seen him speak with such vulnerability to anyone. I almost choked with emotion when I heard my father care about me so much.

On another occasion, my mother and brother could not come with us to Chennai. That time, when he and I went to the beach, my hair became an unmanageable mass due to the strong winds. When I looked at him in despair, he sat me down and braided it! I could not believe he knew how to! When I asked him, he just smiled. That was how reliable he was and how he was there for me. And, that was how observant he was. He probably had seen how it was done, and he just did it! It also gave me the assurance that I could bank on my father's support no matter what the situation was.

# chapter 8

Being a kid in the eighties in India meant one terrific thing: street games. Times were safer and parents did not bother where the child was between five and seven in the evening. Any kid between the ages of five and fifteen gathered on a pre-designated street in the locality. Then, usually an older boy, a self-declared leader, would choose a game for the rest to play. After a few customary oppositions and later a truce, the games would begin.

The games were varied in the days of no internet and video games—could be Gully Cricket, Gilli-Danda, Lagori, or even plain hide-and-seek. Then there were at least three variants for the simple game of tag. The idea was to play a game that involved two groups, each with eight to ten kids.

I had waited with bated breath to turn five when I could join this elite band of street players. My older cousin was already a part of it and I was on cloud nine on the day I was allowed to join in with my brothers. They were a year younger than me, but my mother preferred all of us to go and come back together. Since I was not particularly known for my gentler ways, my mother let me out each evening after a stern warning not to rough house with older kids.

Those evenings were fun like I hadn't known before. Not even the beach and the ice cream in Chennai came close to the adrenalin rush I felt running on the streets. It helped that I was tall for my age and rather well built. I ran fast, chased hard, and threw well. Though the older kids in the group tend to get the younger ones eliminated quickly, I stayed on tenaciously till the end of every game we played.

One day, maybe ten or fifteen days after my initiation into being a street player, we were playing Gilli-Danda. This game is a poor but innovative cousin of cricket. There is no need for a bat or a ball or wickets. All you need are two sticks—a long one called Danda and a short one called Gilli. A player from the team elected to bat first will hit the Gilli with the Danda. The player has to do it twice; once to lift the Gilli off the ground and next, to make it fly long and far. The opposite team has to run after the flying Gilli and catch it before it lands on the ground.

I was one of the fielders designated to catch the Gilli when it was in the air. I was good at it too. I would position myself precisely below it and catch it. That evening was no different. Just when I thought I had run enough to catch the Gilli, I realized I had misjudged the distance. The Gilli hit me squarely on the face and before I knew it, my glasses had shattered to a thousand pieces. Quite miraculously, I had escaped an eye injury.

I came home, aborting the game. Having to return home before the game ended saddened me a lot more than losing my glasses. But without them, I could see nothing. I was as good as blind without my glasses. My mother flew into a panic at first and, once she was sure I was unharmed, into a rage. "I told you not to compete with the older kids. What if something had happened to your eyes?" I was let off with a stern warning and she gave me the spare glasses she had kept in the almirah.

Promising my mother that I would be extremely careful while playing, and fully intending to do so, I started playing again. But, kids will be kids. Being cautious isn't their strong trait. In another month's time, in another sporting accident, I lost those second pair of glasses too. My parents hadn't ordered the replacement glasses yet. This meant I had to strut around

blindly for a week because that was how long it took to get a new pair of glasses.

That was when my mom put an end to my playing. She told me with finality, "Find something else to do. We can't risk your eyes. The next time you break your glasses, you may get shards into the eyes. That is permanent blindness."

My parents could not be more different from each other. While my father was soft-spoken, gentle, and coaxed me to do things, my mother was a strict disciplinarian who did not mollycoddle me. It was always tough love with her and she hardly ever reasoned with us when we opposed an idea. She simply mandated it!

According to Baumrind, a developmental psychologist in the '60s, there are four types of parenting:

1. Authoritative parenting
2. Authoritarian parenting
3. Permissive parenting
4. Negligent parenting.

As one can guess from the categories, Authoritative Parenting and Permissive Parenting have positive results on the kids. Authoritative parenting, which was my mother's way, rules are clear cut, expectations are high but at the same time, a child's independence is valued. In permissive parenting, there are very few rules, and the parent is indulgent and lenient. If I am to look back now, I was very lucky to have a father who was all about permissive parenting and an authoritative mother. They were a good balance to bring out the best in me and my brother.

Coming back to my story of girl-with-the-broken-glasses, I was also the girl-with-the-saddest-heart. That being a summer night, children were playing well beyond the usual time. That

evening and many more evenings and nights after that, I cried copiously each time I watched while the lucky ones played, which included my brother and cousins. A rage began to grow in me, wondering why it had happened to me and not to anyone else. Why only I was being punished? Why was I born with weak eyes?

On one such evening, my father sat next to me. "You are a smart child and you should learn to look at the bright side of life! Why feel this sad when you can do a thousand interesting things? Maybe this happened to you because God wants you to discover some other bigger joy." He was talking to a five-year-old me but what he said and how he said it lit a bulb in me. After that evening, I cried no more. I learned to cope. I knew I had to learn to make peace with my disability. I still sat on the porch and watched the others but not with sadness anymore.

One subsequent night, while watching the others, I removed my glasses to wipe them. In that instant, everything in front of me blurred. I could hear the voices but could not see anyone. Putting on my glasses, I glanced up at the sky and I was struck by awe. It was the same night sky I had seen all my life, but that night I saw it mindfully for the first time. The gleaming moon and the twinkling held me captive. What beautiful world was up there in the sky? Just that very thought excited.

After that, I looked forward to nightfall so that I could watch the sky. One of my uncles, who sat next to me most of the nights, began to explain the concept of planets and constellations. The more I learned, the more questions I had. How many planets were out there in this universe? Are there lives on those planets? Maybe that was when the researcher in me was born. Someone with endless questions and a thirst to find answers.

One day, my uncle showed me the constellation the Big Dipper and the pole-star Polaris that lies close to the Big Dipper. He taught me how to locate the pole star with the help of the Big Dipper. Then he narrated the fascinating story of Dhruva from Hindu mythology. The Big Dipper is called the Saptarishi Mandala in the Hindu scriptures, and Polaris is called the Dhruva Nakshatra. Saptarishis are the seven sages nominated by the creator God Brahma to oversee people on earth. Here is how the story of Dhruva goes. Dhruva, a young prince of five years of age, one day tries to sit on his father King Uttanapada's lap. But he is denied the pleasure by his step-mother Suruchi who pushes him off rudely from the King's lap.

When a very sad Dhruva asks his mother Suniti why only his brother gets to sit on the father's lap but not him, the mother sighs in despair—she is unable to explain to that young boy that it is because his step-mother, Suruchi, is dearer to the King than her. Instead, Suniti tells Dhruva to pray to Lord Vishnu to rid himself of such sadness. Dhruva takes his mother's advice so seriously, he does not merely pray as she suggests but performs a severe penance to Lord Vishnu.

Pleased by the young boy's devotion, Vishnu appears before Dhruva to grant him a boon. However, Dhruva has nothing to ask! God Vishnu, impressed with the selfless devotion of Dhruva, blesses him and assures him that once his time on earth is over, Dhruva will become the pole star and dwell near the great Saptarishis, helping them in their work to protect mankind.

After that, each night when I stared at the sky, I looked at the pole star and saw hope. If Dhruva could perform a severe penance in a forest without food and water and got the blessing of God Vishnu, I too could achieve whatever I wanted, right? That is the power of stories on young minds.

# chapter 9

While I coped with the sorrow of not being able to play any kind of sport, either at home or at school, two new problems awaited me as I grew older. One, I started putting on weight because of all the inactivity. Two, the kids began to bully me. They relentlessly yelled, "Soda Buddi," or "fatty," at me wherever I went. Soda Buddi is a wretched moniker in southern India for girls who wore glasses. It probably came from the thick glass bottles that Sodas were packaged in back then! "Buddi" till date baffles me! It meant, "an old woman" in Hindi. But why would anyone call a young girl old? If I have spent this much thought now about my nickname, you can imagine how much it bothered me then.

I *hated* being called Soda Buddi. I was only nine at that time and wanted to look nice and pretty; it killed me to think that the kids at school thought I was fat and ugly. The teasing and bullying only got worse by the day. "Watch out, Soda Buddi. There is a floor in front of you!" Or more cruel ones like, "Soda Buddi, stop studying and stay at home. Your glasses will cover your whole face otherwise." The school, a place I loved, turned poisonous. It was terrible to be teased and bullied so constantly.

Every child deserves a nurturing and respectful atmosphere at school. To make that happen, it is very essential to educate children to speak up when they are bullied. Parents have to listen to their children to evaluate if the problem needs intervention. Recent studies show that most children hide their angst when bullied. They begin to withdraw, develop severe depression, and might take extreme measures, such as

substance abuse or even suicide. Today there is a lot more awareness about the ill effects of bullying but not while I was growing up.

Childhood in the eighties was a mixed bag. We had a lot more freedom with our time since helicopter parenting was not even a thing back then! On the other hand, there were problems such as mine, gigantic to a child, but nothing of importance to an adult. Parents treated children very differently than today. Their opinions were rarely sought, angst were barely heard, and emotions were handled anything but delicately. Maybe it toughened us up and made us self-reliant, but at that time, it also made us feel helpless. When I tried talking to my parents about the bullying at school, they offered a simplistic solution to ignore those who teased. But it was easier suggested than done.

As I grew older, alongside verbal bullying, I also had to suffer from social bullying. Girls excluded me from their groups, laughed at me, and mocked me in hushed tones. I simply did not understand why I was singled out like this. I was not a bad person; then why was I forced to suffer like this? Luckily, there was such a happy atmosphere at home, I completely forgot about my woes once the school day ended. I was insecure about my physical appearance, but on the other hand, I was quite confident about my intelligence. Thanks to my family, who constantly discussed matters beyond mundane, I knew a lot more about the happenings in the world than the others in my class. Since I saw my grandfather read the newspaper for hours when possible, I did the same. I saw my mother engage herself with one or the other activity, I mimicked her. And, on top of it, my grades were good and I was active in extracurricular activities, be it a debate or a quiz.

So, by the time I was in sixth grade, I was quite done with feeling sorry for myself and came up with a set of solutions to face the bullies.

1. I decided not to hide from anyone. The school hallways were as much mine as they were anyone's.
2. I prepared some good comebacks for when teased, but they were simple and plain ones that were easy to deliver under pressure!
3. I decided to show others that I was hardworking, intelligent, and willing to help them.

Soon, I began to walk around with my head held high and not hide in classrooms during recess. If someone called me "Soda Buddi," I told them calmly to mind their business. If some called me fat, I told them looks mattered only to the movie stars. I built my confidence one block at a time like legos. I befriended many by offering help with their studies and homework. The going was good in building friendly bonds.

However, soon a day came when I had to believe the old adage—God helps those who help themselves! The principal of the school, named Kalyani (which is my middle name!) summoned me to her chamber. She was both feared and revered by everyone at school. Her perfect English and polished manners had always held an appeal to me.

"I see you are being teased by a lot of kids," she replied calmly after I sat nervously at the edge of a chair opposite her.

Despite herculean efforts, my tears flowed. Maybe because an adult had acknowledged my pain. The principal remained silent until I was done with my crying. Then she said cheerily, "See, we will change that from today. I have decided to make you the pupil leader. Nobody dares tease a pupil leader, right?"

My jaws dropped in shock and surprise. A pupil leader was an elected member (usually one of the very popular boys only got the positions). And, it was always someone from the tenth grade.

The historical significance of what she just said is unprecedented not only in the school, but in the town or anywhere in my state as per my knowledge! Could God really be so gracious to me? But why me?

"Ma'am, I don't know what to say." With both happiness and tears flowing at the same time, I gestured with my hands. "What do you mean by making me the pupil leader?" I asked aloud in shock.

"Yes, Kamala Kalyani. Not just because you are being bullied. I have observed you over the years. You handle yourself very well. I have seen you stand up for yourself, lead class projects, and you do manage to look undisturbed by all the teasing."

You are going to take over the position of the unanimous school pupil leader soon, since you are a natural leader.

That afternoon changed my life. Soon, the principal, as promised, announced my position in the school assembly. Overnight, nobody dared tease me. Everyone wanted to be in my good books. I walked through the school corridors with a wooden scale in my hands, a smile on my face, ready to deal with anyone who challenged rules. It now seems silly to me that I used to move with a wooden scale as a symbol of discipline; yet with a smile.

Not that I did not feel highly vengeful toward all those who had been nasty to me or anyone else, but what my father said one night stuck with me.

"Kamala, do not misuse your power, but instead, be fair with everyone. Do not harbor any grudges when you are a leader."

But I was not going easy on anyone wrong. If someone had missed a class, I reported them even if it was someone older than me. If someone teased others or anyone in my earshot, I reported them. Soon, my nickname changed from "Soda Buddi," to "Khal Nayak," meaning *the Villain* in Hindi, national language of India! I didn't mind that at all. My own brother and cousins were frightened and were mindful of me now.

"You are such a pain, Kamala. You can't expect everyone to be right all the time. You can't report students to the principal for small mistakes," My brother or cousin would argue. "And, you shouldn't report us. We are a family."

"I am elected by the principal precisely to report everything. So, don't do anything wrong when I am around is all I can say," I would tell them off with glee. Several boys and girls became wonderful friends on this journey as a leader, probably because they also saw a leader's humor in addition to dedication and discipline.

After nearly five years, the constant pressure of being bullied was off my chest. That was the time I began to discover myself. I had grown up admiring my father's leadership qualities that consisted of authority, compassion, and kindness. Now that I was a pupil leader, I wanted to make the school a better place for everyone, just like him.

# chapter 10

I consider my high school's three years, which is eighth to tenth in my school district, as one of the most blissful times of my life. My school life was no longer filled with anxiety. I had friends, hardly anyone teased or bullied me, and, in fact, quite a few people loved me—something I would never have envisioned a few years earlier, even if God stated so! With this peace came incredible self-discovery!

These were the years where I not only discovered my interests, spiritual leanings, but also my professional aspirations. This was when I blossomed into a person with intentions.

In this chapter, let me talk about how my career goals developed and some related events. As I said earlier, I grew up in a world of drugs (the medicinal kind!). The family business had emerged from being a local pharmacy into a large pharmaceutical distribution entity. Most drugstores, big and small, in the entire district of Kurnool obtained their inventory from us. So, at home, we were surrounded by pharma terms—antipyretic, anti-diabetic, active ingredients, molecules, and many others!

I enjoyed the conversations my uncles and my father had—be it about the new drugs they were going to market or the new clinical trials going on. Although we had godowns where medicines were stored, many cartons of over-the-counter drugs were also delivered home. Being a naturally curious kid, I would intently look at the medicinal compositions and ask how exactly they worked on human bodies. Most often, my family knew what a drug cured and not how it cured a disease. But that was what I wanted to know!

I could also see that a large number of medicines I saw were meant for anti-diabetic and cardiovascular diseases. As I also looked around more for information, I was shocked to learn that cardiovascular diseases were the chief cause of mortality in India. Also, India had the highest number of diabetics. This unduly distressed me. Was there anything I could do when I grew up? I began to read whatever literature I could find and started talking to whoever seemed knowledgeable. That was when a desire to study health-sciences took root in me. Also, my hatred for math! I was also impressed with the respect my family got from people. Though no one in the family was a doctor, my father and uncles knew a lot of medicines as pharmacy owners and regularly guided people. I too wanted to be a respected member of the health industry!

A few things became clear to me in the three years of high school.

1. I wanted to study health sciences.
2. I had to discover something that helped humanity.
3. I would explore every field that interested me.

In the middle of all this self-discovery, I had a new kind of battle to fight. That was with my mother! My ever so gentle and kind mom turned into a strict disciplinarian come evenings. She was of the firm belief that even ninety-nine out of one hundred was not good enough. Being in the top ten was for losers, you had to be at the very top. She drove everyone hard, but especially the first four of us. Every evening, we had to report to the desk at seven sharp and study till ten.

While the others complied, I fought with her. "I am not like everyone else. My eyes hurt if I study for too long. Treat me differently!"

She would have none of it. "You are young. Your eyes will get used to the long hours. The doctor says you can study for three hours at a stretch."

But soon I plucked up enough courage to have a candid discussion with my mother. "Amma, you have been a topper all your life. That was your drive and your dream. But you can't expect that from me."

My mother never gave up a fight. "When you are capable of it, why not? Why are you bent on throwing away the gift from God? When you can excel and you shouldn't settle for less."

"I am happy learning and not merely chasing marks. I want to learn a lot of things outside of school and not just pour over textbooks."

The argument was a never-ending one. Most children in the eighties did not have their parents hovering over them like my mother. She was a hybrid of the eighties and the modern times! She did not mollycoddle us like today's parents but did the helicoptering nonetheless! Also, most kids my age though had to start studying at seven (that was the magic hour in every household!). They could wind up at nine. What they did during those two hours was not monitored. If they had trouble cracking a homework problem, it was usually the older sibling who helped, not the parents. But in our house, my mom was the self-appointed tutor. She wouldn't budge from our study area for three hours which was very painful!

Whenever I fought with my mother too strongly, my father would take my side and try reasoning with her. "Let Kamala be. Her physical energy levels are low and she complains of eyestrain. Let her do what she can."

But my mother would have none of it. Maybe she could have engaged gentler ways like rewards and coaxing to make me study, but that was not her! Though I hated, truly hated,

being driven so hard by her, looking back I am glad she did what she did. She inculcated an instinct to fight in me. I learned that my best can always be bettered with hard work. She did not just teach us mathematics and science, but also the benefits of hard work.

For every parent, the million-dollar question is how much pressure is too much? How much is too little? Because studies show that if a kid is pressured constantly to excel, they become stressed, depressed, and anxious. A sense that they are not good enough begins to consume them. They resort to cheating and lying to escape the wrath of parents.

In our case, all the push did not backfire but instead, made us perform better. Looking back, I feel it worked only because my mother spent time with us and did not simply demand excellence. She knew first-hand what each of us was capable of and helped where we lacked.

Along the way, we both made peace. I worked a little harder and she began to loosen the grip on my studies. However, many of my friends had already begun the ambitious journey toward becoming a doctor or an engineer with extra tuitions and mail-order classes. But for me, with my mother finally backing off, I was happy pottering around people and things.

# chapter 11

Alongside my clarity about the profession I wanted to choose, I also began to understand the different tenets of spirituality. Religious devotion was important to me and my family, but I began to feel there was something beyond that. I began to observe people and happenings more closely feeling the vibes I emitted and received. The more tuned in I was, the more I felt the universe was communicating with me through subtle messages by way of coincidences. I didn't know how to interpret the coincidences that were happening to me but I sure became very aware of them around the age of thirteen.

The first time I observed a coincidence was when I was in my grandfather's room. I remember it so vividly as if it happened yesterday. In a religious Hindu household, recitals and chants from the holy scriptures are everyday events. Reading or listening to the Sundara Kanda section of Ramayana is one part.

I will digress a little here to talk about Sundara Kanda because it has played a very energizing role in my life. This popular section from Ramayana has sixty-eight chapters and talks about the valour of Hanuman. (I am assuming the reader is aware of Ramayana here. If not, I urge you to read this great scripture at least once in your life.) Hanuman's bravery, confidence, and his unwavering faith in Lord Srirama are enumerated in these chapters, along with beautiful descriptions of nature. The story in this part is of Hanuman crossing the ocean to reach Sri Lanka to locate Seetha. This section emphasizes ever so charmingly the fact that there was no hurdle in the

world that Hanuman could not leap over and no task that he couldn't get done. All because of his faith in Lord Sri Rama.

Coming back to my story, my grandfather listened to a few chapters a day on the tape-recorder with my grandmother sitting next to him, listening as intently. As I have mentioned before, my grandfather was a great devotee of Sri Rama. I loved to be a part of that routine. The narrator not only sang the original Sanskrit verses but also explained each of them in Telugu. He summarized at the end of each recital the importance of selfless deeds and how each one of us had that spirit of Hanuman in us, if only we tapped into it. Till date, when the chips are down, I listen to Sundara Kanda which leaves me energized and gives me the confidence to resolve my problems.

One such afternoon while I listened intently, the phrase "Raghu Rama Seetha Kalyana" came up. I had heard it before but that time it sent an electric jolt through me. This phrase depicts a momentous event in Ramayana—that of the wedding of Lord Rama with Seetha. Putting together the names of the four of us in my family, Raghu (my brother), Rama (My father), Seetha (my mother), and Kalyana (Kalyani was my middle name and many in my family except few till date call me by that.) was exactly that holy phrase!

I ran to my mother to ask if they had intentionally named me and my brother to make that phrase. My mother, surprised, answered me in the negative: "It hadn't even occurred to me till today! We named your brother after Lord Rama and you after my grandmother."

After that, I sat quietly, but my mind was chaotic trying to put together any other such coincidences in my life. That was when it hit me that my parents were Rama and Seetha, a couple worshipped with fervor all over India for their ideal marriage. And, my parents do have a perfect marriage. They complement one another so perfectly. There is so much love

and respect between them and they are Rama and Seetha in the spirit. (Of course, unlike the divine couple, my parents do fight hard but in the next few minutes, they are back to being the best of friends. I do ever so fondly call them Tom and Jerry!)

"How do you think this happened with your names?" I asked my mother and she just laughed. "Maybe I was born to marry your father, that is why!" She was someone who could have been a doctor and life had veered her to marry my father! Then, was her pain of not being a doctor a pre-destined one? What pains and pleasures are already decided for me then?

Looking at me puzzling over these coincidences, my grandmother added to my quest. "Don't you think I have five sons and they are as united as the Pancha Pandavas?"

Was she right! I had heard people address my father and his brothers as Pancha Pandavas a myriad of times but until that day it hadn't struck me as extraordinary.

Pandavas, the five brothers, are from the other much-revered Hindu epic, *Mahabharata*. Pandavas were known for their valour, unity, love, and affection toward each other. Each one had a unique strength and when they combined those, they were a formidable lot. So were my father and his brothers! Each one of them had a unique strength and their combined strengths had resulted in a highly successful family business.

Then one of my aunts teased my grandmother, "Let us not forget that our in-house Pandavas are also followers of the mother's words!"

Such banter was common because my grandmother was a light-hearted soul. Though my aunt had said that in jest, she was right! My father and his brothers never once said anything hurtful to my grandmother and as far as I can remember, always followed her advice. Let me narrate in brief a story from *Mahabharata* that shows the devotion of the Pandava

brothers to their mother. Prince Arjuna wins the hand of Princess Draupadi in a contest organized by her father. When home, he excitedly declares to his mother who is inside: "Mother! See what I have won!"

Hearing the words, Kunthi shouts her reply from inside the house. "Make sure to share what you have won with your brothers equally."

Pandavas are shocked by this but they never disobey their mother. So all five of them together marry Draupadi! Epics do narrate extreme situations to drive home morals.

The more I looked, the more coincidences in my life unearthed before me. My brother and I shared the same birthday! How appreciation for this extraordinary coincidence escaped me, I am still wondering. We could have chosen any of the 365 days to be born, but why did we choose these days to be born? Were we destined for a life that is interwoven somehow?

The next coincidental thing that occurred was not a happy one. On the day I was turning twelve, my beloved grandfather passed away. I was so overcome with grief, I declared that never again I would celebrate my birthday. My mother consoled me through my grief. "Then you celebrate the day after your birthday to remember your grandfather. I believe that my grandfather chose my birthday to pass away because he wanted me to always remember his grit and his acceptance of pain. On a lighter note, my brother, who chose to have his birthday celebrated on his original day, till date teases me that it was a ploy from me to have a two-day-long celebration for my birthday! Jokes apart, my birthday in my mind is not just about my birthday, but it is a day I remember my grandfather. Also, from that day onwards, the numbers 1 and 2 have proved to be immensely important to me.

Perspectives on why coincidences happen, and what they might mean, It is called "synchronicity" and it has even made its way into the Merriam-Webster dictionary. It is defined as coincidental occurrences that seem related but cannot be explained by the conventional mechanism of causality. I don't know if these synchronous events happen to everyone but only that I notice them more or if they happen a lot in my life. But I feel it is the universe guiding me to make my decisions through these signs. Call it God or spirit angels, whenever I am stuck, there is a sign that shows me the way.

# chapter 12

In my early teens was when I also became interested in understanding the Hindu religion and the many norms that surround it. Festivals reign supreme in India! When you are a child, they are very exciting times. I loved the hoopla around each festival. Loads of colourful flowers, cartons of fruits, shiny silver articles, tall lamps, mounds of turmeric and Kumkum—it was a feast to the eyes to see the Pooja room. The festivities would start a day before any major festival gathering the items I mentioned above.

The next morning, before the priest came, flowers were arranged artistically on the deities, fruits kept decoratively on silver plates, multiple lamps were lit, and incense sticks overloaded the senses. I wouldn't miss a minute of any of this excitement. The food offered to God was cooked with utmost devotion and cleanliness. And, such varieties of sweets and savouries were cooked! When the priest arrived, it was an altogether different kind of energy at home. The mantras were chanted in loud baritones, the bells were rung, Arathi (wicks dipped in ghee and lit on a silver plate) was offered to the Gods. One by one, the fruits and the Naivedya (food made for the Gods) too were offered.

My mother prepared the Naivedya with such sincerity and dedication, she wouldn't even attend the worship. She wore a sari that was freshly washed and nobody could touch her while she cooked. It was a complicated procedure by itself—the sweets and savouries prepared for God could not come into contact with any other food, nor could it be tasted before the offerings were made. I often felt bad for her. I wanted her

to be part of the rituals that I enjoyed so much. "Amma, come watch the Pooja. You are missing everything by hiding in the kitchen."

She would smile, "This is my pooja. Making the Naivedya is what makes me happy!"

Though I disapproved of her then, now I do understand how each one has their connection with God. That was mother's way. I have friends who take utmost pleasure in decorating the deities. Some are delighted to chant complex mantras. For me, it is a combination of it all, though I do seem more mesmerized by the chants. It transported into a world that was beyond what I saw before me. Many of my friends were already losing faith in such elaborate rituals. I wanted to understand why I felt so energized by this devotional fervor. I wanted to know why the rituals were a certain way. The meticulous procedures followed by the priest also left me with a lot of wonders. I loved that whole experience.

The more I questioned, the more I fell in love with the concept of our festivals. There was a reason behind all the festivals. Yugadi is the celebration of the Hindu new year according to the Lunar calendar. Sankranthi is the beginning of the harvest season. Ganesha Chaturthi to celebrate the birth of Lord Ganesha, the remover of obstacles, Shivaratri to honor Lord Shiva by renouncing materialism, Deepavali, "festival of lights," to mark the end of the demon Narakasura as well as to recognize the greatness of another King called Bali. I can write a whole chapter on Hindu festivals! On the one hand, festivities instill spirituality and on the other, they also bring in a celebratory mood. A welcome change from day-to-day life.

My friend, seeing at my interest, invited me to join a Satsang sessions he held with his friends every week in the local temple. Satsang translates to being a part of a good

company. The main part of a Satsang is the singing of Bhajans. Here upbeat devotional songs are sung by everyone. It is not one's musical prowess that is tested here but one's Bhakti. It is an energizing experience when everyone sings in unison. I couldn't go with my friend as often as I would have liked, but whenever life overwhelmed me, I found my peace at the Satsang.

I later researched the effects of chanting or listening to mantras and singing the Bhajans in a Satsang. Both the activities are proven to calm the mind and elevate one's consciousness to a higher level. Many times, you can even see tears rolling down people's eyes when they sing Bhajans. Today, I may not be as disciplined in performing all the rituals at home but I know the power of chanting. I know when I chant alone or sing with a group, my energy levels increase. What an ingenious way our ancestors have found to focus our minds on something greater than ourselves!

Around this time, my close friend Shanthi moved a little farther away from where I lived. After months of postponing visiting her, I set out one evening. On the way, very close to her house, I found a temple-like structure, which drew me in. I entered the premises out of a whim, and it was a truly surreal experience. It was a newly constructed temple of Shirdi Baba and I fell in love with the aura that surrounded that white marble statue of Baba. His serene face, forgiving stance, the calmness all around mesmerized me. Soon after my first visit to the Baba Mandir, my aunt Prasuna moved near the temple. Again, was it just a coincidence that I visited my friend only after that temple was built or that my aunt moved there? I think not! Till date, I am a great devotee of Baba. When I surrender to him and narrate my problems, I feel lighter.

I was not deliberately raised to be a spiritual child but it was a way of life at home. Again, research shows (I am a

researcher at heart, so I cannot stop researching on any topic that intrigues me!) children exposed to spirituality have a higher emotional quotient, are more positive, and are less likely to indulge in substance abuse. Quoting the great Swami Vivekanda, spirituality is the science of the soul. That has how spirituality worked for me. When my soul depletes, which I know is what happens when I am agitated, overworked, or plain sad, I have some form of spirituality to fall back on, be it listening to Sundara Kanda or chanting a mantra, or attending a Satsang or my favorite of all, visiting a Baba Mandir!

# chapter 13

While talking about my teen years, I also must talk about one more realization: we were a highly conservative family. Not that I wasn't aware of this before, but around thirteen years of age, it began to agitate me. Especially the restrictions on how we girls dressed. Till then, I was accepting of these impositions but not anymore.

Tulasi and I were not allowed to wear knee-length skirts, only those that kissed the ankles. "But, our uniforms are knee-length. Why should we not wear the same kind of skirts outside the school?" I would ask my eldest uncle.

"You won't understand it now. But it is for your safety." My uncle would dismiss my angst.

I argued the same with my father but he would shrug off. He was not going to pick a battle with his elder brother on this. My mother or any other woman in the house wasn't of much help either.

Another matter of anguish to my young self was that I could not eat eggs! I loved eggs but we were not allowed to eat that in our house in Kurnool. We belong to the community where we follow vegetarianism. But, the young me did not understand this part of the tradition. I only knew that we are not to eat eggs in our house.

If I may take a moment to digress here, among the many reasons I loved going to Nellore, my maternal grandparents' house, was being allowed to eat eggs! Even as I sat on the big bus that took us to Nellore, I looked forward to the freedom I got there. I could wear what I wanted and eat anything I liked. I am told that in Nellore I not only ate eggs to my

heart's content but also went to bed holding a boiled egg in hand! lol!

Nellore is known for its garment industry and my mother went all out shopping the moment we got off the bus. She collected designs and patterns for her blouses and my dresses all through the year from women's and movie magazines. It was very endearing to see my usually stressed mother come alive and let her hair down. Hers was an easier task. When it came to my clothes, I had a mind of my own. I eyed all those skirts and dresses that I possibly couldn't wear in Kurnool. Finally, my mother would convince me patiently to select those that met the norms of the family—no short dresses, no sleeveless, no deep backs. And, I was only twelve or thirteen years old! I was happy to get close to a dozen pretty outfits tailor-made for me but as I grew older, it irked me that I had so many restrictions imposed on me on what to wear.

Girls, according to Hindu traditions, are not to cut their hair. And I hated my long, well-oiled plaits. I felt so ugly looking at myself in the mirror—the oil from the hair seeping onto the face, eyes enlarged behind the large glasses, and my overweight self. I wanted to look pretty like those TV news anchors who had short bobs. I spent hours folding my hair into a bob and I looked pretty to myself! I would pester my grandmother to let me cut my hair. My pestering was in vain, which added to my frustration. What I wear, how I keep my hair, and what I eat should be left to me, right? I didn't rebel or fight, but I kept looking for answers about why my life was so restricted.

The things I was angry about, I agree, are superficial. But what Tulasi faced when she completed her tenth standard due to the conservative outlook of our family is not trivial. She was the smartest of all grandchildren. She was intelligent, hardworking, and impressively systematic. Her aspiration was

clear, she wanted to be a doctor. After the tenth grade, for even a chance to get into a medical college, she needed more rigorous coaching than what the school offered. In those days, we had to write a competitive exam called EAMCET/SAT+ACT like/SAT like (Engineering, Agricultural, Medical Common Entrance Exam—a highly self-explanatory acronym, I must say!) To crack the EAMCET/SAT+ACT like/SAT like code was a Herculean task.

Unfortunately, Kurnool did not have any proper training centers and one had to move to Hyderabad. But the family outright vetoed Tulasi leaving home to stay in a hostel in Hyderabad. To this day, I can't say if it was the conservative outlook that girls have to stay with the parents and then with the husband or if it was simply overprotectiveness from the family. Despite Tulasi's many appeals, she was not sent for the EAMCET/SAT+ACT like/SAT like coaching. She, too, accepted it quite gracefully and gave up her dream of being a doctor but it left me fearful of what would happen to my aspirations.

I spoke to mother one of those nights that kept me awake. "Amma, what if I want to be a doctor? I don't want my fate to be like Tulasi's."

My mother smiled. "If you want to be a doctor or anything else, I will stand up for you. I won't let your career goals get quashed."

Till then, I knew I wanted to be in healthcare but was not sure if I wanted to be a doctor. That night somehow made my goal clear. I could not imagine being anything but a doctor. Being with patients, curing them, helping them—it was as though I had found my calling.

Then, before my mother fell asleep, I declared to her. "The day I get into a medical college, I am going to get a short bob!"

Talk about priorities!

# chapter 14

Amidst triumphs and tribulations, I reached the tenth standard. This was the time one has to be very clear about their career goals in India. Because, come the eleventh grade, or as it is called the pre-university-college (PUC) in India, a student has to choose one of the three streams of education—Science, Commerce, or Arts, or Humanities as it is now called. Most parents in India are very particular about their children taking up the science stream and becoming an engineer or a doctor. Those who are outside of India might be surprised about this near obsession Indian parents have about a degree in Engineering or Medicine. But, we have to bear in mind that every parent only wants the best for their children. Given the population of India, getting a job after completing an undergraduate degree is very slim if one is not an engineer or a doctor. So, naturally, parents urge the children to get into the Science stream.

The one difference I find between when I studied almost two decades ago and now is the mushrooming of engineering colleges. When I was studying in twelfth, if getting into a medical college was a near-impossible feat, engineering wasn't much easier either. However, with the advent of the IT boom, there are no restrictions on the number of private engineering colleges and hence, every other kid I meet now in India is some sort of an IT professional.

However, from what I can see, getting into a medical college is still a hard task in India just like how it is in the rest of the world. I will get into that part in a little bit but now I must talk about a heart-breaking event that occurred in my

life. Our large family decided to split up. As I learned later, it was mostly a decision driven by financial concerns. Educating the older children in the family was getting more and more expensive and the parents of younger children were sharing that burden. So it was amicably decided we would go our separate ways.

Kudos to the elders in the family because what could have turned into a very traumatic experience for the children was made pleasant. Though the family got divided, all the brothers decided to live on the same street. What a relief to all of us cousins who were not used to being on our own! Instead of one house, now we had five houses. We could go into any house to have a meal or a snack or to study. We were still called by our aunts when they cooked something nice. We still had our uncles spending jolly times with us.

When I look back now at that event, I feel how well the family handled that potentially problematic financial situation. Who would be happy in the long run bearing some others' costs, even if it is your own loving family's? Chinese philosopher Confucius says, "Men do not stumble over mountains but molehills." But the wise thing to do is also to not let molehills grow into mountains! It takes a lot of skill to foresee a problem. Most often people are so caught up in their day-to-day living, they forget to look ahead.

Quoting a French philosopher, "All of humanity's problems stem from a man's inability to sit quietly in a room alone." How true is this statement! Thanks to my father, I am a strong believer in meditative silences. Most often, when I come out of being quiet for a while, solutions to problems emerge naturally. Though I do not know who thought of splitting up the family, I highly admire the elders who carried it through so graciously.

As I have mentioned in an earlier chapter, my eldest uncle passed away when still in his early forties. My aunt stayed on with my grandmother but did not move out of the house to be near even her parents. This was possible only because every member of the family felt a sense of belonging. One cannot force such an idea into people, but we were lucky that it was an innate trait in all of us to love and be caring towards each other. (Though it is an aside, I must mention here the composure my aunt displayed when she faced the traumatic loss of her husband. I barely remember seeing her making a display of her grief. Instead, I only remember how much strength she exuded in consoling her children and my grief-stricken grandmother. I feel I coped with losing my uncle by drawing my strength from my aunt.)

Coming back to my educational goals, by the time I was in the tenth grade that dream of being a doctor was set in cast iron. Here let me give you an idea of how difficult it was to get into medical school in the early nineties (it is almost the same even now, I hear). Of nearly a hundred thousand aspirants, only about three thousand made it! So, even to aspire for a degree in medicine took quite a lot of courage! But challenges energized me and I never shied away from them. I was ready for the hard work I had to put in. Even two years earlier, I was resisting the two-hour study time imposed by my mother, but now I was willingly taking on endless hours of studying!

The famous verse in Bhagavad Gita is,

*"Karmanye Vadhikaraste ma phaleshu kadachana. Ma karma phala hetur bhur mate sangostvakarmani."*

This beautiful verse translates to this: "You are only responsible for your work but not its results. Do not be attached to the gains of your work but at the same time, do not be idle."

This is the advice of Lord Sri Krishna to Arjuna that only the work we put in is under our control and not what it results in. Even if things don't go our way, we must give it to the will of God and move on to doing more good work that we believe in.

This is the verse my father quoted to me often during those dreadful two years of PUC, though I did not assimilate this thought into my life until much later in life. However, it shows that adults need to advise whether children take to it immediately or not. Because the words one hears often from parents and teachers suddenly begin to make sense one fine day!

# *chapter 15*

By the time I completed my tenth grade, we were a nuclear family but the extended family still played a major role in our lives. Major decisions in any household were made only after discussing it with everyone else. My ambition to pursue a medical degree was met with concerns. One good thing was, the training for EAMCET/SAT+ACT like/SAT like coaching had started in Kurnool itself and I didn't have to move to Hyderabad. However, everyone knew the insane amount of hard work that awaited it and it concerned my uncles. As I have mentioned before, I did suffer from low energy levels and also my eyes were a matter of concern. I had about -14D power by then. So naturally, my uncles were worried that those innumerable hours of studying might degenerate my eyes further. But both my parents stood by me. My father convinced the others that, if I was willing to put in the work required, then I should. He would make sure my health and eyes would not deteriorate. One of my uncles expressed concern if my father could bear the cost of a medical degree. To which I replied firmly. If I got into medical school it had to be on my merit and not through my father's money.

Admissions to medical colleges worked differently in India those days. Only if a student was in the top 500 ranks, out of nearly a lakh, then they qualified for a merit quota where the tuition fee was highly subsidized. Otherwise, the rank didn't matter as long as one paid a much higher fee. I did not want a payment-based admission.

Once the college started (as said earlier, eleventh and twelfth grades are called the Pre-University-College), we all

had no time to even settle in. Twelve-to-thirteen-hour study days started almost immediately! We had to study three subjects to pursue a medical degree: Physics, Chemistry, and Biology. Between attending school, post-school coaching, and taking innumerable tests daily left me in a daze. Let alone any form of recreation, I barely had the time to eat or sleep. When everyone went to the movies, I stayed back to study. When everyone was watching a gripping cricket match, I stayed in my room to study. When everyone had good family time, I went up to the terrace to study in peace. I put on weight, my skin lost its luster, my glasses grew thicker. For once, my efforts were on par with my mother's expectations!

Needless to say, my mother nourished me to the best of her ability. She was on cloud nine that I wanted to be a doctor. She often pointed at a prestigious medical college that was barely two kilometers from home and said that soon I was going to be part of that elite institution. I began to believe, too, that that was where I was going to be in the next couple of years. *Why not?* I would ask myself. *I am quite intelligent and I am working so hard, so why wouldn't I get into that medical college?*

The two years passed in a blur. Even falling sick was not an option because the lessons were taught very quickly. My eye strain was at an all-time high. My allergies were at their worst. My back hurt and my whole body ached all the time. Even when I barely had the strength to get up from the bed, I went through the motion. School, coaching center, and my study desk. I couldn't wait for my final exams to get over.

All things, good or bad, have to come to an end. So did my two-year nightmare. I still shudder from the anxiety I went through before my exams. Until the question paper came to me and I began to write, I couldn't even breathe! But my hard work had ensured that I knew most of the answers.

That was the subjective board exam where there was time to think about a question. But the EAMCET/SAT+ACT like/SAT like exams were a whole different ball game! They were objective exams where we had to answer sixty questions in sixty minutes and the wrong answers were scored negatively! I had no clue how right or wrong my answers were. But the day I finished the last EAMCET/SAT+ACT like/SAT like exam, I only remember coming home and crashing on the bed and sleeping for twelve hours! After that day, I ate, slept, and watched some non-stop TV. It took a few days for me to even believe that I didn't have to get to my study desk every waking hour!

Once my sleep and recreation debt were paid, I worried about my results. All my hard work would be such a waste if I did not get a good rank.

I was up all night gazing at the "Goddess Saraswati" photo, which was right next to the wall of my grandfather's photo in the main hall. My mother always made me worship the Goddess Saraswati mantra: "Om Aim Saraswatyai Namah"; which honestly, I did not know the true essence and the energy that I would be attracting due to such beliefs in faith and spirituality through my commitment to education. My world of worshipping Saraswati until my late twenties was about education. Saraswati is worshipped by all persons interested in knowledge, especially students, teachers, scholars, and scientists. Saraswati, is the goddess of knowledge and the arts; which, at the age of seventeen, I did not realize that education is the first stepping stone of knowledge and it is a never-ending path in our quest for the purpose of life.

In her popular images and pictures, Goddess Saraswati is generally depicted with four arms (some pictures may show only two arms), wearing a white sari—traditional outfit of Indian women—and seated on a stunningly beautiful and

peaceful white lotus. She holds a book and a rosary in her rear two hands, while the front two hands are engaged in playing a lute (veena). Beyond being the Hindu Goddess of knowledge, music, and all the creative arts, Saraswati is called the Mother of the Vedas and the repository of Brahma's (the creator as per Hinduism) creative intelligence. She is also called Vak Devi, the goddess of speech. But, my path to knowledge driven through my interests in higher education has opened my third eye to knowledge; which you will see in my later chapters.

# chapter 16

The day the result was going to be announced, I could barely stand still. Anxiety seeping through me, I asked my father how I had done as soon as he returned from my college with the result. My father simply shook his head and sighed. It meant only one thing, my EAMCET/SAT+ACT like/SAT like rank was not good enough to get me into any medical college in Andhra Pradesh. I had prepared myself to face both the good and the bad outcomes. But when the bad news was delivered, my whole world fell apart. My body felt numb, stomach clenched in knots, and my breath halted for a moment. I managed to walk to my room and collapse on the chair. No words can describe the heartbreak I went through. Two years of slaving was a complete waste. Why me? What had I done wrong?

The next week, I can only remember my head pounding and the eyes burning from the non-stop tears. I barely ate and despite everyone in the family trying to console me, I felt hollowed out. My mother was a bigger mess than me! She couldn't even stomach that I was not going to be a doctor. She had firmly believed that I was going to be a medical student at the college near home. Through all these emotional storms, my father remained steady. His philosophical and spiritual outlook toward life keeps him always calm and practical. After a couple of days of my crying in anguish, he came into my room and asked me to step out.

"You have to think about what you want to do next. Crying is not going to change the results. You worked hard and you should be proud of that." My Uncle Sridhar (My

dad's youngest brother) said, looking me in the eye. Somehow, the strength in his eyes and pride on his face soothed me. He was right. If I kept moping and crying, I was going to miss the deadlines for other colleges too. Tulasi was doing her Bachelor's of Science in Microbiology. Maybe, I could consider that. There was always the option of getting a Masters degree in the same. Though I knew that was the right course of action, my heart was just not willing to accept that I was not going to be a doctor. That I was not going to work with bodies. That I was not going to have any patients I could cure.

I kept trying to pull myself out of that state of melancholy. If my grandfather could live paralyzed for two decades without a complaint, why was I crying over something that may not even matter a few years down the road? I picked up the application form to apply for a Bachelor's of Science and began to fill it. That was when a miracle happened! My eyes fell on a box of medicines for dogs. A couple of years earlier, my family had diversified to distributing veterinary medicines. The market was a growing one and our business had caught the wagon early. I had heard my father and uncles discuss that segment innumerable times, but till then, I hadn't paid any attention.

I ran to my father. "I think I will qualify for veterinary medicine. Can you please check?" I asked him breathlessly. After medical and dentistry, the next coveted segment was veterinary medicines. Unfortunately, we had no career counselors who showed us the different prospects in case we didn't qualify for a degree in medicine. The schools and the coaching centers only focussed on enabling us to crack the exams. I feel that even before such a training starts, it is important to educate the aspirants about a plan B.

My father looked at me with concern. "Why this change of heart? You never were interested in it before."

"If I can't be a human doctor, I will be an animal doctor. I want to be a doctor! As long as I stay in this stream, I can always switch later." I have no idea where I got that wisdom! That is why I believe in divine guidance in our lives.

My father still looked sceptical. "There is no veterinary college in Kurnool. I don't think the family will agree to send you out of town."

By then my mother had made an entry into the conversation. Even before I replied, she stated to my father. "It is her dream. Her professional goal. We saw how hard she worked for two years. We can't deny her what she wants now. We will convince the family."

I did my homework before the family meeting. My rank qualified me for admission to a prestigious institution with Veterinary Medicine offered, in Tirupati, which was around 350 kilometers from Kurnool. Ample buses plied between the two towns. They were a reputed college with a decent percentage of girl students.

As expected, there were grave concerns from the family. *We have never sent a girl outside of town before marriage. Is it safe? How do we know the hostel is safe? What if something untoward happens? We won't even be close enough to help her.*

My parents fielded all the questions for me! They convinced the family that they felt confident and safe to send me to Tirupati. By the end of the night, even my grandmother had given me her blessings. They all had seen how I had slogged, so I guess they didn't have the heart to disappoint me any more than life already had.

As I stepped out to go home, Tulasi held my hand. "All the best, Kamala. I wish I had your forethought and smartness to choose veterinary instead of going in for Bachelor's of Science. I am so proud of you!"

That night, I cried again, and this time in pure joy! We keep hearing the words providence, destiny, and fate, but how many times do we believe in them? My father was a follower of Swami Vivekananda. One of the quotes I read from a book on my father's desk was this: "Take up one idea. Make that one idea your life—think of it, dream about it, and live on that idea. This is the way to success." You can also think of owning that one idea in terms of the Law of Attraction, which states that we attract what we put out through our thoughts. In other words, the mind translates our strong thoughts into reality. Thus the one most important factor in achieving success is to have a clear goal. Goals will change over time but it is important to have one at any point in time. I truly believe that since I so longed to be a doctor and someone who makes a difference to the world, it manifested into a reality. It was God who gave me the wisdom to choose Veterinary Sciences, and as my story unfolds you will know what an important role that training has played in my life, including the man I married eventually!

Coming back to the story, the day after the family approved of going to Tirupati, I applied to the college and within a week the admission was complete. The day I held the admission card in my hands, I felt dizzy with happiness. The next thing I did that morning was to head out to a beauty parlor! I had gotten admission into a medical school so it was time to get my haircut! There certainly were going to be raised brows and disappointing words from the elders, but I had a promise to keep up—a promise that I had made myself!

# chapter 17

Before I begin talking about my life at Tirupati, let me talk about my dear hometown, Kurnool. Except for its proximity to a holy place called Srisailam, Kurnool is quite nondescript. It is a little town on the banks of the Tungabhadra river. At one time, it was under the rule of the renowned emperor Sri Krishna Devaraya.

When I was probably ten, one lazy afternoon, I was exploring our house. That was how the screen-free childhood worked—when bored, create your excitement! One such exploration made me stumble upon some exotic-looking rocks kept under my father's almirah. They were carefully wrapped in a cloth and enclosed in a box. My eyes popped out of my soda glasses when I held them! What were these rocks?

I wasted no time running to my father with my find! He laughed of course that nothing escaped my tentacles at home but then explained the origin of those rocks. The little nerd that I was, I loved information overload! Kurnool district is known for its gold, diamond, and copper deposits, he explained. It also contains huge reserves of cement-flux and limestone, making it a hub for cement companies (he explained it in much greater detail, but I will cut it short here). And, coming to the rocks I held dearly, they were the fragments of large rocks my father had collected from the marvelous rock formations found around Kurnool.

That was when I remembered a book my mother had—a book about various types of rocks and minerals. Till then that book hadn't piqued my curiosity, but that day, all I wanted was to read it from start to finish! (It was quite a task to get

that book from my mother since she had won it for standing first in her college first year/freshman year. As you may guess, she was extremely careful with all her academic accolades—as she should be!)

That book was a revelation to me. Can there be so many types of rocks? Steatite, Quartz, Lime—all in and around my hometown! That book, along with my father's explanations, showed me what a blessed land I was from! There is a natural rock garden just outside of Kurnool called the Oravackal (quite a tongue-twister!) rock garden, where we often went on family picnics. It is a 200-acre land with a cave and hosts fabulous rock formations. There is even a large body of water making the whole place serene. Since that beautiful piece of land was right next to where we lived, I had taken it for granted till then. Just to add a little tidbit here—the super-hit movie Bahubali, originally made in Telugu but later translated into many languages, was partly shot in the Oravackal rock garden.

Now, when I think about the geography of Kurnool, I wonder if that was why Srishailam, a place only about 150 kilometers away from Kurnool, housed a Jyotirlinga. A Jyotirlinga means "the light of Lord Shiva." There are twelve holy places in India that house the Jyotirlingas. The Hindus believe that visiting and praying to Lord Shiva in the form of a Jyotirlinga washes away one's sins. Lord Shiva is known as Mallikarjuna in Srisailam.

Srisailam is also a Shakthi Peetha. The legend is that when Goddess Sati immolated herself, her body got scattered all over the earth. Wherever a part of her body fell, it is called a Shakthi Peetha. Sati's neck is believed to have fallen in Srisailam. There are 51 Shakthi Peethas spread across India. Some are even in Sri Lanka and Pakistan. I have heard that a Shakthi Peetha in Pakistan is frequented by both the Hindus and Muslims.

I ponder often about the origin of these holy places. I let my imagination run wild too. What could a Jyotirlinga be? Could it be a piece of an asteroid that our ancestors somehow knew about? How is it that the lands rich in natural resources became the holy places? Why did our Gurus want us to visit these places? The more I think, the more it makes me surrender to our scriptures and the wisdom of ancient India. One day, I do want to take up researching about where science meets faith in India.

Despite Kurnool being so close to the hub of Hindu faith, quite amazingly, there was no religious animosity in that region. Kurnool has more than 40 percent Muslim population so I grew up with a lot of wonderful Muslim and Christian folks. My classmates and our business employees consisted of a large number of Muslims. Their way of living was different or more unique from ours—from the daily prayers to food to festivals—but there were also a lot of similarities. I am ever so grateful for growing up in Kurnool because I got to know another religion and culture very closely.

I had many Muslim friends. My first friend in school who did not bully me was Mohammad Ahmed. I teased him often why he needed two names which were so similar. To which he would tease me back for the same reason that I needed two names, Kamala and Kalyani! Knowing my sweet-tooth, he would bring me a lot of sweets from home. What a friend to have!

Also, a lot of my father's employees were Muslims who filled our house with sweets and savouries during their festivals. Recalling a rather light incident—one of those employees knew about my obsessive liking for eggs. Whenever he visited us at home, he would pass me a box of Egg Biryani or an Omelette. I would run breathlessly to the terrace, find a corner, and relish the food. I can still smell that aromatic Biryani if I

close my eyes! On one such afternoon, my brother followed me without my notice. Oh well, once he found out my secret, I was forced to share the loot with him!

As I grew older, I made friends with a lot of Muslim girls, who never ceased to amaze me with their positive outlook. They enjoyed coming to school and studying. They did quite well in their academics too, despite knowing that by the end of the tenth grade, their education would be stopped and they would be married off. But that never deterred them or made them slack off.

I asked one of them how she kept up her enthusiasm with studies knowing that it would stop soon.

She laughed. "Today, I can come to school and I thank Allah for that. Whatever happens in the future, I will enjoy this freedom I have today and give school my best shot." I met her recently and she is now a teacher! A dream coupled with hard work never fails.

It is a known fact that most people feel demotivated when there is no reward for their work. But these girls had an indomitable spirit. Not just the Muslim girls, many girls from Hindu families also knew their schooling would end by the tenth grade. That was how it worked in small towns; the girls' education was never a priority.

This bothered me greatly. Just like how my mother or my aunt stopping their careers to become homemakers saddened me, this discrimination for girls filled me with grief. Why are women pushed to a life of domesticity even when it is not their choice?

I tried to help the less privileged friends of mine in whatever way I could. Being a pupil leader, I made sure they participated in sports and debates. I kept telling them to fight for their rights and not bow down easily. Don't get me wrong—I

was not a rebel but I just couldn't tolerate inequality of any kind.

Also, the communal riots that broke out all over India because of the Babri Masjid incident left me shaken. To recap that event, Babri Masjid in Ayodhya, Uttar Pradesh, was demolished by a few Hindus and this resulted in Muslim outrage. For months on end, India suffered from inter-communal riots. And, Kurnool was no exception. My eldest uncle, during these testing times, showed me how one should do everything to protect the people they care about.

The year was 1992 when I was around thirteen years of age. One evening I remember looking out the window from the first floor when I saw my uncle park a jeep in a great hurry. As he jumped out of the driver's seat, looking anxious, my first thought was, where on earth did this jeep come from? We didn't own a jeep or even a car!

As I came down to ask him, I heard him talk in an urgent tone to my father. "There will be more vehicles. Get as much food as you can. The violence has left many of our people stranded in their shops and on the roadside."

I felt confused. What was going on? It was a complete frenzy for the next hour. The womenfolk cooking easy-to-pack sorts of dishes, men packaging them and loading them into vehicles, some leaving, some arriving—everything was happening at a lightning speed. Finally, when my uncles left, I asked my mother what was going on.

"Violence has broken out because of the Babri Masjid demolition. It has turned into a Hindu-Muslim riot."

I knew there was some unrest due to the demolition of the Masjid. But I hadn't in my wildest dreams thought that it would affect our little town. However, I soon realized that it had affected all of India. But how my eldest uncle spearheaded the efforts to help those in need, irrespective of what religion

they belonged to, opened my eyes to a whole new side of him. Because of the riots, looting had begun and most shopkeepers refused to leave their premises for the fear of being robbed. My father and my uncles distributed food packets to such shop owners every day for almost a week. Then, there was also a tent pitched in front of our house and whoever came there was served food and water.

Soon, the town calmed down and none of the people I knew, Hindus or Muslims, were harmed. That was a relief. But it left me wondering about the communal fights. Don't we all belong to the same human race? I sure am glad to have known the people I knew while growing up, irrespective of their religion. Ayodhya, where Babri Masjid happened, was known as the "divine land that enriched the faith of two religions", a quote in reference to India's eleventh president, Dr. APJ Abdul Kalam. A vision he had of the holy land is one of harmonious integrity by the twenty-first century, one which will treat all physical, mental, and spiritual pains. The former Indian president, who was an avid scientist, an author, and a visionary patriot, wanted to make Ayodhya an abode of harmony rather than echo the civil war of the past.

President AJ Kalam's unique and optimistic perspective on religion, race, caste, etc., has an important influence on my perception of these topics that many nations, people, and humanity unfortunately still fight over. His life is an example that any human, of any religion, should celebrate and respect all religions. Just like AJ Kalam, all holy books of the world's well-known religions like Bhagavad Gita, Bible, and Quran are an integral part of my religious knowledge to understand and appreciate the "unity in diversity".

His quote on religious approach was this: "For great men, religion is a way of making friends; small people make religion a fighting tool."

It is sad to me that after leaving Tirupati, I never returned to live in Kurnool and visited the town only as a guest. My heart lies with Kurnool. As Jeremy Irons says, "We all have our time machines. Some take us back, called memories, and some take us forward, called dreams."

It is the Ayodhya of Kamala which can be found at Kurnool. It is my honor to spend more quality time in this magical place in the future.

Like President AJ Abdul Kalam, in my vision of Mother Earth, especially with my deep roots from Holy India into Hopeful America, I want to contribute an exemplary drop to this oceanic effort we all are making to bring the world to a harmonious state.

This poem is a gift from my beloved guru, Swamini Shraddananda Saraswati.

## YOU LIFT THE BURDEN OFF OF ME

Beloved Mother
Divine Madre of the Earth and of all beings
Blessed Virgin who brings life and light to the world
Worshipful Warrioress who is the protector of all
Most Precious Shakti who infuses all that is with Her
    sacred dance
Revered and Exalted Ma who showers us with grace
Most elegant and ancient of mystics who is cloaked
    in mystery
When i speak your name
When the whispers draw your form
And the wind sings of your divine nature
You lift the burden off of me
In your compassionate wisdom
You show me the way

To serve the hearts of all
When i am doubting the strength of the chosen way
You open your eyes to see for me
When i am quiet with not much right to say
You open your mouth to sing the names that awaken me
When i am sad for the suffering of all beings
You open your heart and show me what it means to heal
You lift the burden off of me
Each time i bow down at your feet
You lift the burden off of me
Each time i dance, each time i sing
You lift the burden off of me
Each time I pray
You lift the burden off of me
And finally i see
All is as it is meant to be
For a moment is merely an eternity
And eternity is just long enough
To know the freedom that comes from adoring you

# *chapter 18*

A few years back, it struck me that I have evolved through life like a lotus flower or Kamala. There have always been murky waters around me but I have managed to fight my way out of it and bloom, petal by petal. My life in Tirupati is the first petal that unfurled out of murky waters. You will know soon what muck I had to battle in order not to get sucked in.

When I landed in Tirupati, I had mixed feelings—like any other seventeen-year-old, I was a pampered, overprotected girl and suddenly, there I was—all on my own! There was freedom but with that came a lot of responsibility. Nobody cared if I ate or slept. I had to care for myself. I missed home terribly but I also knew it was a significant phase in my life and I could not waste time being impractical. Also, there were at least twenty girls who had joined my batch, and having someone in the same boat fills one with courage to face life.

College kept us busy the first week. All-day orientation lectures, laboratory visits, and meetings with professors. Come evening, I had to get used to the hostel living. Then, the first month, every night the seniors would get us together for the infamous ragging sessions. Fortunately, in the girls' hostel, the ragging was quite good-natured and not mean-spirited. The seniors had some fun at our expense. While many new girls were too shy, I was the opposite. Maybe because I was never considered an attractive girl during the teen years, I had learned to rely on my personality more than my looks.

So, when the seniors asked us to perform an awkward dance or mouth a silly dialogue, the others hesitated but I

performed with aplomb! If they asked me to sing, I sang and danced. If they asked me to mimic an actor, I over-performed! Soon, the seniors were so exasperated, I was left out of the ragging sessions. What is the fun in bullying someone who takes it in her stride! Just to get my fun out of the whole junior-senior divide, I told everyone that I only knew Hindi and it was quite funny to watch everyone struggle to translate their Telugu, my native language, conversations into Hindi, India's national language, for my sake! I was found out eventually but everyone took it in a lighter vein! But by then, I had had my share of fun! Then, someone caught my eye, a girl in my class who lives with me in the same dorm, was observing me from far away. I caught her a few times gazing at me quietly but this time, she was laughing a lot. She told me her name is "Durga", one of my favorite goddess forms since childhood. Goddess Durga is considered as the feminine epitome of strength. She is depicted in a variety of ancient India's scriptures as a goddess having feminine prowess, power, determination over desire and urges. My friend Durga became an embodiment of Mother Goddess Durga in my life, who always believed in my seen and unseen powers of strength and determination.

Toward the end of the first month, the seniors were much friendlier, but soon, much to my discomfort, they started recruiting the newcomers into their caste-based groups. In Andhra, caste/religion politics plays out at all levels, including at the student groups. There were groups of Reddis, Kammas, Vaishyas, Christians, Muslims, etc. This truly saddened me because my world-view was that of universal goodwill. Groups based on castes and religions began to suffocate me. I refused to join any of these groups. I belonged to the Vaishya community but I did not disclose that to anyone. Instead, I made friends with those who had come from outside of Andhra.

A couple of months later was my birthday and I decided to do something unique. I bought a hundred pieces of a large cake for the classroom and distributed it to everyone. I followed that up with a short speech about how I wanted everyone to shed their caste tags and unite as students. After a stunned silence, many walked up to me and said they loved my idea and how they too did not want to belong to any micro-group.

Then a boy, light-eyed, fair-skinned, and good-looking, walked up to me and smiled. "Quite a leader you are!"

I just laughed. "I try!"

He introduced himself as Mr. 101 on the first day. When I was reading the chart that displayed the student identification numbers, mine ending with 2 and the prior number, 1, belonged to Mr. 101. I had met him briefly too on that particular day. If you remember from a previous chapter, numbers 1 and 2 are very significant for me. I had an intuition that morning when I spoke to him that he was going to have a very precious experience in my life but just was not clear yet then; but his energy was very attractive for me.

I had even acquired the title "Comrade Kamala" for being what I am; by the end of the month. Though everyone said I was a fun girl to be around, nobody thought I was frivolous. On the contrary, many respected me because I was not afraid to be me which was honestly not very common in those days in India. Being "audacious," which is another significant petal attribute of my Kamala (Lotus) or Kamala personality. A quote that touched my heart about this attribute is the one by Dr. Martin Luther King Jr "I have an ultimate faith in America and an audacious faith in mankind."

The first six months of college, as you can see, were nothing too extraordinary, mostly happy days. But I missed my home terribly and kept rushing home at every possible

instant. My mother, though having been brave while sending me, was quite crestfallen. Every time I visited home, I only heard from everyone how much she missed me. Well, it was mutual. Thankfully, I was only a night away by bus.

To end this chapter on a lighter note, I convinced my parents that I needed a two-wheeler to move around in Tirupati. The distances were too much to walk—they finally agreed. My father went to Tirupati to get me a vehicle. He took me to a dealership that belonged to a relative and the moment I saw the man, my eyes teared up—he looked exactly like my late grandfather. He was kind and calm like my grandfather too. Despite being a busy man, he showed me around patiently. But, nothing appealed to me.

When I had almost given up on buying a scooter, my eyes fell on a lone Scootie (a very popular two-wheeler brand in India.) parked in a far corner. I knew that was what I wanted! It was white and it looked like a pigeon that used to fly around me whenever I studied on the terrace back home! A lot of pigeons flew around me making a huge ruckus, but one particularly white pigeon would perch next to me, looking at me proudly! The Scootie that caught my attention looked like that proud white pigeon to me. The showroom had pushed it to a corner since that was a slightly older model but I had to have that and none else!

Like President Dr. A.P. J. J Kalam, I am a believer in the signs and language of the universe. Though many people, especially with a scientific bend of mind, dismiss this phenomenon of signs, I look for them everywhere when I have to make a decision. Not that every decision I make turns out well but I never regret any of my decisions—after all, I made them without an iota of doubt. Many times, the Universe has not made it easy for me. I have had to suffer through pains and disappointments before reaching my destination. That is

a topic I will reserve for later chapters which ultimately have a deep-rooted lifetime of impactful experiences.

Coming back to the story of my scooter, once we came out of the showroom, my father handed me the keys, but not before a million safety instructions. Just when we were stepping out, he recognized a relative who was walking in. That man held the high post of the Transport Commissioner of Tirupati and to my embarrassment, my father, after a short chat, asked him to keep an eye on me! To which the man gave hearty laughter and gave me his number, asking me to call him any time. That is how it works in India—relatives and friends, even if you have barely stayed in touch, will come forward to help. One can, without any hesitation, stay with a relative if they are in town. It is different in big cities where the lives are busy, but in small towns, people never hesitate to host someone. And, being a teenager, I rolled my eyes at my father's words thinking why would anyone need to keep an eye on me. Little did I know then that a time would arrive when I sought that gentleman's help. Sometimes I do wonder if everyone we meet in life is put in our path for a reason. These valuable experiences from my father later bloomed the "petal of Network intelligence" in my Kamala; that we need to always try our best to care and nurture people irrespective of their relationship with us.

Once my father left, I rode the scooter to the nearest mechanic shop. In the nineties, the trend was to get the mechanic shops to make slogan stickers for vehicles. I already knew the slogan I wanted. Within the next hour, I was riding my white Scootie with the following phrase in bold black letters: "It is My Style." I felt no less than the then trending Bollywood actress Kajol, with the wind blowing through my short bob while I rode my scooter!

Though this chapter might seem like a mishmash of events, each one of them has gone on to assume a greater proportion and in an oddly connected way too.

# chapter 19

The first year of college was harder than PUC, but the difference was, I truly enjoyed the subjects I was studying: Veterinary Anatomy, Veterinary Physiology, Immunology, Pharmacology, and Biochemistry. The textbook *Anatomy and Physiology for Dummies*, written by Erin Odya, encompasses a multidisciplinary approach to learning. It is unfortunate that some people think that finding out about the inner workings of the body can rob it of its mysterious quality, which is that it is boring to watch. Anyone who has even glanced at their own body knows that it is a world of awe-inspiring complexity and hidden wonders. Our bodies dance among molecules, cells, tissues, organs, muscles, sinews, and bones, and, with the right blend of imperfections, can do beautiful and humbling things together.

The way in which this was delivered here made me realize that, potentially, there is a whole universe within you with all those galaxies, stars, planets, and so on. I felt like I had been transported back into "Yashoda's world of universal form". Watching and hearing this story on television and the radio, reading comic book versions, and listening from grandparents when I was growing up, were my favorite childhood memories. According to traditional Indian mythology, Krishna is the Hindu head deity and symbol of love, compassion, and tenderness. Yashodha was Lord Krishna's foster mother. He is portrayed in Hindu mythology as a playful god, a devout lover, a universal sense of unity, and a child-like god.

There is the famous story of the infant Krishna I used to love watching as a child on TV, where Krishna is wrongly

accused of eating a bit of dirt. His mother, Yashoda, comes up to him in a furious rush and scolds him: "I heard from your friends that you are eating dirt". Then Krishna graciously denies and responds "It is all a lie ... Who said that; I haven't, and if you think they are truthful, then you can look within my mouth to see whether I have taken clay or not," said the supreme personality of all and everything, disguised as an innocent, naughty, yet confused human child.

"Hmmm... Open your mouth, I shall see," says Yashoda. When the little adorable Lord was so ordered by His mother, He immediately opened His mouth just like an ordinary boy.

Yashoda sees in Krishna's mouth the complete opulence of creation; the entire timeless universe. She saw the entire outer space in all directions, mountains, islands, oceans, seas, planets, air, fire, moon, and stars. Along with the moon and the stars she also saw the entire elements, water, sky, land, and the various life forms in them and the three qualities of material nature. She also could perceive that within His mouth were all living entities, eternal time, material nature, spiritual nature, activity, consciousness and different forms of the whole creation. She also saw, within his mouth, herself taking baby Krishna on her lap and having him breastfeed. Upon seeing all this, she became struck with awe and began to wonder whether she was dreaming or actually seeing something extraordinary. "My little Lord, you can close your mouth," she said with lots of respect.

In any part of the universe there is a whole universe— Hamlet saw infinite space in a nutshell; William Blake saw a world in a grain of sand, a heaven in a wild flower, and eternity in an hour.   — Albarrán Cabrera

Listrening, reading about this experience of Yashoda, and my studying of all the various courses of animal and human body speciality functions as a doctor-scientist through modern day education has bloomed the inquisitive "petals of passion for knowledge" driven with magical faith and spirituality.

Humans are the universe pretending to be isolated individuals. Our reality, as we know it, is the result of what is observed—the beholder, and his point of view. Therefore, lines of thought and debates in today's world about race, color, and sex create different realities from a common universe.

For any one interested in very simple terms,

- Anatomy is the branch of biology that deals with study of our body parts.
- Physiology is a branch of biology that deals with the way living organisms function.
- Immunology is about how the body fights disease and infection.
- Pharmacology is the branch of science that makes us understand how any medicine or drug works and interacts within our bodies.
- Biochemistry is the study of the chemistry that takes place in living organisms, especially the structure and function of their chemical components, such as proteins, carbohydrates, lipids, nucleic acids, and small molecules present in cells.

During the vet school days, these five diverse, most complex scientific subjects, with an ultimate universal and unified goal of making the body live better, is a fascinating experience for me as a scientist, human, and also now as a humanitarian plus a rare-disease patient. Inspired by the real-life humanitarian lessons from the 1993 Babri Masjid learnings (communal

clash between Hindus and Muslims that shook India), I even wrote, edited, directed a theatrical stage show in my veterinary second year empowering the message that "There is Unity in Diversity" just like our various courses we have taken across Physiology, Pharmacology, Biochemistry, Immunology, Anatomy, etc. We all together are the supreme force and we should learn from our own making of our bodies.

Now, focusing especially on my Physiology course work in the vet school, one of the professors, Dr. H. Rao, who taught us the subject Cloning was so knowledgeable and eloquent. Though my mother's dream and my passion had been to study the human body, I felt the opportunity to learn veterinary medicine was for a greater reason like Yashoda's experience with Little Krishna to gather hidden knowledge. Out of my interest, I even studied books on human physiology to compare and contrast with that of animals. I will not go into many technical details here, except to mention one currently relevant piece of information. Since the early 2000s, doctors and veterinarians have begun to work together extensively in drug research and life sciences. Recently, many veterinarians were asked to join the Covid research teams because of their cross-collaborative knowledge on animal biology that is very similar to human biology in many aspects. Hence, my training as a veterinarian has helped me stand in good stead during my career. My first-year courses in veterinary medicine deep rooted the inquisitive insights of the potential synergies between animals, humans, and microbes. This is where modern insights from COVID-19 pandemic, HIV epidemic, etc. are making a strong case for understanding the basic biology behind these synergies. I will talk more about this, how my education and thirst for knowledge is helping me as a rare-disease patient battling with Multiple Sclerosis or Parkinson's disease-like signs in the later chapters.

I was magically drawn to the most unique "state of the art" lab that Dr. H. Rao ran; which I first named it as an "Ultra modern" in my teenage years. When I asked around, I learned that Dr. Cloning (aka Dr. H. Rao I named him) was a pioneer researcher in the field of cloning. Dolly the sheep had just been cloned and he had done the same with rabbits. A new ambition sprouted in me that I wanted to work with them in their lab! But I also heard from seniors and other faculty members that it was impossible, since the lab did not entertain undergrad students, much less a Sophomore. But I was never the one to give up on a dream!

I mustered the courage to talk to Dr. Cloning and asked him if I could work in the lab. He replied respectfully saying it was only for the faculty and postgraduates doing master's and doctorate degrees pursuing higher degrees in research. But I would ask him every once in a while the same question. Although Dr. Cloning had the reputation of being a very strict professor, he showed a soft corner toward me; which I always felt was a magical sign for me. Maybe my enthusiasm and hunger for knowledge amused him!

Each time he refused to let me work, I would argue with a simple smile which I think impressed him. "How many students have come and asked you for a chance to work at the lab, Sir? Please give me a chance because I am requesting you so much." I had no ego when I pleaded my case. "How do I become a researcher if you don't give me the opportunity?" I did get to work in the lab later but not before fate had tested me harshly.

The first year went by quickly. Though almost everyone I knew reeled under the pressure of studies, I coped much better and I studied with a lot of enthusiasm. I believe that when you are enthusiastic, you become more energetic. I was quite happy with my performance in the exams but I didn't

expect myself to be one of the gifted Magna Cum Laudes in the class. I rang my mother immediately after getting my marks—if there was one person who loved a top ranker, it was my mother!

"I told you that you are capable of being at the elite as you love learning!" My mother's voice brimmed with pride.

I laughed. "I am happy to be a learner, Mom, but not ecstatic like you! I enjoy the process of learning and good grades are a by-product or a gift in my definition!"

I was certainly happy with my top performance, because I was recognized as a bright but enthusiastic learner. But what gladdened me more was that I loved what I was studying with true passion. I knew the difference between when I slogged for my PUC exams and now. Then, studying seemed like drudgery, having to rote-learn a lot to crack the exams. But now studying was a pleasure after learning all the complex, fascinating yet intricate magic behind the living forms. The famous saying by Lana Del Rey "Doing what you love is freedom. Loving what you do is happiness," couldn't be truer. I am grateful to my life for giving me the freedom to do what I love.

In the meantime, my brother had completed his twelfth grade and wanted to take up engineering. My mother simply refused to send him out of town. She said she could not bear sending away both her children. Luckily for her, Kurnool did boast of a good engineering college. He was mighty irritated when he called me. "You got to stay in a hostel and also buy a bike but now mom won't let me do either! I am paying for your freedom!"

I laughed. "You should have chosen a field that had no prospects in Kurnool—as I did! Anyway, you are a boy and you will enjoy a lot more freedom than me wherever you live!" That was the truth too. My family was a lot more lenient in

unique aspects with boys than girls. Now I do understand that they feared for the girls' safety but when you are young, you can't see the adult viewpoint!

You can guess by now how attached my mother was to me and my brother. I was even equally attached to all my uncles, aunts, cousins, etc. Her attachment is because I was named after her grandmother "Kamala Maddali". She would often call me "Grandma Kamala" by referring to me as "Kamala Amma", which means a respectful gesture towards an elder. This emotional bonding between us is very special. We share this special relationship, as I am Kamala Maddali Sr, reborn as "Kamala Kalyani Maddali Jr" in my mother's womb, and who is an embodiment of adventure, strength, passion and compassion, just like Sita in the hindu epic, Ramayana. The Ramayana, to me, is a story of the struggle to overcome diffi-culties and the tough choices the characters like Ram, Sita made in keeping with the dharma or path of rightness, the socially accepted ideals of that time. In today's world can be personalized to the current socially matured ideals. I believe by emphasizing and understanding the qualities of strength and courage in the stories from both Rama and Sita as not only as a couple with a family, but as responsible leaders for the kingdom, parents, human citizens of mother earth is very important. I will discuss more about how such understanding can bring about the good change I wanted to see from the contemporary societal perspective of women today who are seeking strong role models can turn to these examples to serve as an inner moral compass.

I was touched by the quote given by my dear friend and mentor, Swamini Shraddhananda Saraswati, "The Divine Mother is the source of every intimacy that flows through this life and she is the womb of all that is created."

My mother would ask me to visit Kurnool even when we had no official holidays. Which, as a young girl who missed home, I did. Anytime my mother phoned me and asked to visit home, I dropped everything, took a bus, and headed to Kurnool. As a result, I missed a few classes with the emotional side of me being more bonded to my mother and father. One thing, I must say that even though I loved being on my own in a dorm and college, I certainly missed being with my family, especially my parents, brothers, cousins, uncles, aunts, grandparents, etc. The family ecosystem I had in my childhood is very special and a unique bonding; which certainly made me skip a few physiology classes without a conscious assessment of the situation. I had done so in my first year too but it hadn't proved to be a problem. I would come back to Tirupati, stay up as late as I could and catch up.

In India, most colleges have a very strict policy about attendance. A student has to attend a minimum of 75 percent of the total classes to be eligible for taking the final exams. However, our college never insisted nor acted on that policy and were more forgiving or lenient for their own good reasons. To be more clear, no one "followed the rule" including the administration. Thus, even though we had attended a bit less than the minimum number of classes, the college had given me the exam eligibility in the first year. I and a few others were under the impression that the same run would continue. So, I kept missing classes to head home to spend time with my family members.

However, that year, the college decided to pull the rug from under our feet. With less than two weeks before the exams, when we were done with all the classes, the college put out a list of students who had a shortage of attendance. And guess who featured at the top of the list along with twenty others? Yours truly! Till then, I had been nothing but an ideal

student—attentive in class and on time with all the assign-
ments. I had done well in all the tests too. When someone
told me that I had a shortage of attendance, my first reaction
was panic, breathlessness, fear—any extreme emotion you can
imagine. But I consoled myself. The college, in its history,
hadn't penalized a single student for the lack of attendance.
Why would they start with us? Must be some formality.
Right? Guess what—wrong! A few hours after that dreadful
list, the college issued an official notice that such students are
ineligible to write the exams. I felt like I was in a muddy valley
deep rooted in darkness with no path to climb up and see the
light. How could something so horrible happen to me and
how could my unintentional, emotional actions have become
a grave misstep in my academic excellence?

# *chapter 20*

I went to college still hoping that it would all be sorted by the end of the day. But no such luck awaited us. There were twenty plus of us with a shortage of attendance. What transpired that day was what usually transpires among aggrieved students—we all huddled in a room and came up with a request letter that we were going to submit to the management and ask for forgiveness.

A friend who came to see me whispered to me, "Kamala, all the departments have given you the attendance, except Physiology. Why don't you go talk to Dr. Cloning?" What an irony! The one subject I loved had become my ruin. But I didn't think it would be of any use. It was not just me or one subject the college was dealing with.

Even after three days of us waiting before the administrative building, nothing got resolved. A few other students, though they didn't have the same problem as us, had joined us in our hour of despair. Now, one thing I did not do, which I should have, was inform my parents of my predicament. I was too ashamed to admit that I had landed myself in trouble. I learnt as I interacted more with the fellow students-in-trouble that at least some of them had genuine reasons to miss the classes, such as ill-health. One of the girls confessed to me that she got severe menstrual cramps for almost five days every month which had made her miss her classes. I knew I was plain wrong to miss the classes to visit home and even those with health problems should have taken permission from the college. True that we had taken the college policy for granted. But, the management was also short-sighted; in not giving us

any warning until it was too late. If only they had informed us of the shortage when there was still time for us to makeup, we would have. Soon, we decided to hold a protest in front of the highest offical's chamber. When we were two days into the protest, replete with slogans, banners, and the works, I got a call from the office. They told me that since I was a good student with good grades, they were willing to make an exception in my case and let me off the hook. What about the others? What about those who had a more pressing reason than me? I asked the same questions to the official who spoke to me.

He shook his head. "Don't be idealistic. Just take the offer, go back to the hostel, and study. Others are not your concern."

At the verge of tears, I pleaded with him. "Give us all a way out. Give us a way to make up for our mistake. Please forgive us for an unintentional mistake."

The official shook his head. "We can't do that. If we keep excusing the students, then nobody will take the rules seriously."

I tried to reason more. "But some of them had a genuine reason to skip classes. One broke his arm, another had health problems, one had a death in the family."

"Then they should have approached us!" He sounded a final warning to me. "I want you to quietly go to your room and we will rescue you this year. If you continue to protest with the others, you will be punished too."

I felt torn between my self-interest and the loyalty to the group. I took a deep breath and stood still for a good five minutes. No thoughts came to my head but my instincts took over and I refused. I said I wanted the same treatment as others and walked out. The man said I was being dumb to lose a year because the management was firm on not letting us write the final exam. I was ready to take my chances.

When I came out and narrated what had happened, everyone was shocked to silence. Then, they all hugged me with tears in their eyes. I was the only girl speaking up and a few other boys spearheading the protest and making plans for our next action, and I hadn't abandoned them.

My friends looked visibly moved. My dear friend, Durga, asked me in tears if we would be all right losing a year if it came to that. All I did was talk to her and then ended up crying with her and then wiping my tears. No, I was not all right losing a year! No, I was not even sure if what I had done would meet with my parents' approval. A few of my good friends tried their best to reason with me and console me—I take the deal instead of losing a year. But I couldn't bring myself to do so.

I suggested we go to Hyderabad and meet the Vice-Chancellor of the university. That very night we all piled into a bus and went to Hyderabad. I very daringly talked about the lifestyle challenges that girls would have during their monthly menstrual periods that would prevent them from their day-to-day functionality as a student in a college setting. Please understand I am talking in a society where girls were not given a voice to be heard and I know that I was breaking all the rules in this scenario to make the management understand the various personalized reasons behind many students' shortage of attendances. I was honestly expecting at least few would get excused as they had a sincere reason; at least from my understanding, But that visit proved futile too. The Vice-Chancellor refused to even meet with us. The message conveyed to us was that we had flouted the rules and nobody was going to help us.

Now that I am an adult, I can appreciate the point of view of the academic institution better, however, it was the artifacts of educational institutions that left me feeling too

alienated, lacking compassion, forgiveness, and humanity after all these years. Despite their amazing personalities, most academics did not demonstrate the traits of empathy, forgiveness, and humanity that are so crucial to the present generation of students. Well, we were only nineteen. When there is not enough life experience, mistakes are bound to happen. We chose to disregard the classes out of ignorance. Someone could have sat us down a month before and explained to us the effect of our action. We could have taken extra credits and done extra assignments to prove our "curious learner" within us.

If adults and authorities handle the youth patiently and with respect, they will comply more. Not just in my case, but in general, youngsters are given rules they have to obey without an explanation as to why there is such a rule in the first place. There is even a term "Adultism," used for adults who treat the young as inferior only because of their age. When the same young people grow into adults, the possibility is much higher of them turning into "adultiests" toward the next generation. Somewhere, this has to change. If someone at work makes a mistake, the penalties are not as harsh as what is doled out to a youngster.

The inevitable happened to me. I had lost a year. I had to pack my bags and head home. Before that, I had to tell my parents why I was heading home! On that day in 1997, I was told by many, "Let us never break the rules." This epic experience as a student reminds me of the quote from General Donald MacArthur, "You are remembered for the rules you break." And yes, it became an epic moment of my college history!

# *chapter 21*

J ust before leaving the campus, on an impulse, I visited
    the physiology department where I met the head of the
department, Dr. Cloning. He was genuinely shocked that I
was denied a year.

"I am very sorry to hear what happened to you, Kamala. I
don't get involved with the administrative part of work. So, I
wasn't aware of your situation."

With tears streaming down my eyes, I managed to tell
him. "Sir, I love this subject. I love your lab. I love the research
you are doing. One day, I will get a PhD in physiology and
make you proud."

He smiled. "Your ethics and values are beyond your age.
Don't get disheartened. Just stay positive and I will see you
next year."

Once home, it was the usual drama one can imagine.
Almost all of the family members were very upset and disap-
pointed at me due to this scenario. My brother was livid with
anger. "How could you be so foolish? Do you think you are
Mahatma Gandhi to save the world? When they gave you a
choice to quit protesting, why did you continue?"

My father was gentle. "What has happened has happened.
Though, if you had told me, I would have reasoned with the
college on all your behalf. But don't cry over spilt milk now."

My mom bawled. "Why do you have to go through so
much trauma? You are bright, you are kind, but you end up
suffering so much." Of course, she had to add how unfair it is
that I did not get into a "proper" medical college even though
so many unworthy had!

That night as I sat alone, I thought of my grandfather. He was such a fighter! He could not move his paralyzed body but he still kept his dignity. He wrote every single day with his barely working left hand. How could I not fight this?

However much I tried to stay strong, I broke down when alone. I could not bear that for one whole year, I would be useless. Everything else, be it friends or the excitement the college provided, seemed secondary. The biggest chagrin was I was going to stagnate for a year. On one such night, when I sat on the outside porch staring at the sky, my grandmother sat next to me.

Ruffling my short hair, she smiled. "You know your mother's father whom you called "Kodi Tata"? Kodi means Chicken and Tata means Grandfather. He used to have a chicken tattoo on his most favorite collection of white shirts ... such a funny smile comes whenever I think of him. Well I have a blessed talent always coming up with nicknames for my favorite people in my life! My grandmother told me that he used to dress me up in a police costume with hair tied up like my boy cut in my college days! He used to call you "Kamala Pandu," and "Pandu" means fruit! Well, there is a very sweet orange or tangerine variety in Asia called Kamala." So many forms of me indeed!

My grandmother then reminded me of the funny part; I used to run around yelling, "Pandu means fruit!" I dressed as a cop with a string of beautiful pearls on my chest. I just thought that was unique and the rule of cop and pearl did not match in my mind and I laughed a lot! I then said that rule does not make sense and hence I broke the rule of wearing pearls at my will. There is a cassette—yes, the technology which is totally outdated where I asked my grandparents for a pearl necklace, bangles, rings, etc. We will come back later to my obsession with pearls and how I learned to understand

ways to gather some attributes of pearl psychology in my life battles.

Then growing sad again, I poured my heart out to her. "You know, everyone will be learning, my classmates, my brothers and sisters. Raghu, Ravi, Tulasi. But I will be sitting around doing nothing."

She said plainly. "Why should you stop being 'You' no matter what others around you are doing? Learning does not end just because you can't go to college full time. Find something to learn on your own. Like Ekalavya! For me your paternal grandfather, Mr. Gupta, who was a principal but paralyzed for life in his early fifties, is an embodiment of Ekalavya who never gave up learning and trying!"

With her words, suddenly a light bulb went on in my head. She used to tell me the story of Ekalavya as a child and he was one of those scriptural characters who made me cry every time I heard the story. In India, we grow up with so many stories from epics and Hindu texts, the right ones always spring at us to guide us through difficult times. Let me take a moment here to quickly narrate the story of Ekalavya from the epic *Mahabharata*, which changed the course of how I handled my year away from college.

Ekalavya was a tribal boy who one day chanced upon the Pandava princes learning archery from their Guru, Dronacharya. That moment, Ekalavya fell in love with both the art of archery and the skill of the teacher. Once the princes disbursed, Ekalavya approached Dronacharya. "Guru, can you please teach me archery too? I am a tribal boy and I feel deeply chagrined when the poor deer in the forest become prey to tigers and cheetahs. If I am an accurate shooter, I can protect them."

Dronacharya shook his head. "I am sorry, boy. I cannot teach anyone outside of the royal family. That is my pledge to the royals."

Highly disappointed, Ekalavya went home. But he decided not to give up on the desire to learn archery. He built a statue of Dronacharya from clay and garlanded it. Every day he practiced shooting after offering a prayer to the statue. Within a short time, diligent and focused practice made Ekalavya an expert archer.

This is where I want my story to stop! I wanted to be like Ekalavya who taught himself things. I wanted my motivation to be my teacher. Blooming my "petals of motivation."

Before I go on with my account, let me complete the story. One day, the Pandava prince, Arjuna, discovered that Ekalavya was a better archer than him and enquired Ekalavya where he had learned archery. When Ekalayva answered that his Guru was Dronacharya, Aruja was livid.

He confronted Guru Dronacharya. "You promised me that I would be the best archer in the world. Also, you were not to teach anyone out of the royal family. How could you make that tribal boy a better archer than me?"

Dronacharya, despite knowing that the tribal boy was a self-taught archer, made a cruel demand. "Ekalavya, since you have accepted me as your Guru, I want your right thumb as my Guru Dakshina (fees to the teacher)."

Ekalayva, without a question or a moment's hesitation, cut off his thumb and offered it to Guru Dronacharya. That is where the story ends according to the elders as well as my grandma and the TV serial shows of Mahabharata. I will touch up again on Ekalavya in my later chapters and the strong impact I have in my life from him in my life's battle as a rare-disease patient.

Though on the outset, the story makes Dronacharya a villain, we as children were taught to see beyond this. Because Dronacharya made that unreasonable request, Ekalayva was immortalized as the greatest disciple in the world, instead of being regarded as merely a great archer. Also, Dronacharya was compelled to make that request because of a promise he had made—he would make Arjuna the greatest archer in the world.

The story oddly soothed me. How could I be wrong if all I had done was to keep up the promise I had made my friends? If Ekalavya could cut off his right thumb upon his Guru Drona's mandate, I too could sacrifice a year because the college mandated it. Maybe I too would be remembered for a long time as the girl who gave up a year to keep her integrity—okay that was my wishful thinking!

That night, I sat down to think about my next year. I would go mad if I didn't do anything worthwhile. One option was to learn things that I never had the time to before—like to play the violin, or to knit like my mother. I could start with those. Then, I decided to make a few resolutions that would reduce my misery.

1) To stop thinking about all my classmates writing exams and about the painful situation. I was going to distract myself with a walk, or by listening to music, my most favorite hobby even today, or some new activity whenever melancholy consumes me.

2) To start listening to my inner voice of hope and see or bloom through the mud.

3) To ignore those who told me how wrong I was to lose a year.

The first resolution was manageable. After a few weeks, I researched what I missed in my childhood and joined Violin classes as I really love music, joined a traditional dancing class,

and also learned computer programming in the era of Y2K in 1995 and beyond. innumerable activities to keep me engaged.

All of my friends, Durga, Mr. 101, Lata, Radha, and many others, helped me engage very positively and we have a lifetime of wonderful memories.

The second resolution was moderately difficult. I had to control my thoughts and emotions when I spoke to my friends. Most often we forget that when we vent to someone, we are draining their energy. So I wanted to be a positive force to my kind and loving friends, especially Durga. When the exams started, I called them before every exam to wish them well and also helped them in whatever way I could. This felt better than simply venting my angst and wallowing in self-pity.

The third resolution was extremely difficult. I had to control my reaction to people who provoked me. It was hard work to smile and move on when all I wanted to do was to shout and say that it was my life and my ideals. I was a lot more patient by the end of this one-year-long ordeal.

As a first step toward being busy, I bought a violin and found a good teacher. Learning to play the violin made me forget my woes for at least that one hour of class. Oh boy, violin was difficult to learn since I was never classically trained—unlike the other girls in South India who learn classical singing for at least a year or two. But that challenge was what I needed. At first, all I could play were some awful-sounding notes with lots of giggles and hidden tears of healing, and the same notes were so beautiful when my teacher played! I had some of the best smiles with my dear friend Durga and Radha with my violin skills! A couple of months into the training, when my brother said I wasn't so horrible anymore, it felt like I had climbed Mount Everest! Till then, he would walk around the house with his fingers stuck in the ears whenever I visited and I practiced!

My dance classes, which I did not tell anyone at that time, were a disaster. My glasses almost fell in the middle of every ten minutes, as I would sweat and my glasses would slide from my face. I cried that my vision impeded me from one of the passions I always wanted to pursue. I have certainly added this to my bucket list in my life, one day I will learn at least some aspects of the most beautiful dance of India-Bharatha Natyam and Kuchipudi and even do a stage performance to inspire my soul. A heart-touching quote by Eckhert Tolle, "Life is the dancer and you are the dance," makes my soul dance with all the musical tunes and challenges I have battled and am battling. We will come to this in my later chapters.

Coming back to the college, though I could not attend the third-year classes, I had to stay on campus to take the second-year class subject where I was held back due to shortage of attendance. Because a student with a shortage of attendance had to attend one class a week in that subject, in my case, physiology. Even the thought was a punishment. What was I going to do for the rest of the time? Even that weekly class was a repeat and it would be terribly boring. Moreover, how could I bear looking at everyone else moving on but me?

Then it struck me! Why not ask Dr. Cloning again about working in the lab? I was anyway going to be on campus and I had all the time in the world! Didn't Ekalavya ask Dronacharya despite being a tribal boy and Drona being a Guru of the royals? It didn't work out too well in his case, but it might for me. In case I was allowed to work, then I wouldn't shed one more tear about the lost year!

Alexander Graham Bell said, "When one door closes, another opens; but we often look so long and so regretfully upon the closed door that we do not see the one which has opened for us." I was not going to dwell on the closed door anymore. When I packed my bag to head back to Tirupati, I

was a bundle of nerves, but I was also oddly excited. My gut was telling me that something good was happening.

# *chapter 22*

Paulo Coelho says, "Miracles only happen to those who believe in miracles." I was a dreamer and still am. I am someone who believes that the impossible can turn possible with perseverance and faith. And, I am not egoistic and I can take no for an answer quite gracefully. All these factors aided me in carving out for myself a successful year. The day after I came back to Tirupati, I went and met Dr. Cloning in the lab. He was quite friendly and warm, which made it easier for me to ask (yet again!) if I could work with him. I had gone well prepared to present my case but he nodded an agreement the moment I asked!

"You do have to spend a year without much to do. Why don't you start by reading some of the research papers I have. These are relevant to the work we do here."

I was on cloud nine walking out of the lab with a bulky stash of journals and printouts! Nobody could believe or even know that I was going to work in the lab. That was how impossible it was; because even today most of the academic institutions do not have internship programs or mentoring programs. I poured over the papers and books the next three days and met with Dr. Cloning. He looked quite surprised that I had read all of that in three days, but that I believe proved to him how serious I was about working in the lab.

I was allowed inside the lab, assisting the professors and post-graduates with the research. It was a wonderland where time moves fast. Looking inside the high-power microscopes to study the structure of the embryo. Understanding the practical applications of DNA and how it was used in cloning. I

will not go into the details of the cloning process here, but in that one year at the lab, I learned more than what my classmates were learning from classrooms. If this was not a miracle, what else is? One of my favorite quotes that I learned from this experience in Dr. Cloning's lab was "Surround Yourself With Those On The Same Mission," which bloomed further my petals of positivity, hope, perseverance, faith, mentoring, etc. I deeply thank Dr. Cloning for his empathy and mentoring during one of the most challenging stages of my college life.

I could have been a disaster as there has been several negative thoughts including the suicidal range; because we live in a world even today that modern education is only measured by degrees, jobs, job titles, etc., versus the attributes that built the right personality to become what you are and the efforts this person can take to share their inspiring story to others in the community to replicate that energy. This is very much needed in today's battle with mental health issues worldwide. I was thinking that the education system needs a change, with practical and experiential learning taking a lead on age-old theoretical and instructional approaches. While college degrees and certificates are an important part of education, it may not be enough. We still need to assure essential skills to kickstart a career and, not to mention, finding a job in the field. I foresee in addition to so-called guides or advisors, we need more mentors in the modern education system from elementary to post-doc and beyond. Because, mentoring helps build emotional well being, networking intelligence, empathetic intelligence, and focus on the why approaches,and the list is like an ocean of benefits.

I want to dedicate a special moment of gratitude to my dearest girlfriends during college, Durga, Radhika, and Lata Naidu. Their love for their brothers reminded me of several

Hindu mythological devis like below; who were historic sisters for their eternal love to their brothers.

Subhadra was born as Krishna and Balarama's affectionate sister. Krishna played the lead part in orchestrating her marriage to Arjuna, since the alliance meant that Krishna could easily lend a helping hand to Arjuna and the Pandavas, so they could emerge victorious in the battle of Kurukshetra. Subhadra begot a legendary warrior son with Arjuna, who was named as Abhimanyu.

According to the Rigveda, Yami (or Yamuna the river) is the twin-sister of Yamaraj, the Hindu mythological God of Death. They were born to Saranyu and Vivasvant. It is said that the tradition of celebrating "Raksha Bandhan," known as "Rakhi,"was started by Yami and Yamaraj. Old Hindu texts reveal that Yamuna tied a rakhi to Yama and thus made him an immortal. Yama, moved by his sister's affectionate gesture declared that whoever gets a rakhi tied from his sister will be blessed to live a long life.

The day of Raksha Bandhan, the sacred thread that binds sisters and brothers. I used to especially miss all my brothers. Each of my three girlfriends were a mentor, pivotal caregiver, or a champion of their brother's achievements. Their love for their brothers even today, even after being married, symbolized the idea of "Vasudhaika Kutumbam" that the world belongs to the family that is defined by you. I am inspired more to be the most caring and daring sister not only for my biological siblings and cousins but for anyone in need on this planet.

I no longer minded the one-year-long break from college. What could have been a devastating and depressing year, turned into an exciting experience. One thing I learned from this episode was that we have to fight every bad situation until it turns better. There is no problem in this world that has no solution. Never accept defeat without fighting. I sincerely

urge you all to do the same. Don't let anything or anyone thwart your dream.

In the middle of all this confusion, I got into a terrible road accident on my scooter. I was hit by a truck. Luckily, I survived the crash, but I broke my ankle. It was simply devastating—a broken ankle meant, no more lab visits, no more riding around the town, no more meeting friends. It felt like God was testing me.

To make matters worse, my brother who visited me asked me if he could take my scooter back. That was when I broke down. It was not just a vehicle for me—it was my emotional anchor. I had so many memories associated with it, even the thought of parting with my Scootie was a cause of distress. My brother was quite taken aback, looking at my devastation. "Okay! Keep your Scootie. I thought I would take it since it was lying idle!"

As soon as he left, my roommate, who also had lost that year due to a shortage of attendance, laughed. "Your brother doesn't know that Scootie is your boyfriend!"

I laughed too. "Scootie is my boyfriend, and I think my boyfriend likes you too Durga; I joked! Since we both had lost that year, we used to go around town, with our two-wheeler boyfriend. Now that too had to end until my leg healed. God was really testing my resolve.

In the course of the next two months, I read everything I could lay my hands on. From the research papers that Dr. Cloning had given me to spirituality to bestselling fiction. I had to come out of that phase stronger. And what better way than to read?

I was handicapped with a long cast from my left ankle to the knee. My mother, Sita, just dropped everything at home and moved to my dorm for three months. I was truly touched by her concern and affection. She had a busy life of her own

with my dad, extended family, and business, but she just dropped everything and came for me. That was when we grew even closer. Sharing our dreams and aspirations, stories of our childhood, exchanging any exciting news that we came across. It was a wholesome friendship between a teenage daughter and her mother.

Let me spend a bit more on this valuable life lesson and experience of me spending a full three months with my Mother Sita who is a unique leader with the best title, "Mother of Kamala Kalyani." When she said that, it deeply rooted a striking lightning of strength through my spine and into my Lotus roots. When we look for leadership lessons from history, we generally tend to look at heroes from Greek mythology, like Hercules, Achilles, Odysseus, Theseus, or Ancient Greek and Roman history—Alexander the Great, Julius Caesar, Spartacus, etc. Yes, I mean it. Despite my schooling in India, I know all these great leaders but I never learned about the heroines or She-Heroes from ancient India. I heard things are slowly changing now in educating the ancient golder leaders and warriors of India and many other cultures with honor and grace. But, even during my schooling time closer home in India, Rama and Krishna rule the roost, with Arjuna, and Karna from mythology, or Emperor Asoka and Chandragupta Maurya from ancient Indian history thrown in occasionally.

But as they say History is just His-story, which I told my mother I would like to call it Herstory or Humstory so we can talk about humans, both heroes and heroines of the world, including India's, who are the greatest leaders or role models! And it set me thinking about which heroines from Indian mythology or history may we look at to draw leadership lessons from. That brought me to my favourite Shero of all time—Sita!

I said Sita? That sweet, soft, self-sacrificing naari. You ask, When did Sita demonstrate leadership? My observations on leadership from all these heroes I read about is portrayed as conquest and victory to us. It has come to connote power over people, leading large groups and having many followers. I want to see leaders who first lead themselves by their own life experiences and become a leader like I think I am shaping to be. Hence, my question to the Universe is, "What of the importance of leading the self first and then others in parallel?" From one's failures and just not successes. My Mother was very quiet and then after five minutes she started talking, "Wow, you are so right. You just took me back into my childhood, Dear." My mother was a topper in everything she touched and learned because she wants to learn with true passion and dedication. We then talked for hours about Sita; which I never imagined that I would have this conversation in 1998 almost twenty-two years ago.

This is where I feel we can learn from Sita's actions and choices as one of the unseen and unrecognized empathetic leaders of the ancient times. Here are some lessons we can draw from Sita.

Sita is variously portrayed as a strong, resilient, forbearing heroine of the epic Ramayana, but more often, as its greatest victim. She is valorized for her chastity and being a devoted wife but also seen as lacking in voice and agency. Much attention is paid to the suffering that she endured over her lifetime, but little to her response to these situations.

Let life purpose be your guide—Our purpose in life answers the most important question of Why. Keeping one's life purpose front and center at all times acts as the compass necessary for the challenging task of leading others. Sita demonstrates relentless focus on her purpose: to be a dedicated and worthy partner to her husband, Rama, in all his

endeavors. Even when he exhorts her to stay in the palace and serve his parents, she argues her case to accompany him in long years of exile. All her actions and decisions later in the story emerge from this one central Why, even though it means hardship, pain, and suffering for her.

Follow your inner Conscience—I said, "Mother, in my experience thus far as a nineteen year old, several people including family, friends, strangers will say something, talking over you, behind you, it is what they do. A leader needs to be able to separate out the essence from the background noise and act based on his or her inner guidance. Sita knows she will incur the wrath of Rama and Lakshman for overstepping the Lakshman rekha drawn outside her hermitage for her own protection, but she chooses to do so anyway as she feels duty bound to give alms to a needy mendicant who has come to her door. She chooses to live by her values, not by fear. Even though the situation doesn't turn out to her benefit, she steadfastly stands by her values repeatedly. This attribute that we just discussed is the approach I took in my battle for standing up for myself and others that led me to lose one year. But the valuable life lessons I am learning to lead myself in my times of failure, new attributes I am building with violin and computer programming, to stay positive and keep learning, bonding with my mother in my late teens, etc., which is very important for building the relationship bank of your own. They are deep rooting me in my pond of life. But my acceptance of an honest failure had been rewarded by the Universe when I got to work with great researchers in a state of the art laboratory. One thing I have always believed in is to have goals and dreams. Without them, you will just drift through life without a sense of purpose."

These most valuable learning moments with my mother remind me of a very powerful quote by David Levithan. "I am

a firm believer in serendipity—all the random pieces coming together in one wonderful moment, when suddenly you see what their purpose was all along." What a magical serendipity and blessing to have my Mother Sita in my life who is an embodiment of God-Mother Sita from Ramayana, and raising another Kamala Sita, an avatar within me!

By the time the year drew to an end, I was mentally a fitter and stronger person. Life's most valuable lessons are learned through hardships. Adversities prepare you to face your worst fears and when you deal with it, you gain a unique kind of strength. When you face a new problem, you deal with it better with the previous experiences. My advice to those of you facing any problem is don't get sulky or get bogged down. Instead, think of how to get past your problem to build a life of your dreams.

There was another story from *Mahabharata* that I found very inspiring. That of King Harischandra. The king was known for his truthful and honest ways. So much so that a great sage named Vishwamitra put the King through many hardships to test if he would falter from the path of truth. Again, the hurdles thrown at Harischandra were extreme— such as, for the sake of truth, he had to lose his Kingdom, his wife, and also his son. But the King never wavered, he remained ethical even when the situations were adverse. As I mentioned before, the scriptural stories take to extreme examples to illustrate the value of being moralistic and when one hears such stories at a young and impressionable age, it has an impact that lasts a lifetime.

# *chapter 23*

When I look around myself, I find many people who refuse to go after what they want for the fear of rejection, be it a college admission, a job, or love, etc. Robert Kiyosaki says, "The better you are at communicating, negotiating, and handling your fear of rejection, the easier life is." This I find to be very true. The fear of rejection is severe, especially when finding a soulmate. We all want to find that right man or woman but we don't want to get hurt in the process. We want that perfect partner to come seeking us. Also, after being rejected, keeping your self-esteem intact is the hardest. If people feel dejected after being turned down after one or two dates, and we try to find faults in ourselves for not accepting a beautiful unique version of ourselves as a girl with feelings. Maybe, the Universe has a better plan for me to match with the right life partner? I think it is very important to share my high-level experience in this matter as today's school systems where the mind is not too mature (Middle-school on in my personal experience talk about physical looks and relationships).

In the epic, Mahabharata, Draupadi is someone who never hesitated to ask for what she wanted, whether it was help or revenge. Though she had the most tragic life, I do find her very inspiring. If one is stubborn like Draupadi, it also shows their indomitable spirit. There are many fascinating episodes that show Draupadi's strength and I have drawn my inspiration from her more than once.

Some are driven by heart, some by the brain, but I am driven by my inner voice. When my desire to make my good

friend a life partner deepened by the days, I knew I needed to act. Either I had to confess to him how I felt or coach myself to treat him lifelong as just a friend. I felt he was drawn to me as more than a friend too but there was no proof of that. It is very dicey to fall in love with your best friend. You are staking something that is going so right for the two of you in the hope of more. You don't know if that will turn out marvelous or fall flat with a thud. I decided to leave it to a lifelong spiritual Sai Baba to guide me in the right direction.

Like many millions of devotees around the world, I have immense faith in Shirdi Sai Baba. Till then, I would only pray to him every time I visit the temple and offer a rose out of my love, but that day, I was going to request him to show me the right path. Should I propose or not? The temple calmed me down the moment I entered. The serene idol of Baba was smiling at me. His kind eyes gave me a new kind of strength. The white marble walls, devotees sitting with their eyes closed or circumambulating the idol—the ambience held silent power. Breath got stuck in my throat and my eyes welled up when I looked at Baba. Closing my eyes, I prayed. I asked him, repeatedly, the question that plagued my mind. To my chagrin, for a long time, I kept asking and the answer wasn't coming from Baba.

After almost an hour of this trance state, I opened my eyes and saw the priest light a lamp to Baba and do an Arati. It suddenly struck me. I would circumambulate the temple premises 365 times with a lit lamp in my hand. If the lamp stays lit after I finish going around for 365 times, then I would take Baba's answer as a yes to proposing to my class-mate and one of my best friends. If not, I was going to forget about him forever as a possible life partner, but be a lifelong friend. Lighting a small mud lamp and holding it in my palm, I started going around the temple. One may think how on

earth I came up with that idea, but I have heard many people go through such thoughts when in the presence of Baba.

That is the thing about faith. It gives you the strength to power through life. Once you have an unwavering trust in the higher power, you learn to accept the outcomes of life more peacefully. According to the Bible, faith means trust, confidence, assurance, and belief. This is such an all-encompassing definition of faith. This is how a child trusts the mother. That is how a true devotee draws strength from God.

Ralph Waldo Emerson says "God enters by a private door into every individual." But one has to keep that door open for God to come in, right? I am not talking about any particular religion or spiritual master here. Each one to his or her own faith. As for me, faith in a higher power, call it God or the Universe, has always helped me make my decisions. Once I act based on the signs from the universe, or my inner voice, or by praying at length, I don't second guess my actions. If things don't go my way, I don't blame myself or anyone else because I was guided by God to take that action.

That night I told my roommate and good friend about my decision to propose to Mr. 101 and how I had arrived at that decision. She was quite surprised at first and then laughed. She was one of those who used to always say Mr. 101 and Ms. 102 should be a couple. "I am happy, Kamala. Probably any other girl in your position would have asked a good friend for advice but you got it from your Guru Sai Baba!"

The next day, despite being nervous, I spoke to Mr. 101. Surprisingly, Baba himself backed me, right? I made my point quite calmly. "Over the past year, I have gradually fallen in love with you. It would be wonderful if you felt that way as well. If not, please don't be awkward. I am more than happy to not just be your friend but your lifelong best friend." I said this from the heart. My question to Baba was whether I

should communicate my feelings to Mr. 101 or not. I hadn't prayed for my love to be accepted.

After a few moments of almost shocked silence, Mr. 101 asked for time to make a decision. I completely understood his perspective. I was sad, of course, but I wasn't angry. I enjoyed experiencing pain and heartbreak; this gave me strength, especially during the shortage year of college.

# *chapter 24*

Then, within two months we were a committed couple, welcoming with grace and valor the challenges of an intercaste marriage in India. I just want to take this moment to truly thank Mr. 101 for an incredibly profound, meaningful, and impactful experience.

My third and fourth year passed quickly. They were happy years where I secured good grades, and also visited the research lab whenever I could. Each time I went to the lab, my desire to study physiology deepened. While I was in my fourth year, my goal was to obtain a PhD in the US in Physiology and also I developed a greater interest in Pharmacology by my fourth year. Despite the busy days at the college being very hectic, I began to research the universities. This was the time I was introduced to a computer in 1997, during my shortage year, and saw the first ray of light of the skills-based application that I could use to plan my bright future. This skillset I learned has helped me with my research for higher education, pursuing and planning with confidence, and self-mentoring my goal setting. I realized how much I loved doing any kind of research. I was learning so much about how the universities worked abroad. How different their curriculums were compared to ours. While in India we study a broader range of topics, in the US the focus is on the depth. I started building my own dreams about studying in one of those research-oriented organizations in the US.

There were not many students in the early 1990s and absolutely not even one female role model who pursued a doctorate degree in the USA with a veterinary-medicine

background from my university. That was a shocking moment for me and also an eye-opening pursuit to bring the change.

Also, even though few of the students were planning their higher studies, they were pretty much 99.9 percent male students. I am the only female planning to pursue higher studies and also we live in a culture where we do not talk about helping each other; as it is all about competition.

This experience during my planning for higher studies deeply planted insights into "the value of lifelong mentoring" as a philanthropy to build positive environments ranging from schools, colleges, communities, organizations, families, etc. I have taken this gap or challenge as a lifelong commitment to mentor women, students, and aspiring professionals in the STEM field. Hence, I launched the "Women in Bio" Philadelphia chapter in 2015 where I am based to foster mentoring for women and girls in the field of life sciences. I also coach one-on-one with many male and female students, especially highschoolers, college level, and professionals at various levels. I was even called the "Wonderwoman of Science" by a few of them.

While few students were particularly talking about elite universities, including ivy league schools, for me the university did not matter as much as the subject of interest. Then, I pursued GRE and TOEFL, which are mandatory pre-requisites for US schools, and my scores were only okay and not near perfect like few others. A couple folks got in with full scholarships too—which was quite an achievement. Pretty much every girl I knew went to the USA on a dependent visa, marrying a life partner who has settled in the USA with a H1 Visa or green card. I am very happy for them and their decision but that is not for me nor my path. I am a very independent soul who believes in building the foundation of my fort with my own hands. I was super determined to pursue my

dream to study in the USA on my own as a student also with the goal of paying back my father any funds that I borrow from the bank.

Then I started the adventure with the Visa and application-planning process. I met a woman named Latha who ran an agency that helped students with their Visas. She was so well-informed, so clear in her thoughts, and so practical, she soon became someone I admired beyond her profession. Soon, we became good friends. She was older than me and was running a successful business but none of those differences mattered in our friendship. Through her, I learned how to write a statement of purpose, how to talk to the Visa officers with precision and clarity. She not only helped students with the Visa but also guided them about precisely how to live abroad.

She is one of my soul-sisters as her encouragement had a profound influence on my decision to fight all the battles with my family. She used to correct me gently. "You must have your own goals. Whether Mr. 101 goes or not, you must!" I hate to see you as a "goal-less person" like many girls who leave their dreams after higher degrees in India and depend on their family's decision for their next path.

I deeply thank my father for helping me immediately with networking through his friends who got settled in the USA, despite the fact that he was scared to send me all alone to the USA for my higher degree and, oh boy, my mother was all up for it but did not understand why I was flying from the nest all the way to the other side of the world. This was a very important step for me to put the emotional bonding of my parents and me—and especially my mother Sita with me. Ironically, my father and I are more bonded since my childhood but I became more bonded with my mother since my twenties. I will address this emotional distress of being away

from parents and the impact I had in my definition of family in my thirties and forties.

Before I knew it, my final year drew to an end. On the day of my graduation when I looked at my parents, my heart brimmed with pride at how proud I had made them. I was Dr. Kamala Kalyani Maddali from that day on and the first doctorate degree holder of my family in the seven generations or so on both paternal and maternal sides! I felt like I was sitting in the lap of Goddess Saraswati, a goddess of wisdom, voice, music, art, and also knowledge. We always see Goddess Saraswati wearing a white sari, sitting on white lotus, and riding the white swan. The reason behind this colour is, white is the colour of peace and knowledge. Unless we are in peace, we cannot imbibe knowledge. What a beautiful culture I am born into. I felt surrounded by all these mentors sitting on Kamala's Lotus with their unique attributes. This bloomed my petal of knowledge and my hunger and desire to be more passionate for knowledge.

As I packed up my room and bid goodbyes to my friends, professors, Durga, RK and Latha, I went through an array of emotions. I was looking forward to my next phase of life which involved studying in the US, being a part of the state-of-the-art research world. At the same time, I was missing my life in Tirupati. That place had transformed me from an unsure teen into a confident woman. I had arrived in that city as a coddled, protected young girl. I was leaving as someone who knew how to live by herself, face hardships, and rise from the ashes like the phoenix.

The most valuable lesson I had learned was, if your intentions are pure, you will always find an earth angel to tide you through life—like I had many good friends. I would like to take a moment of gratitude and thank every friend of mine

for giving me the most memorable experiences of friendship during my veterinary school days.

Before I begin the story about my life beyond graduation, let me talk a little about Tirupati, a holy town that is home to Lord Venkateshwara, avatar of Vishnu according to Indian mythology. The temple, situated atop a beautiful hill, is one of the richest in India. Devotees throng the place all through the year to visit the temple. Tirupati itself is a small town that houses many smaller temples apart from the famous Venkateshwara temple, which I call "the Vatican City of the East for Hindus." It is the most visited place of worship in the world; visited by about 50,000 to 100,000 pilgrims daily; while on special occasions and annual festivals, the number of pilgrims shoots up to 500,000 and more, making it the most-visited holy place in the world.

Before you drive to the temple located on a beautiful hill, you find a huge statue and it always gives me the opportunity to look and appreciate the magic in the greater skies because of its height. I always used to have a magical feeling when I saw the statue of Garuda; it is a huge humanoid bird creature, half man and half bird, with his bird features usually resembling an eagle. Garuda has the torso of a man, but he usually has the wings, talons, head, and beak of a bird. In some cases, however, particularly when he is serving as Vishnu's mount, he may appear entirely as a bird. Garuda's "eagle eye" is very symbolic for this ability to see clearly through any ignorance and misconception, and straight into the truth of each situation. When practicing the posture Garudasana, in yoga (which I started doing since late 2013 in the USA); using your dristhi (meaning gaze or pointed focus) and focusing on the breathing can be a useful tool for bringing us out of ignorance, mind—chatter and ego—and right into reality and momentary experience. Garuda, the mighty eagle, is one

of my favorite birds for the powerful message it carries and no wonder I got so bonded with the American bald eagle which was adopted as the national bird symbol of the United States of America in 1782. The bald eagle (Haliaeetus Leucocephalus) was chosen for its majestic beauty, great strength, long life, and because it's native to North America. I felt like what a coincidence coming from the motherland of ancient culture, India, and the mighty Eagle is welcoming me everywhere I go in the pursuit of knowledge.

Tirupati is also an up and coming small town, which is turning into an educational hub and big city now. I felt blessed to be living in that holy city. That place is amazingly known for its top five highest literacy rate in the nation.

Promising myself to visit the place as often as I could, I boarded the bus that took me back to Kurnool. When I told my family that I was going to sit for GRE and TOEFL and try to get an admission into a prestigious university in Missouri, there was tremendous resistance. Sending me to Tirupati was a big step for our conservative family, and now to send a girl abroad without marriage was unthinkable. All my uncles collectively voiced to my father that this was a dumb idea. Three voices of Charlie's Angels first started with my mother, then my dad's youngest sister, Prasuna, and my grandmother, Ranaganayaki, supported me. My mother was so vocal, "She is Kamala, my grandmother, and she should pursue her dreams just like she used to encourage me in my childhood and I only partially fulfilled through my Bachelor's in Biology." Then, she held her mother-in-law, Mrs. Ranganayaki, my paternal grandmother, who was in tears that her husband (My paternal grandfather, the mighty principal, Mr. Venkateswarala Gupta, who was paralyzed in bed for life) always encouraged her and other women to pursue higher education but they never acted

on it. They could have pursued higher education and also balanced family responsibilities.

I continued to be so adamant with my dad and uncles, I made even that patient man, my father, lose his calm! He just gave me a long stare and said in anger that I was free to do whatever I wanted with my life. For the first time in my life, he did not even speak to me for more than two weeks out of fear of sending away a daughter alone to the greater west. I absolutely understood his fear but it was time to unshackle fears and become more fierce and fearless, if I need to pursue the path to higher education. An inner voice in me roared like a lion! Girls should be empowered to make decisions about their own lives, and being self-reliant has always been my foundational learning through my mother's journey and my journey in education.

I had my goals clear and they were not easy goals at all. I had to get good grades in GRE and TOEFL. While the latter was fine, I had a tough time with GRE—I was never so smart in math and now GRE practice tests showed me how pathetic I was with analytical reasoning. I took practice tests all day long. I worked as hard as I had during my PUC exams. Finally, when the day arrived for my GRE test, I was a bundle of nerves.

You might very well be wondering what this test is all about and who exactly has to take it. For the first question, I recommend hanging out on the ETS website for a little bit—the test is complex and multi-layered and requires time for people to go through. The GRE is for almost everyone who wants to apply to graduate school in the United States, except for those applying to medical school, business school, and law school (Those students will take the MCAT, the GMAT and the LSAT, respectively). The Graduate Record Examinations (GRE) is an assessment used as part of the selection process for

higher education in the United States. It is owned and administered by Educational Testing Service and was established in 1936. The assessment evaluates your verbal reasoning, quantitative reasoning, analytical writing, and critical thinking skills. It is a computer-based test that incorporates topics such as algebra, geometry, arithmetic, and vocabulary.

To be more precise, my mind was going in circles when I tried to learn and excel with my PhD in the fields of medicine, science, and biology. How come a general test like GRE is an accurate predictor of success, commitment, expertise, intellectual curiosity? In considering prospective doctoral students, universities should evaluate a wide range of factors, from academic strength and intellectual curiosity to research experiences through application components including transcripts, letters of recommendation, personal statements, and in-person or virtual interviews. I made up my mind that despite my scores I was going to represent every element of my academic, intellectual, emotional intelligence to pursue the highest degree in the land of innovation, Mother America. I am going to be a "Changemaker" with humility and spirituality in my pursuit of higher education and leave the decision to the Mother Universe.

Despite my hard work studying sixteen to eighteen hour days since my fourth year of vet school, I had done very badly in the Quantitative and Analytical assessment parts of the exam which reflected in my total score. It was abysmal—I had scored only 1100 out of 2200 which are both surprising combinations of my lucky numbers. I was happy to see and feel my lucky numbers but this time I am not able to interpret why these lucky patterns are challenging me. By then, I was at a mature stage of "what is life teaching me versus why is this happening to me?" Time will guide me, I promised to my inner spirit with rolling tears on my cheeks.

The minimum score to apply for higher education in the USA was 1350 and I hadn't even made that cut. The world seemed to come to an end. The evaluation system enraged me. I am a medical doctor and why am I not being tested on my educational, academic, personal skills I thought? I cried so hard for so many days, my father, who was, up till then, opposed to my going to the US, made a resolute declaration: he would send me to the US no matter how difficult it was! He said he would even sell the house if need be. I cried even more! How much did he love me? Even when I was doing something against his wishes, he was willing to support me.

During my last year in vet school, a few seniors (All being males only, which disheartened me) got admissions into top twenty-five graduate schools in the USA and most of their scores for the GRE were 1900 to 2000-plus, out of 2200. But, many of them didn't have the intellectual and emotional intelligence like I did.

None of them even pursued education as a path to knowledge through learning as I did. Their goals were purely to use education for high-paying jobs and stellar careers; a classic modern way of education measured with return on investment for you and only you. Do not get me wrong, I absolutely agree that higher education gets us a good job, salary, lifestyle for sure. But, all my life when I read about Goddess Saraswati, education was about health and wealth of prosperity. It is the path to knowledge to become the best being driven with purpose and a path to enlightenment.

I decided that I had to take the exam again to score the minimum of 1350. The arduous process of sample tests began again and the second time around guess how much I scored? Exactly 1350! My father and uncle were surprised when they heard the number and my father winked at his younger brother and I was a bit surprised at their expressions. My uncle used

to have a book of numerology, which is not for everyone of course. I used to sneak in his room and quietly read the book in my elementary education days, especially given the significance that India had for the eternal number "0".

Astrology is, in fact, both an art and a science. It has, in turn, many branches and sub-branches—each equal in importance and accuracy. All of them have independent existence. Numerology, or a study of the number system, is one such branch of astrology. Numerology is an ancient Indian discipline. Not only the Number Zero, the whole numeric system was given by Bharat in India . It is written on the pyramids of Egypt that the Egyptians had got the knowledge of numerology from The Aryans of Bharat, which is India. In Ancient Egypt, numbers did not simply designate quantities but instead were considered to be concrete definitions of energetic formative principles of nature. The Egyptians called these energetic principles neteru (gods).

Use of Numerology particularly has grown in leaps and bounds for just one reason: in the predictions made with the help of Numerology, only the date, the month, and the year of one's birth are all that is required. Precise knowledge of the time of birth and place are not required at all. Thus, all those people who don't know the precise time of their birth can also learn important facts about their lives.

Numerology energy represented by the combinations of numbers was very intriguing for me since my childhood. That is how I got to put the pieces of puzzles from 1 and 2 in my life since my birth. My uncle sat down and told me that the number 135's energy tends to be philanthropic, concerned with and seeking to promote human welfare—but in its own creative way. The 135 energy resonates with optimism, independence, philanthropy, altruism, creative expression, and benevolence. If it could, the energy would permeate the

entire world with comfort, health, happiness, and a facility for personal expression of freedom. The 135 energy is self-sufficient, optimistic, and has a global consciousness.

The number 135 reduces to the single-digit number nine. The energy represented by the number nine—humanitarianism, tolerance, and philanthropy—contributes the majority of the resonance represented by the number 135.

Even though my GRE score 1350 was by no means a good score, that held the key to my future; it might be the combination of magical numbers! Now, the next step was to get admission to the university based in the USA for a PhD or Doctorate program in Physiology. Then I asked my father if he knew anyone at all from the US academia from whom I could get a reference for my Visa application. I was and still am a great believer in the power of networking. There is no force stronger than relationships. A recommendation from a US professor would greatly improve my chances of admission. My father dug into his past connections and bingo! There was an old friend of his whose brother-in-law worked as a professor in the US. Call it providence or coincidence, the said brother-in-law was a professor at none other than the university based in the wonderful state of Missouri! It was such a powerful moment. The universe aided me.

I had a telephone interview with the professor and he was quite impressed with the work I had done with Dr. Cloning. And I got on with the work of sending my application, recommendations, and a statement of purpose. And soon, I got the happy news! I was accepted as a PhD candidate in the department of physiology! I was on cloud nine. On the one hand, my professional aspirations were coming true and on the other, so were the personal. Life seemed perfect.

But there was a caveat—I did not qualify for student assistance, which meant I had to ask my father to support me for at

least a semester. He was more than happy to do so and offered the support so willingly by taking a bank loan. I promised him that I would pay back the loan and he chuckled with a smile. Now, it was the next step of applying for the student Visa. A university admission does not guarantee a Visa to go to the US. Latha guided me with the process. She said, since my GRE score was low, I had to write a convincing cover letter to the Visa officer. I sat down to write. And write I did! By the time the night ended I had a twenty-eight page journal about my passion for healthcare with my life experiences up until then. This was to convince the Visa officer why it was important for me to study in the US. This is quite unheard of—most cover letters are two pages maximum.

# *chapter 25*

Gathering all my documents, transcripts, and the bulky cover letter, I stood in the Visa line in Chennai. Everyone in the queue was in the same boat as me—aspiring to go to the USA to make it big in life. I wondered what each one of them aspired for. So many youngsters with so many dreams! When it was finally my turn, I stepped inside with trepidation. I could not suffer another heartbreak of getting my Visa rejected.

The Visa officer looked through my file dispassionately. He flipped through the transcripts, then my admission documents from the university. Each time he turned a page with a stoic expression, my heart thudded faster and my breathing grew rapid. Finally, he picked up my Visa statement-of-purpose or SOP as it is popularly called. He read the first page. Then picked it up and raised a brow at me indicating the thickness of it. I smiled nervously. He then read some more, a little more, and then read it all patiently for a good half hour! Everyone by then had begun to cast curious glances at our counter. It is not usual for an officer to spend that kind of time with a Visa aspirant, then again, it is not usual for an aspirant to write a twenty-eight page SOP either!

Putting the SOP down, he smiled at me—a warm smile that melted all my fears. "So, you wrote this?"

I nodded and murmured a yes.

"Tell me, why is it so important for you to go to the US?" He wanted to know if I had indeed written that I guess.

I perked up. "Sir, I want to research in the field of medicines that will help people."

"Why can't you do it here in India?"

"It is very difficult for a veterinarian to pursue research in the field of human physiology in India as things just do not work that way in India at this time because it is too out of the box." I kept my answers short for a change!

"What makes you want to pursue human physiology after studying Veterinary medicine?" He was calm and asked me with a genuine interest. He was not trying to intimidate me or to disqualify me, which gave me the courage to reply confidently.

"I wanted to be a doctor but I could not get in. However, after studying Veterinary medicine I now believe I can contribute to the field of health sciences given the synergies in biology. Animal physiology is not all that different for humans. Also, I have learned that, with hard work and passion, one can achieve success in any field of interest." Since he still looked interested, I was encouraged to continue. "My father and mother are my healthcare and education heroes. He studied organic chemistry and wanted to get a PhD in the same but because of life's circumstances and also his entrepreneurial instincts, he joined his elder brother to run a pharmacy." I proudly completed the story of my family's successful business. "I do want to do combined research in both physiology and pharmacology since my family has been in the pharmacy business for decades now."

When I stopped to take a breath amidst my animated speech, the officer smiled and signed the form. "America can use your passion! I will grant you the Visa and good luck. By the way, never lose the 'smiles and sparks in your expressions, the world needs more people like you," he chuckled.

I can't explain in words the relief, triumph, and happiness that coursed through me with those words! I was one more step closer to my dream. The uncertainties were all over now. I

had to pack up, buy a ticket, and head to the land of the brave and free and dreamers!

I have always strongly believed that hard work, passion, and diligence result in magic. And sometimes doing something that feels right to you, though it may not be the norm, yields results. When I started writing my SOP, I thought I would complete it in two or three pages, as was normal. However, I knew I had to be very convincing in my letter. My GRE score was bad, I had no scholarship, and I was changing from Veterinary Sciences to PhD in physiology. I asked myself what would convince me if I were the Visa officer? The answer was simple: only the truth, hope, and passion in my voice through the journal. And that was how my SOP was. I tried to convey my dreams and aspirations to help people with new research. Also, when your hope and goal is for the good of society, people respond benevolently. I have always been socially conscious—maybe a trait I inherited from my father. When someone is suffering, my first instinct is to help them in any way I can. When I see a lack in my environment, I want to fill it. Because of that, people come forward to help me in my endeavors.

I still remember a few incidents from high school. Though the school was training us well academically, there were hardly any extracurricular activities for students to take part in. I researched other schools for weeks and came up with a list of activities we could take part in—inter-school debates, quizzes, essay writing, science fares—the principal was quite taken by surprise to see my exhaustive list. She granted permission for almost all the activities and said I should always keep up that leadership streak in me. "Kamala Kalyani, your kind of leadership is rare. You want to be a leader who makes a change. I have seen how you encouraged shy girls and even boys to be a part of public events. Do keep up this spirit to bring in

bigger changes in the world." No wonder I live by Mahatma Gandhi's motto, "Be the Change you want to see" in everything I do.

That day with the Visa in hand, I sure hoped to make a difference in society with my work. I did not know how but I knew the Universe would guide me when the time came. In Bhagavad-Gita, Krishna advises Arjuna thus: You must work to set an example to the society. Be the great person whose path the commoners follow. This verse that I read as a young girl, from my father's copy of Bhagavad-Gita has stuck with me. That is who I want to be—a virtuous leader who is worthy of being followed by others! Big dreamer, but as another of my favorite quotes go: "Dream Big. Shoot for the moon, even if you miss, you will land among the stars!"

After my travel expenses and tuition fees, my father handed me ten thousand US dollars for my living expenses. As I sat on the flight, a worry began to creep up. What if I run out of that money and still can't find any scholarship? I hated even the idea of having to burden my father, or my brother who was in the USA pursuing his Masters, or my fiancé, Mr. 101. Though he was very generous and kind to offer that he would take care of me, I wanted to be independent. I prayed to Sai Baba fervently that I was willing to work as hard as it takes, but to please make me financially independent.

# chapter 26

As the flight took off into the clouds like Garuda flying into Mother America as the Greater American Eagle, my mind conjured up thoughts relentlessly. I thought of my parents and how unique they were. My father, though a man of few words, had the most fantastic connection with people he worked with. I remember him advising me so often how important it is to build relationships because people in your life are your biggest asset. When I had asked him to request his friend to connect me with his brother-in-law, Dr. VR's uncle, who is Dr. CR in Missouri, my father had made me visit his friend. "If you want his help, you have to ask in person. This is a precious real-life experience of network intelligence that no degree can teach," he said.

It turned out to be a wonderful morning for me. I had gone into a house where I hardly knew anyone but by the end of the two-hour visit, my father's friend, Bhopal, and his wife, Veena, became my well-wishers. I referred to them as uncle and aunty within a few minutes of meeting them; they even taught me to make a few quick dishes that would come in handy when I lived abroad. And, to this day, I use her recipe for Paneer Butter Masala! Among Indian communities world-wide, "Aunty" and "Uncle" are commonly used to refer to elders even if they are not relatives. I liked it because it bonds the network of humanity, which is made of social creatures.

I had to remember the lessons learned from my family. My mother's precision and eye for beautiful things—those qualities were hard to imbibe but I at least had to try. I always feel sad when I think of my mother showing her books and

transcripts to us proudly. Her dreams were not fulfilled, but God was good to me. I was going to the US to pursue higher studies.

The next day I landed in my university, I went to meet my advisor. I had excessive butterflies in my stomach even though Mr. 101 kept assuring me that professors treat students like equals in the US and I had nothing to worry about. But I worried nonetheless. I wanted a unique topic for my PhD—something that would let me combine physiology with pharmacology. Would he agree?

Somehow, the Universe has always matched me with excellent superiors—whether it was my principal, Mrs Kalyani, or Dr. Cloning. My luck continued with Dr. D—my advisor. I still remember the first time I met him. He came out of his chamber to greet me and for a moment I gaped at him—was he a professor or a movie star? His warm smile and friendly nature made me feel at ease almost immediately. This is an aside but my brother always teases me that somehow I surround myself with good-looking guys! And, I am not complaining!

D was a keen and astute researcher. This was his first time as an assistant professor and I was his first student so we formed an instant bond. As days went by, he understood my insatiable appetite for learning and my unorthodox ways. His inability to pronounce my name as Kamala Kalyani made him call me "Kalaini" for my middle name "Kalyani," and my first name Kamala as Ka-Ma-La, which I found highly amusing, he said it very nicely! Later, even when he could pronounce my name, I told him he could call me by both names—that made me feel warm and welcomed. Dr. D was amazed knowing the meaning of both my names and said, "Welcome Lotus Goddess of Education." He chuckled.

Dr. D's wry wit made working with him very pleasant. Though I never asked him for an assistantship, within three

months, I was his official research assistant and was given a full scholarship!

I will talk about two things here—one, my research topic. Two, an unfortunate incident that occurred in my second semester. First, the research topic. Dr. D's research was on studying the effect of physical exercise on the heart. For that matter, our department, the Department of Biomedical Sciences, is one of the top-ten universities in the US specializing in exercise and its impact on cardio-vascular study.

When I started working with him, Dr. D assigned me to study the effects of testosterone, male sex hormone, on the functionality of the heart. When I began working, the lab was the first thing that caught my attention. The first time I could zoom in on a cell in a high-powered microscope, I was blown away! I could actually see little channels through which blood flowed. With each stimulus, caffeine or exercise, the cells responded through vibrations. My interest was always to discover why heart attacks were on such a rise in India, and Dr. D's research was nicely aligned with my own curiosity. I loved my work—if I could find out what was causing heart attacks in men, then the solution could not be far away.

I spent abnormally long hours in the lab. Seeing the clock strike two or even three in the morning became a common occurrence in my life. Staring into the microscope for such long hours was taking a toll on my eyes, but I was not willing to give up on that cutting-edge research.

While everything was going perfectly smooth, a most unfortunate incident occurred. In my second semester, I had to take a prerequisite course on writing. At the end of the term, we were given a topic to write a term paper. As anyone would do, I Googled, looked up books and journals, and wrote a decent term paper. The shock awaited me a week later when I was called by the professor who conducted the

course. She was furious and blasted me that my entire paper was plagiarized. I was dumb-struck. I didn't even know what I had done wrong.

"I will report you to the provost and make sure you are expelled," were the final words of the professor.

This is what had happened. In India, I never wrote a formal paper during undergraduate studies. We study for the exams and answer questions. Here, when I wrote that term paper, due to my ignorance about the process, I hadn't mentioned my sources. Now I understand what a crime it is to use someone's work without quoting them, but back then I didn't.

Soon that afternoon Dr. D called me to his chamber. I had never seen him angry until then and he had turned cold with rage. "How could you plagiarize? Forget a PhD, you are not even fit to get a Master's. There are only two reported for plagiarism in the entire university—you and another Indian student."

His words cut through me like a knife. Through my uncontrolled sobs, I managed to explain to him that it was a mistake. I had done so because I was never trained to write a paper. Dr. D cooled down and told me to talk to the Vice-Chancellor. "Explain to him what you just told me. I am sure he will understand." This empathy that Dr. D showcased was the one exactly missing in my Veterinary education system despite the professors being talented and amazing persons but they were more strict and lived by the rules rather than guidelines to guide a student. Of course, my experience with Dr. Cloning and a few others in Vet school were the exeption.

As I was about to leave, I asked Dr. D to give me information about the other Indian. I was sure he would be like me too—a victim of ignorance. That same evening I met with the other student who was at the verge of a collapse. He was from northern India and he too had no clue about crediting and

146

citing sources. I convinced him to go with me to the provost. "We at least have to explain that we had no criminal intent! After that, if we get expelled, it is our bad luck."

"Fine. I will go with you but you do the talking. I am no good at that." He said miserably.

As I walked back to the hostel that evening, I felt as miserable as him. All my strength that I had displayed before him melted into a heap the moment I was alone. This was my break-year all over again. Then, I had resurrected myself. Here, if expelled, I had to head home to India. My past experience of losing one year in Veterinary Medicine was very evident like a whirlpool or tornado haunting me to America I felt. No other university would entertain me. All that money and effort would all be a waste. I cried all night without a wink of sleep.

However, by the time I met the provost, I felt oddly confident that Mother America is a land of freedom of speech and let me be honest and sincere about my strengths and weaknesses. Somehow, the fact that I had made an honest mistake and not tried to cheat the system, gave me strength. The Vice-Chancellor is a thorough gentleman. He heard me so patiently, despite being the head of the university. That is one thing I will always appreciate about the US—nobody treats anybody like an inferior.

I explained to him my case, the other student's case and then posed a concern. "Most of us international students are clueless about this etiquette of writing. We come here with dreams about achieving something, not to deceive or hoodwink anyone. It would be most kind of you if you could have a course for the international students pursuing PhDs regarding this very etiquette."

By the time I finished talking, the provost smiled. "I do see the sincerity in you. I have spoken to your professor who

was all praise for your hard work and diligence. I will have the case dismissed against you."

He added before letting us go. "I also appreciate how you thought of students who might be lacking in writing skills. I appreciate your universality. Keep it up and keep being what you are," he complimented. It was a moment of epitome for me that assured me that my universal heart is indeed a much necessary positive force on Mother Earth. It bloomed my "petal of universality" in my Kamala Lotus.

I collapsed on the bed in my room and slept all day! I was saved! The truth, trust, and hope had saved me. I began to understand that people appreciate me because I think beyond myself. I can't live my life any other way. I can never simply live for myself.

The next day, Dr. D shook my hands and laughed. "You really are a winner, Kalaini or Kamala, like your great-grand-mother you told me about! Now back to work."

But in order to forget that disturbing incident, I needed some place where I could push my limits—work harder. But my eyes were a problem. I explained to Dr. D how I was unable to carry out the current research and that was when he suggested a parallel project he had. "Why don't you work on the effects of protein levels in the arteries?" His empathy was amazing and always inspired me to keep grooming my empathy angle.

His suggestions opened up new doorways of learning. The research was easy on the eyes and it also allowed students to take courses in the Department of Medicine at the Medical School. Yes, a medical school, finally. The more I learned, the more I wanted to learn about how intricately connected a human body is. In my third semester, I wrote a proposal for a grant with Dr. D. I did the research and writing, with him overseeing my work keenly. In fact, after that episode with my

writing, I had requested Dr. D to teach me the art of technical writing. I owe a great deal to him for going that extra mile to train me. He is one of the best mentors of my life.

He would read everything I wrote in detail which he did not do with the others. At times, being the nice man he was, he would apologize to me. "I am checking your writing because we do not want another mishap."

"I owe you for this help, Dr. D., I know how much extra work this is for you," I would say and I meant it. I was grateful to him for his help in a domain outside of research.

But I did not disappoint him in the least, if I may say so myself! The proposal for research we wrote, got us a grant for fifty thousand dollars. I was given full scholarship assistance, which was much more than any student got. Now I finally relaxed and I could forget that bitter incident—the girl who was almost thrown out of the university for plagiarizing had now written a proposal and won a grant! Again, when you work hard, intend well, magic happens.

# *chapter 27*

This is the stage of my life where I met "Devi" and the transforming experience I had as genuinely shared in the chapter named "Devi"

Life is not just about eating, studying, working, earning, family life, etc. Life has much deeper meaning which most people today aren't aware of because it is neither taught in schools and colleges nor do people seriously want to learn about it. People give great importance to momentary pleasures and if they find any interruption or obstacle in their pursuit for self-indulgence then they become agitated internally and externally. Most of us spend all our time, energy, and effort in taking care of our externals such as accumulating wealth, planning for careers, etc., and we spend very negligible time in attending to the needs of our inner self. But it's a grave mistake because if our inner foundation is weak then we can crumble at the slightest whiff of any adversity.

However, if we equip ourselves with the knowledge of who we are and what the purpose of this human form of life is, then we would in fact shudder at the thought of doing anything whimsically. A child may put his hand in the fire because he may not know that it will burn his hand. Similarly, an ignorant human can waste life but as soon as he understands the importance of the human form of life then he will desist from committing any harm to himself or to others. Human life is very precious because as humans we have the opportunity to do ultimate good to self and to the entire humanity. Importance of human life is exhorted in Vedas and so Vedanta sutra exhorts to all: "Inquire about the absolute truth (athato

brahma jijnasa)." If we can develop a relationship with our own self, then we can easily confront all the difficulties just like Arjuna, who after taking the guidance of Krishna, was easily able to subdue all his weaknesses and negative emotions.

Meaningful messages of spiritual literatures like Vedas, Bible, Quran, etc., will equip us with sufficient knowledge which will prevent us from giving in to our lower self and making any irrational decisions in our life.

Having a human form of life, we have the opportunity to return to our eternal home which is full of bliss. And for this we just need to think rationally, introspect intelligently, and develop a desire to find a lasting solution to all our problems.

So, each and every moment of life should be utilized for self-realization and not for wasting it in the spur of the moment.

By now, reading the opening chapter, "Devi," in my book, everyone knows the story of Gajendra Moksha. Instead of going again to the story, I will just jot down some meanings to be drawn from the story by us in our lives. These are the lessons we can draw from the epic of Gajendra Moksha.

Gajendra represents the King of Indriyas (our senses). He did not respect Sage Agastya in the previous birth as Indradyumna, a terrible king due to his arrogance. So the arrogance made him take another birth as Gajendra.

The story makes it clear that Gajendra lives an extravagant life, all powerful, and is very well regarded among his herds. But he was unable to escape Crocodile Makara's clutches while taking a bath with his herd. All the members leave him to die alone when the Lord appears to grant him release (Nirvana), following his prayer from the depths of his heart.

He also sheds his arrogance and realizes that no matter how powerful he is, he is alone, and only the Almighty can rescue him from the clutches of this world of make believe.

On the other hand, Makara, a powerful Crocodile, was a great Gandharva King named HuHu. Once, Sage Devala and HuHu were taking a bath in a river. When the sage was praying to the Sun God, out of fun HuHu pulled the leg of the sage from underwater. The sage cursed him to be born as a Crocodile. He can receive liberation from this form only if a good soul seeks out Lord Vishnu.

Here Makara represents bad deeds, or darkness and ignorance. When a good soul calls for Lord Vishnu, the tendency of doing bad deeds in the other person also goes away. While the first one got Moksha, the second one turns his attention to the service of God.

Each one of us can be compared to Gajendra, the Makara is sin, and the lake is the world we live in. So we can become purified souls when we constantly and sincerely take time to think about the Mother Universe, our senses will maintain their balance, we will feel more able to control our negative actions, and the world will be a better place to live.

Several of the scriptures from antiquity are a treasure house of knowledge and wisdom that fills with wisdom as one benefits from reading them.

Every Indian scripture teaches us to be dispassionate. Gita declares that a man who is dispassionate toward objects and detached from even his own family is knowledgeable, the one who is not is ignorant. I strive for knowledge from all spheres. I knew from a very young age about every story from the epics I heard talked about. With the ills of over-attachment, I had rendered myself a helpless and broken mass. I had to heal a lot.

The lotus flower's daily resurrection is certainly interesting, and surely symbolic of revival. (This makes it the perfect gift for anyone recovering from injury or a traumatic experience like mine.) But the flower also has a fascinating will to live.

A lotus seed can withstand thousands of years without water, able to germinate over two centuries later.

The flower also blooms in the most unlikely of places such as the mud of murky river water in Australia or Southern Asia. Not only does it find sanctuary in the muck, but due to the waxy protective layer on its petals, its beauty is blithely unaffected when it reblooms each morning. It continues to resurrect itself, coming back just as beautiful as it was when last seen. With such refusal to accept defeat, it's almost impossible not to associate this flower with unwavering faith. Although cultures have largely dubbed the lotus as a spiritual figurehead, it is most emblematic of the faith within ourselves. I deeply thank my universal perspectives of self-healing from the wisdom and purpose of life that Ancient India has given to the world in the form of scriptures, vedas, ancient sacred texts, idols on beautiful kamalas, humanoid forms of various nature friends like eagles, snakes, elephants, peacocks, swans, mice, cows, pigs, lions, tigers, etc. It just is the perfect ecosystem of humans and animals to respect and learn from each other and to prosper together.

There is an incident in Ramayana where Sita puts herself through the test of fire. To prove her chastity, Sita walks into a lit pyre and comes out of it unscathed and stronger. I had put myself through the jaws of death with my attempted suicide. When I survived, I was a new person. Nothing in the world was going to make me so weak again. I realized that I am slowly blooming my petals of appreciation, perseverance, gratitude, and self-empowerment.

A note to youngsters who, in moments of weakness, think of taking their lives. Suicide is one of the leading causes of death among adolescents and youth. Being a suicide survivor, I want to tell those who are going through troubled times to open up and talk to someone. Sometimes, the troubles

are a lot bigger and messier in your head but another person who listens to you will give you a fresh perspective. Talk to someone—friend, parent, teacher, therapist—but do not let despair build up in your head. If even for a moment I had thought of my parents and what a hole my action would burn in their hearts, I wouldn't have taken that step.

A desire to live life on one's own terms, expecting people around to accept their way of living, a never-compromising attitude, and carrying tons of emotions on their sleeves are some of the attributes which characterize people today. The end result is never a pleasant one because, in this world, we will never always get what we want. Love, obsession, extreme passion—sometimes even the most rational human beings go through irrational emotions. What I am trying to say here is that it is all right to feel the way you do. But be aware at all times if your feelings are being destructive to your mental wellbeing. If so, get them out of your system. Again, talk to someone, take the help of counselors, but do not let yourself be swallowed by your emotions.

"There is no health without mental health." Famously said by US Surgeon General David Satcher, MD. There is a concise and tragically overlooked mantra of healthcare in America. As the saying goes, When our health goes, so goes the health of our nation! Mental health is the cornerstone of good health, yet it is the most stigmatized and under-funded segment of healthcare. That is until COVID-19 shook the foundations of mental health and made each of us realize how close to home, mental health issues can come.

Mental Health has lived between subjectivity and science since the time of Hippocrates. The closest science research to objectively define mental health conditions has been the *Diagnostic and Statistical Manual* (DSM5) first released in 1952, now on its fifth edition released in 2013. Ask your

average mental health professional to recite verbatim this 1000 page mental health manual and few could give you a passing grade let alone an accurate synopsis. Every behavioral health clinician subjectively probes and questions patients based on the patient's chief complaints and their own subjective intrigues and scholarly focuses. However, science is not subjective, but rather objective. Research is all about the data and facts! Where the DSM5 has failed many clinicians and patients alike, technology is starting to step in and bring objective science to mental health.

In 2003, Dr. Nelson Handal, M.D., a double-board certified Distinguished Fellow of the American Psychiatric Association, had a vision for an algorithm that always asked the right questions and uncovered every comorbidity. His dream became reality in Clinicom. In 2004, Dr. Handal performed the world's first comprehensive online mental health assessment. Clinicom is capable of assessing anyone anywhere with the internet for fifty-five mental health conditions from the comfort of their own homes, even on any mobile device. Clinicom has evolved over the years to include powerful follow-up features and real-world evidence tools that help guide clinical decision-making. To date, Clinicom has been used to suggest over 298,896 diagnoses and has been used as a prescreening tool in over seventy-two Clinical research studies. According to Forbes's #1 health-tech innovator, John Nosta, Clinicom has done for Psychiatry what the digital camera has done for photography.

My dear friend, Dr. Nelson Handal, was gracious enough to give the quote: "As psychiatrists We need a lot of information and empathy to help people adapt to the constant challenges that they Experience. More so, if they suffer from mental illness, trauma, substance abuse, and/or isolation. Nothing is more rewarding than being able to actually lift

people from that dark and hopeless place. More so, if one develops something like technology enabled strategies like Clinicom for that mission. His mission is close to my heart with regards to this most important mission in making our communities healthier and stronger mentally."

# chapter 28

My professional life spiraled upward. When I started working, I was in a different world altogether, unaffected by pleasure or pain, and fascinated by Mother Nature's miracles in her hard work to engineer various beings on Earth. I thank God for that trait and perception in me. Also, through my research, I was gaining a better perspective on how connected the mind and body are. I took courses in Molecular Biology. I began to understand how the heart, brain, and all the other organs work in unison.

My PhD research topic was to study why men over fifty were more prone to heart attacks. I used to observe when cardiovascular cells were given low, medium, and high doses of caffeine. The agitation the cells went through at high dose was almost disturbing. Giving a little basic information, cells contain molecules that give them the ability to grow and reproduce. I began researching at the molecular level what triggered the cells to get over-energized. What was triggering the hyper-activity of the cells that were in turn leading to cardiac problems?

Once I could see the overactive cells; I would picture a person getting angry about something abruptly like we all do when we take on several challenges such as a new job, being newly wed, family planning, buying a house or car, etc. Where our never ending library of desires and responsibilities reside. The cells were abnormally energized with higher caffeine and the same happened when we added cortisol, the hormone that is released at times of stress in our bodies. It occurred to me then how, if we don't control our extreme

emotions or reactions, the hormones will overdose our bodies and gravely impact our health, cell by cell! When I talked to Dr. D about this agitated state of the cells, he said something in a lighter vein, but there was so much truth behind that statement. "So, you think those cells are begging for life?" He asked me curiously.

They do, Dr. D, and it is a daunting task for our heart cells to handle these emotions that we unnecessarily pump into our bodies! The cells do beg for life as I see in the microscope. No wonder we get so exhausted after an argument or when aggrieved or even when ecstatic. Any overly felt emotion causes the cell vibrations to exceed their normal limits. There is a phrase in India that says, if you make a child laugh too much, they will cry later. Now I understand the scientific reason behind it. Excessive mirth, too, causes an energy drain on the body. If you want a healthy body, a healthy mind is the key. For a healthy mind, moderation is the key.

My third year and the beginning of my fourth year in Missouri passed quickly. I was knee-deep in my academic world—research, writing papers, attending seminars, and working on assistantships. When you are busy, time flies. A few months down the road, there was a seminar organized by our department. I was going to make a presentation on why men over fifty have more heart attacks. Since this was my research topic, I was naturally very passionate about it and I felt a need to be more effective in communicating the problem. I had to convince, not just my fraternity, but also those who were outside the field of medicine. For this, my presentation had to be unique. It could not simply contain charts, dry facts, and complicated numbers. I prepared a presentation that sounded like storytelling. My advisor, Dr. D, laughed in glee when I did a dry run before him. "I love it, Kalaini! You are the most unorthodox thinker I have met and as you always talk you

are the rarest in modern times that I sense you perceive spirituality in science." Then I thought in my mind, "Well, I just saw the emotional and spiritual dance of the heart cell or our emotions in a petri dish from being pious to paranoid vice versa."

I was very fortunate to have him as my advisor—someone bright, enthusiastic about new research, and also kind and patient. And the liking was very mutual since he often told me that he didn't envision anyone replacing me as his favorite student!

When I made that presentation at the seminar, one of the judges who met me after the talk was from a top-five pharma company. She was very open in praising my research and presentation and to my surprise made a job offer! "If you are interested, I would like to hire you for my company."

My mouth must have opened wide in surprise. "I am still at least six months away from defending my thesis," I said.

"That is all right with me. Give me a call when you finish your PhD defence."

I managed not to dance with joy right there! If you remember my earlier mention, my family runs pharmacy chains in my hometown and all my childhood I was surrounded by pharmaceutical products and medicines. I was dancing in my mind that an angel came looking for me and offered me a job in a top-five pharmaceutical company. The seminar was attended by people from many experts across the university from schools of Veterinary medicine, Medicine, Engineering, etc. I worked harder than ever to complete my PhD as fast as I could. The day my degree was awarded, I had finished my doctorate's within three years and five months! I am a believer of hard work and magic and that combination has never failed me. My father was ecstatic with the news.

The lady who had hired me created a post for me. She said she was very keen to have someone from the Veterinary background who could understand and apply knowledge from animal physiology and pharmacology to understand the new medicines development for humans. I cannot believe that she created the perfect dream job for me based on all my education since my childhood with my academic excellence and my spiritual excellence through my life challenges.

In my third year, 2006, the company went through a huge setback. One of their drugs for body pains was proven to be causing unprecedented cardiac arrests and subsequent deaths. The company withdrew the drug and paid the penalty. But that set the entire pharma research in motion. Is our understanding of the drug and the patient interaction so poor? When so many thousands of trials were conducted before releasing the medicine to the end-user, how did we go wrong this badly?

It opened up research just like my lab experiment. I talked about "caffeine and heart cells" biomarkers—not just within this pharma company but throughout the whole industry. Simply put, biomarkers are molecules that indicate normal or abnormal processes taking place in your body and may be a sign of an underlying condition or disease. This may be found in blood, other bodily fluids, or tissues. Fever is an indication of an ailment and a biomarker for any potential viral or bacterial infection. As almost everyone is aware, glucose is a biomarker for Diabetes. In oncology, the study of cancer, a cancerous molecule in a tumor can be a biomarker. Then there are the BRCA gene mutations that are indicative of breast cancer and also ovarian cancer. Actress Angelina Jolie went through mastectomy after her BRCA test turned positive.

In essence, biomarkers help in the early detection of diseases and also predict how the medicines are working by measuring

various biomarkers in the normal functionality of various body parts. The more I read about it, the more the importance of that research became apparent to me. I began talking to different departments in the company working on biomarkers. I began attending meetings held in various departments that were researching biomarkers. The lady who had hired me gave me the nod to be a part of this though it was not my job. I felt like a butterfly within the organization and transformed ideas into initiatives and crafted my role as a "transformer queen" as some of my colleagues used to call me as I am always about transformation in our understanding of science.

In India, diabetes and cardiovascular diseases are almost always a package. So when I saw a department working on the biomarkers for cardiovascular diseases, I jumped in. When I served on the various internal and external committees on biomarkers, it hit me—I wanted to work with different pharma companies to understand the technology and approaches because it is more justified to take such transformative approaches across the whole field of healthcare. There were so many innovations happening at different places—genetic research, MRI, STEM, biomedical engineering, Robotics, etc. I began to feel restless not being a part of that world and rather wanted to be in a sandbox and learn more. It dawned on me that if I continued to work for one pharma company only, I would never be a part of that larger world of innovation.

That was when I decided to do the unthinkable—quit a top-five pharma company, a fortune-100 player. This decision planted a major difference of opinion for the first time with everyone in my life. An important aspect for me is I always followed my unique experience of defining a family which is a universal family, "Vasudhaika Kutumbam," which consists of parents, grandparents, extended family, spouse, children,

in-laws, and on top of that, friends, peers, patients, and patient advocates. Later, I will discuss my experiences briefly about the modern evolution of atomic families (a new name coined by me) and its impact on human health.

But I stood my ground. I was qualified and I had a vision—I was going to find a job that put me at the center of innovation. I felt constricted working for that one single pharmaceutical company. After all, I had grown with a family that dealt with medicines from hundreds of pharma companies across the globe. How could I confine myself to one?

# chapter 29

When I quit the job it was the year 2008. I have to talk about the emotional turmoil that began to unfold in my life. As I mentioned, my family was not really in favor of quitting my job and I think anyone in this situation is justified with the family members' reactions. When your family/partner/parent disapproves of your decision, it weighs on your mind.

But I was different. I came from a family that did not rely on employment. Since then, I have begun to realize that when we assess and judge people's decisions, we don't take into account the formative years of their lives. I had grown up in a family that was all about ethical entrepreneurship and business growth in addition to a higher education, like my father did. My father had a Master's in Organic Chemistry. He aspired to get a PhD in the same and he was even accepted into a prestigious university. However, my eldest uncle, having to shoulder the family responsibility, had joined a pharmacy as a sales executive.

When my father was contemplating pursuing a PhD, my uncle proposed to my father the idea of starting a pharmacy of their own—as my grandfather was paralyzed for life. My father had taken up on the offer. One, he knew his involvement would empower his elder brother. Two, my father, too, wanted the excitement of entrepreneurship and a place where he could lead by example. As I have stated before, all my younger uncles, one by one, joined their brothers to build a rock-solid business.

Every day we had visitors who came to ask for help in sourcing ethical and lifesaving medicines, shipping medicines to faraway families, and even with ailments for which my father or one of the uncles guided. My dad's youngest brother, Sridhar, was an avid learner and always loved playing with science as a kind of sandbox. His inquisitiveness amazed me a lot and he gave some of the most transformative ideas to my father. I absolutely loved their collaboration—a term I did not know at that time.

Also, they never let the business stagnate. Whenever they saw a need, they provided a solution. That was how they changed from being retailers to partners for society. When the city of Kurnool did not have sufficient Veterinary medicines, they forayed into that segment. Whenever I saw my family and their impact on society, I wanted the same for me. I wanted to help people with my research. I never wanted to work just for a high-paying secure job if it did not satisfy intellectual curiosity and did not show me the impact directly.

Around this time, in 2008, while I was looking for an exciting job, I decided that it was time to start a family. Little did I realize at that time that stress, even if contained and controlled, is not very conducive to childbearing. Mother Nature knows when a woman is ready. Two great things happened—or so I thought. I found my dream job at a Contract Research Organization (CRO.)

To briefly explain what a CRO is, they help any company developing a new drug, medicine, test, or device by carrying out various activities such as clinical trials, pharmacovigilance, and others to help launch a new drug or test or a medical device. Launching a new drug or test or device is an extensive process that requires a highly skilled workforce. As the name suggests, a CRO conducts these activities on a contract basis. Healthcare companies hire CROs to outsource

these responsibilities. It saves them having to recruit and maintain a team. The CROs with a well-established group of experts, offer their services to healthcare companies.

It was the right fit for me. This kind of liaising with different pharma companies was what I was looking for. Though I was hired as a biomarker expert who knew the science behind the body functions, very soon the company realized that I was a scientist who enjoyed networking and interacting. I was put in business development as I loved to take science from the bench to the bedside to help patients. It was the best of two worlds for me—scientist and humanitarian. But there was a big challenge in that position. To get to my workplace, I had to commute three and half hours together. In the very first week of my commute, I got into a terrible accident on the freeway. My car broke to smithereens but I miraculously escaped with not too grievous injuries—though I had to be hospitalized for a few days. My family was much against that commute from the beginning but, after the accident, my mother insisted that I quit my job.

But I was not willing to. One accident could not deter my spirit. I called my father. Being the ever-supportive father that he is, when he came over to the US for the first time, in 2006, he was the one who helped me drive with confidence "You drive and I will sit next to you. Whatever happens to you will happen to me!" He joked. He then told me his wisdom of learning when he used to drive a motor-bike 100 to 200 kilometers everyday to bring awareness about medications to villagers in remote places who had no access to cutting-edge science. He and my younger uncle, Sridhar, used to coach patients and farmers on various advancements for human and animal diseases. The impact drifted me toward positive outcomes rather than the pain of commuting. But, he recommended one thing: make sure

you "self-care" throughout this process and when it is time to quit the commute you just do it!

Before I resumed work, with my insane three-hour commute, he gave me advice that was so profound. "Driving is simple. All you need to know are when to accelerate and when to apply brakes." He added after a pause and his inimitable warm smile. "It is not much different from life either. To cruise through life smoothly, you must know when to express yourself and when to suppress." I am not sure I follow his advice with driving or with life all the time, but I do remember those words whenever I feel overwhelmed and calm myself.

It had been five years since my marriage in 2003, and the timing seemed just right for planning a baby Kamala. Yes, I always loved the idea of having a girl for some magical reason. But, as I mentioned at the beginning of the chapter, though I conceived, my mind and body were not in synergy. I was going through a lot of hidden stresses which led to the inevitable—a miscarriage.

# *chapter 30*

Without going into the minutiae, let me talk briefly about my various stress points. As I mentioned earlier, in my life experience and understanding with several families since I was thirty years old, 21st century modern day families can be called "atomic families". This means every family's values, beliefs, cultures, and traditions are different. This counter-perception of differences as conflicts versus acceptance of them as "uniqueness," with gratitude, has led to familial disconcert in many families worldwide. This causes tremendous grief and contributes to all levels of stress like the "cortisol rush impact on the heart cell" in my PhD lab experiment. I will call it from now on "life in a petri dish". Petri dish means "living laboratory" in a dish covered with a slight plastic, transparent cover. If you want to know more about petri dishes, please read about Richard Julius Petri, a German microbiologist, late 19th century. Dr. Petri worked as an assistant to the celebrated German physician and pioneering microbiologist, Dr. Robert Koch (1843-1910). At that time, Koch was considered to be, along with Pasteur and Lister, one of the late-nineteenth century's "fathers of microbiology".

I am taking a moment of gratitude here to Pasteur, Lister, Koch, Petri, and I have a "virtual International memorial of microbiology" built in my mind for all of them, mimicking the Mount Rushmore National Memorial for the for their tremendous innovations into the field of microbiology. Microbiology is the study of all living organisms that are too small to be visible with the naked eye. This includes bacteria, archaea, viruses, fungi, prions, protozoa, and algae, collectively known

as "microbes". Thanks to their research that is providing more scientific advancements to treat various diseases like Malaria, Tuberculosis, HIV, Flu, and COVID-19 in 2021.

Hence you can imagine my heart cells throbbing in the cortisol rush being in an "atomic life" staying away from parents, grandparents, aunts, uncles, cousins, etc. Despite a good job, house, car, atomic family, I did not realize the bonding and the ecosystem that a universal family gives versus modern-day atomic families. Many of us from India, even if we come from nuclear families, have relatives spread widely in the same town and many towns around back in India. The social environment and the integrated ecosystem has a tremendous impact and unique approaches to how we handle day-to-day stresses and life's responsibilities.

Finally, after almost five years of trying and three miscarriages, I conceived in early 2009. Let me take a moment and talk about miscarriages and what I have learned through my very painful and healing experiences.

It is so coincidental, a timely memoir, *Becoming*, by Michelle Obama, in 2018, has revealed about my painful journey of miscarriages before she went through In Vitro Fertilization to conceive her two daughters. It is almost like her experience has been written in invisible ink until now; just like mine until today. I have learned some haunting and healing lessons through the series of triple miscarriages. Miscarriage is filled with a "painful cocktail of shock, depression at a cellular level like a cell with no movement in a petri dish". The former first lady's disclosure that she and former President Barack Obama suffered from fertility issues, including losing a pregnancy, has sparked conversations about miscarriage, a common but also commonly misunderstood loss, When you have more than one, you will most likely mistake it for a personal failure, which is not true. From a medical standpoint, no matter how

many times it happens it needs a doctor like a handyman to fix the heater.

It is heartbreaking that I come across women who express that they have lost their identity; especially coming from a society where a woman's success is measured by her children. Being brought up in a conservative society's views toward miscarriages, I had to battle with so much silence from friends and family around pregnancy loss; because people chose not to talk about it. But the same society has the most wonderful healing traditions driven by science to take care of the pregnant mother, newborns, and postpartum care of the new-mom. But the drama, stigma, and silence in relation to miscarriages, built a wall of muteness in my immature world of a soon-to-be mother. It has gravely impacted my physical, physiological, mental, emotional, and spiritual angles of my health by the second miscarraige.

My second miscarraige experience was life-gagging. I was urinating during my regular bathroom break. I suddenly felt an electric shock like a current passed down from my stomach to the outside with excruciating pain. I almost had a blackout and I was very weak and was holding my tummy and ended up catching a dark red, jelly-like, golf-ball-sized object in my very own hands. A scientist by background, I knew something tragic and heart-wrenching was happening! I crashed down in the restroom in a prayer pose to the Universe and deeply begging for answers ... why me? Around ten weeks, a baby is usually fully formed. With fingers, arms, legs, and toes, and might be seen inside the sack.

By the third miscarriage, I started learning the toughest life lesson that "sometimes in tragedy we find our life's purpose just like a Lotus does in muddy waters". I had no source to talk to other than my family members, who were all hyper-emotional about the situation and no one knew who to reach

out to. I then self-guided my spirit to be uplifted by calling friends in the USA and talking to them. Surprisingly, a couple of them had gone through miscarriages they never chose to talk about until I insisted. I think there should be a huge focus on miscarriage education in the global sex-education initiatives and we should implement local support groups for bringing more awareness.

I decided to accept the failure of not being able to conceive with gratitude and promised myself that I am not going to live in a melodrama, if I did not end up conceiving at all. "Those we have held in our arms for a little while even for a few minutes, we hold in our hearts forever like an infinite lifetime." That is how I have started to train my brain to handle the traumatic experience of my second miscarraige out of my three episodes. I promised myself whether I have a baby or not that I would try my best to care and stand up for every baby through my personal advocacy and professional responsibilities. To be more precise, every human on this planet as long as I am in healthcare and wrap my professional acumen with empathy and humanity. I know all my three baby angels have blessed me with trillions of milliseconds of positive energy in me to spread my mission of positivity in anything and everything I do. Surprisingly, I conceived and had a super-healthy pregnancy when I focused on self-care versus becoming pregnant. My son, my bundle of joy, arrived in November 2009, one of the happiest days in my life. His name is Venky, named after his grandfather, and also coincidentally a rhyme of my favorite childhood and lifelong friend, Mickey Mouse. Yes, I love Mickey Mouse and even today I have one "Magical Mickey" especially for me that I self-gifted from Orlando when I took Venky to Disneyland when he was seven years old.

A job I loved, a child I adored, and a happy atomic family. However, life is not a straight line as we all know it and especially from my scientific language it is like an ECG of a heart (An electrocardiogram [ECG or EKG] records the electrical signal from your heart to check for different heart conditions). When I was just a month into motherhood, misfortune struck me like a tight slap on the face. The company began downsizing their US facility and offered to keep me only if I moved to London. Needless to say, I could not do that even though I loved visiting London through the job many times.

I was devastated the day I resigned from my position like any career professional would; but I had the most prestigious role to fulfill: raising my son, who was waiting for me at home. I felt losing my job was God's way of telling me to spend more time with my son. A curse is a blessing in disguise indeed, and I prepared my mind to dedicate my time to my son. After all, I deserve this playful and fun-filled sabbatical to spend time with my son. My jobless state continued for eighteen months but I was immensely happy being a mother. Also, I self-mentored whenever I could make time. I would catch up on the new healthcare research and apply selectively only to those jobs that appealed to me and let me have flexible hours. But I also have to mention how stress started building in me again. It was the first time in my life I had taken a break and being a mother was a big change in a woman's life—both physically and mentally. I felt helpless because I had to do so many things for the house and the new baby. I was brought up in a house where everyone would divide and conquer, while the men went out to run the business. It's no secret that marriage takes a lot of work and, on top of that, having kids is a crazy, yet rewarding, gift of building your own family. A marriage and family is a partnership—it's two people going beyond coming together and learning from each other every single

day. That sounds hard and daunting, but also gives a unique olympian model for each of us. Yes, I mean it, everyone of us should self-reward ourselves for our commitment, dedication, and evolution in our family lives.

Melinda Gates, the co-chair of the Bill & Melinda Gates Foundation and former spouse of Bill Gates, founder of Microsoft recently wrote a book. In her book, *The Moment of Lift: How Empowering Women Change the World*. She relayed several inspiring stories of women she met in areas including Africa, India, and the Philippines, Gates shares her own feminist evolution, including how her roles as wife and mother evolved at home. She is a daughter of an engineer and stay-at-home mom, or homemaker, Melinda earned a Bachelor's Degree in Computer Programming and Economics, and a Master's in Business within five years at Duke before joining Microsoft in 1987.

Melinda and Bill Gates got married on New Year's Day in 1994 and she decided to prioritize her family over her career; she left the co-chair of the Bill & Melinda Gates Foundation when she had her first child, a move that she wrote had stunned her husband. I can relate to myself in this decision I took for eighteen months after three miscarriages. There are many other women out there who want to prioritize a mother's role over a career, at least for the few months or years of early childhood. The topic of maternity leave is a whole book we can debate on in the USA and other countries. There is so much science behind a woman's body and healing after childbirth as it is literally rebirth for a woman in addition to giving birth to a new life. In the book, *The Moment of Lift*, she opens up about redefining the power structure in her marriage, how their foundation worked to equalize hierarchies between men and women around the world and how crucial access to birth control is empowering women. I would

also add "miscarriages" is an equally important topic given the rise of incidences in the late 20th century.

Building intimacy in a family between couples and their children is a lifelong coaching for all of us. Building intimacy with your own self is also important. It builds over time as you connect with someone, including yourself, grow to care about each other, and feel more and more comfortable during your time together. It can include physical or emotional closeness, or even a mix of the two.

Believe it or not, I got some of the best ideas about life's professional responsibilities while cleaning and cooking in the kitchen and no wonder Bill Gates shared chores of cleaning dishes at his own home; in addition to building intimacy and responsibility as a parent and spouse. I call myself the "billionaire of my own world" as you will see in the next chapters how I perceived and assessed my contributions to healthcare and humanity through my "billions of seconds of commitment" through my profession to help patients and families worldwide.

I applaud and share a moment of gratitude with every "Wonderwoman Homemaker" in this world, starting with my grandmothers, my mother Sita, and the rest of my aunt-mothers I grew up with.

I want to dedicate a paragraph to them, starting with my paternal grandmother, Ranganayaki, whose name means an embodiment of Goddess Lakshmi, the feminine aspect of the universe. Until I was writing this book, I did not know the financial situation of my father's family while he and his siblings were in their elementary school and teenage years. When my grandfather was paralyzed at the age of forty-five, my brave and valorous grandmother took the form of Durga, the goddess on the mighty lion. also known as Shakti or Devi, the protective mother of the universe. She is one of the

faith's most popular deities, a protector of all that is good and harmonious in the world. Sitting astride a lion or tiger, the multi-limbed Durga battles the forces of evil in the world. My grandmother was suddenly tasked to be the "CEO of the Maddali company." As a sole homemaker, the valorous leadership she displayed is unimaginable.

My next role model is my maternal grandmother, "Navaneetha," also called, "Santha," meaning "new light" and "peace." Every summer when I visited her with my mother and brother, I recall several scenarios which showcased her leadership qualities in building a healthy environment by managing finances appropriately. She was a single mother who took care of her son and three daughters from her early forties. Her commitment to maintain and manage the house as a sole-breadwinner until her upper-seventies was impeccable. Her son could not be successful in any job he took. For what reason we did not know. For me, she is the "CEO of the Pokuru family," my mother's maiden name. She raised every girl and boy with the same empowering attitude to accept life and learn from it to the best of their ability.

My mother Sita is the "Chief Creative Officer" of my family and of my life as well. Her creativity and passion in biology, science, arts, artwork, and design are inspiring to me even today, no matter what mission I pursue. She has a fascinating storytelling style in her biology records or any science exhibition shows. The way she approached science in her school records just mesmerized me like the movie, Avatar, directed by James Cameron. My mother's drawings combined art with science to create an entirely unique style. It's like Yashoda did when she saw the universe when Krishna opened his mouth when I saw her biology records in the eleventh and twelfth grades. From eighth grade, I would put her records

under my pillow and have an intriguing vision of how the universe created various living creatures beautifully.

As a testament to how remarkable my mom was as an artist and biologist, she taught me her creative skills as a mentor. I am not an artist like her in paper art about science and biology, but I have an amazing knack for imagining the future through science fiction and fairy tales.

As a modern-day homemaker who is also a professional and a full-time mother, I noticed the leadership of a homemaker is like below, where we can share our competencies using real-world experiences. I also believe no degree will give you the real-life experience that being a homemaker does.

1. Productivity
2. Intelligence
3. Multitasking
4. Management
5. Imagination & Creativity
6. Judgement
7. Resourcefulness
8. Self Management
9. Team Leader
10. Expert communicator
11. Forgiveness

The homemaker is a role model for her or his family. By their positive qualities, anyone can teach the other members about the need and importance of cooperation, tolerance, politeness, love, sympathy, empathy, responsibility, etc., for the benefit and wellbeing of the family. Good qualities of a homemaker can help the individual manage the home efficiently and to give happiness, satisfaction, and security with prosperity to all the members of the family. A happy and

healthy home leads to a healthy community, society, and nation. Being a homemaker gives you the "Doctorate's in shaping lives" and royally rewards you for all the hard work and dedication.

Being a homemaker is a trail-blazer role in the world where success and happiness together become clearly evident on a day-to-day basis. Every homemaker is a "CEO" of their family or their own life. You have to be self-empowered to learn and excel at all these multitudes of qualities and keep practicing them for life. (If you are married, unmarried, single, student, wife, husband, father, mother, etc.) I would make these attributes or qualities as my petals within my Kamala Lotus. I think we are all unique, and building your own petals of empowerment will make the best version of YOU.

# *chapter 31*

Before I get into the details of my next job, I want to talk about my learning from those eighteen months I was at home. Everyone needs a break, and especially those with higher education. Obtaining a veterinary-medicine degree and a PhD is exhilarating but also exhausting. But most of us jump into full-time work right after education. Then we keep going through the daily grind and the stresses. Call it a sabbatical year or whatever you want, but take it. Dabble in your interests, explore spirituality, find a sport or art you wanted to learn. I had to be my own strength and my own counselor. I remembered how empowered I felt after my break-year in college, back in 1998, when I was held back due to shortage of attendance. If I turned a setback into an opportunity when I was eighteen, I could do so now. I knew first-hand from my research that stress kills your immune cells and burns your precious energy that could be spent on something worth-while. If I cannot find a source of empathy outside of me, I will build it inside me. I will care for myself and sympathize and empathize with myself too. Nobody knows me as I do.

I looked around for jobs mainly to learn and keep myself active in the field. I found one in India that interested me. I volunteered my services to them virtually and they were more than happy to take me on board. I kept up with the latest research as well as the news around the world. I began inter-acting with people who were doing innovative work in health-care. You would be surprised how responsive people are when you show genuine interest in their work without aspiring for any paid outcomes. On a personal front, I was a new mother

and I cherished my time with my beloved son—from bathing him to playing with him to taking him on walks strapped to a stroller. I accepted that my destiny was to face periodic episodes of pain and emerge from them stronger. That was how I could bloom like a lotus. My favourite quote by Nelson Mandela is this: "The greatest glory of life lies not in never falling but in rising each time we fall." I was going to rise soon. But, with all the learnings from this, I will also give back my good insight to other women in the community and life-sciences sector.

Another petal of my life unfurled against the murky waters of life when I got a call from a top-notch company in health-care with a job offer. Those eighteen months made me think about life in general. We are always measuring our successes against a yardstick set by someone else. We are forgetting to live as human beings driven by values, emotions, and instincts. Instead, we run our lives like a corporation always measuring ourselves against what the industry calls Key Performance Indicators or KPI. Success is not your hefty paycheck or your mansion or the luxury car you drive. Success is your happiness, peace, and the impact you have on society. "Success all depends on the second letter, which is U," as an unknown source quoted.

My third job with a large healthcare company was my dream job where I was at the epicenter of innovation. I was my own version of Curious George. I started working with pharma companies to develop new cancer drugs. And they also managed and ran clinical trials for various drugs. Again, the company quickly recognized that I was a scientist with business acumen and I was assigned work accordingly. My job was to meet the requirements from pharma companies and check if the company had the infrastructure to fulfil that requirement. Even if we didn't have the facility to fulfill

a requirement, if I was convinced of the soundness of the pharma company's need, I had to advocate for the company to invest in the infrastructure. Technically, investing into the future needs is based on the pharma partner needs. As you can see, the dual role of a researcher and business head was highly challenging and engaging to me.

I was talking to healthcare researchers from several reputed pharma companies and understanding their work. It was mind boggling to see the thought, research, and production that was going on in the healthcare industry. I was extremely glad about my decision to exit a big pharma company with gratitude for all the good learnings I had. I could not even have imagined this amount of exposure to innovation if I had stuck with only one pharma player.

Let me talk a little bit more about the revolution the healthcare industry was going through to treat cancer at that time and even today. The industry was coming out of the one-drug-fits-all model and customizing treatments for patients based on their unique makeup of their bodies. This model was called Personalized or Precision Medicine (PM) and I felt immensely lucky to be a part of the PM revolution. Therapies took into account patients' genetics or biomarkers (As explained in my earlier chapter, it is a biological measurement) via genomic tests and body composition. It was the age of the right drug for the right patient with the right test.

Humanity is learning a lot about the genetic makeup we are made of. Let me spend a little here on what it means for all of us with all the knowledge we are discovering about our inner self. It amazes me everytime I sit quietly and think about the new discoveries we are making in science and I nurture the inner Dalai Lama within my spirit. Did you know that if you unraveled all the DNA molecules in your body and

placed them end to end, it would stretch to the Sun and back several times.

Now tell me, why should I not see spirituality or magic in ourselves when science is showing it with day-to-day advancements? Well, this perception of life is making me the world's happiest CEO (Chief Empowerment Officer). I will take every second of credit and stay happy and successful in my unique ways. It might be 0.1 percent of my DNA has this perception of life!

Talking about genes, proteins, and DNA, here is the story telling.

1. DNA is short for deoxyribonucleic acid. DNA is the teacher and the cells are the students that are given instructions by the DNA.

2. DNA is the computer programmer in our cells. A fascinating way to imagine is the cell is the computer or the hardware and the DNA is the program or code written into our bodies and it also does new coding as we keep learning new eating habits, lifestyle habits, etc. Within each string of DNA are sets of instructions called genes. The study of genes is called "Genetics or Genomics".

3. According to the World Health Organization, the main difference between genomics and genetics is that genetics scrutinizes the functioning and composition of the single gene whereas genomics addresses all genes and their interrelationships in order to identify their combined influence on the growth and development of the organism.

4. A gene tells a cell how to make a specific protein. Proteins are used by the cell to perform certain functions, to grow, and to survive.

5. About 99.9 percent of the DNA of every person on the planet is exactly the same. It's that 0.1 percent that is different that makes us all unique.
6. Both genes and proteins are the biomarkers that are measured in various cancer types that are specific to a cancer and more unique to a person.

April 25 is National DNA day. DNA is an essential molecule for life. This commemorative celebration marks the day, in 1953, when trailblazing genomic researchers, James Watson, Francis Crick, Maurice Wilkins, Rosalind Franklin, and their colleagues, published influential papers in the Nature Journal (which is the Rolls Royce of the scientific publication world) on the structure of DNA. If that is all you know about DNA, you're not alone—in fact, nearly three in ten people recently surveyed said their understanding of DNA comes from their high school science class.

It was around 2011, when the first and only therapy for lung cancer approved by the FDA for was based on the ALK gene in cancer patients. The development of this drug—from publication of the discovery of the ALK gene in lung cancer to the FDA's approval in just four years (for a common man it might seem longer but trust me this is one of the fastest drugs developed in precision medicine from 2011 up until recently). It is a remarkable feat in the oncology world and reinforces the importance of collaboration among academic research, pharmaceutical, diagnostic, and regulatory organizations. We saw during the COVID-19 pandemic how everyone in the healthcare industry got the COVID-19 vaccines to the public utility in groundbreaking, Guinness record times.

More than a hundred new trials were happening in the cancer industry and I was in the front-row seat watching it all happen! I was part of the team that was designing tests for

identifying cancer. I was also part of the team that produced those cancer drugs. I was immersed in the biology of cancer and I appreciated more than ever how complex a human body is. It was a revelation to me that there were more than two-hundred types of cancers. And, I was in an industry that found, and is finding, a cure every year for many of them. Cancer Research and Precision Medicine were going to be my field of interest as a lifelong veteran. One thing for sure it opened up my most favorite petal of my Lotus, that is "Knowledge". Indeed, knowledge is power.

My career was a dream run. From being a veterinary doctor in a small town in India, I had come a long way to being a scientist at one of the premier healthcare organizations in the world. It was because I was a learner and I was passionate about the wellbeing of people. It was also because I wanted to be a part of the change-makers who cured diseases and eased the lives of patients. I believed in causes greater than myself. Also because I had the grace of almighty God on me and my serving humanity. I always measured my success by impact on community and humanity.

# chapter 32

As it always happens with my life, a year into my career at my third job, a calamity struck me. One midnight, my husband and I were driving back after a get-together at a friend's place when I had my first paralytic attack. My hand was paralyzed, left cheek drooped, speech slurred, and my legs went limp. My husband drove straight to a hospital, with a three-and-a-half-year-old gazing at me in my eyes. I was admitted in an emergency and the battery of tests started immediately. A whopping forty-plus tests were done in the few days of my hospital stay. I was amazed that so many biomarkers are necessary to study the brain function and trauma that I was suddenly battling with.

I lay in that vegetative state in which my body had problems working with full balance and functionality but my brain didn't. It is one of the death valley experiences anyone can have. At least in a coma, you don't know what is happening. Here you are aware of everything happening around you including the fact that you can't move. It sometimes made me feel very puzzled. I thought of my grandfather. How did he live like this in a semi-paralyzed state for two decades? I felt helpless, desperate, and wanted my life to end.

Mine turned out to be periodic unpredictable patterns in my paralysis and my movements returned after a few hours. I was crying and praying for it to never happen again. But I didn't know then that my prayers would go unanswered for life.

I was kept in the hospital for three days where renowned neurologists did a brain scan wherein they found a few white

spots in the brain. Multiple Sclerosis (MS) was the interim diagnosis until further tests were done. In MS, the immune cells attack the protective sheet around the nerve fibers and thereby hampering the communication between the brain and the rest of the body. The symptoms I had experienced, too, aligned with that of MS—fatigue, neuropathic pain, extreme weakness, numbness in the limbs, disorientation, and a lack of coordination. I was discharged after three days but the inconclusive diagnosis bothered me. Then, I consoled myself—I was under the care of the best neurosurgeons and a cure would be in place soon. They were the experts on top of this and dedicated to learn and teach plus treat patients.

In the next six months, I went through more than eighty tests of all sorts and some extremely painful. There was one test where I had to curve like a ball when the spinal fluid was extracted. It was so painful, I snapped. What was going on here? Eighty tests and forty consultations and my condition was inconclusive? My family was convinced that it was not MS and I should not subject myself to medication for the same. They argued that the white spots in my brain hadn't moved or grown as they would have in the case of an MS patient. Also, I didn't have any early symptoms for MS such as disorientation, memory issues, depression, or others. The spots that made the neurologist suspect my condition to be MS were probably congenital and might be in my genetic make-up that I was the only chosen one since there was no family history.

When I thought back to my childhood, I did suffer from food allergies and severe back pain, neuropathy, and strong nearsightedness of -14. MRI technology is not implemented in early stages of childhood. Those spots on the brain might have been there forever instead of freshly caused by MS damage. Each time I visited the neurologist, I had a long

list of questions to ask her—not just as a patient but also as a clinician and a scientist. The neurologists didn't have the answers—all many could say was that it was a neurological disorder and would continue with only symptomatic treatment for one or two of my signs until it became conclusive.

It built a curiosity in me. How much do we understand the human body? If a battery of tests and highly qualified neurologists could not diagnose my condition, is medical science as advanced as we think? It was quite a shock for me because, till then, I was a complete believer in the medical sciences and we humans are mastering the understanding of the human body. I thought there was nothing a good specialist couldn't cure.

My paralytic attacks continued. Though there was no telling when it would strike me, it didn't halt my life. My profession required me to travel the world. I thoroughly and mindfully enjoyed being exposed to different cultures and innovations at the same time. I continued to work and travel. Luckily, in none of the above scenarios did I have any major paralytic attacks but pain was always my sister including spasms of my face, which make funny emojis with my facial muscles, and mini paralytic attacks.

But soon, as my condition worsened, around three years after my initial diagnosis in 2012, I began to feel restless and my signs started becoming more aggressive. There I was at the epicenter of innovation not as a professional but as a patient, sitting in the hospital clueless.

Such great improvements were happening in the healthcare industry, but were they reaching patients? Many neurologists did not even talk about the latest ways to understand the roles of genes or proteins in my condition. Even if it is in research mode, why were these doctors not having a conversation with me about the latest trends in brain research?

What percentage of people even knew about biomarkers that could help in the early detection of diseases?

Shouldn't innovations reach patients one hundred percent?

I began to feel a need to be in a profession that connected healthcare to patients.

Being at one end of the healthcare spectrum did not appeal to me any longer—this lack of engagement between a clinician and a patient about healthcare innovation. That is when I stepped down from the third role and moved on to the fourth role to connect with patients. Each time I wanted to change my career, I was not driven by money or titles. The only thing that mattered to me was to have a positive impact on patients and new learnings I want to deposit in my knowledge bank. None of the research we do is meaningful if they don't reach the end-users which is all of us humans. Before delving into my next job, let me talk about what I have seen in my circles.

Most abhor, or at least dislike, their jobs because they don't find them meaningful. When one works only because they have to support their livelihood, then it causes burnout. I am not saying everyone can be lucky enough to do what they like. But finding out the impact your work has on others, directly or indirectly, will make it meaningful and drive you with a purpose. With the right thought, you will find better ways to do the job.

Most people have this notion that to be of service to society, they have to be working for NGOs or volunteering. That is far from true. Everything you do will help someone somewhere. Thinking on those lines will lead you to greater opportunities. At the beginning of my career even I was not sure how impactful my job was. But it never stopped me from thinking about the same. Your purpose to life is revealed only when you want to make a difference to others. You have to think constantly to figure out your usefulness to the

community. My learnings thus far from my professional and personal experiences made me a champion for various aspects of empowerment, another most-favorite petal of my Kamala/Lotus. Empowerment in my understanding is self, human, woman, patient aspects linking my professional purpose with my learnings as a patient and empathy for other patients that might not be professional like me in healthcare.

Coming back a little more to my health, the condition worsened by the end of the third year. By then I had lost all hopes of finding a medical cure to it. Not as a patient nor as a clinician scientist could I trust the science of neurology completely anymore. I began getting symptoms my doctors were clueless about. They were MS-like symptoms but not fully. It is the most depressing to have an undiagnosed condition. Not just the paralytic attacks, my spine, too, was battered. It began to feel as though I might end up in a wheelchair at some point in my life. I pride myself in being a strong person, but my health bogged me down.

The doctors said the only thing they could do was to treat for MS. How do I trust those drugs with no better understanding of the disease? I started seeking other opinions outside of the USA as I come from the land of Ayurveda, the most ancient medicine in the world from India. My father's close friend, a neurosurgeon in India, said many in India suffer from it for decades but there is no infrastructure in India to even run the specialized tests. He, too, said what my doctors here had said—the only treatment was the same as MS or MS-like. I was battling with a disorder that didn't even have a name! How much I tried, the question "Why me?" crept its ugly head in all the time.

When I was at the verge of a breakdown, some of my friends and family asked me if it was all in my head. I was devastated when my close family members could not understand my

health condition as it is so enigmatic and unpredictable. How could anyone even think that my condition was psychosomatic? I was spiraling back to the days when I stayed at home as a new mother. Where I was judged harshly for being a stay-at-home mother. I decided I was not going to let myself down that road of self-pity and self-doubt. I had to be stronger than that. The Universe was putting me through another trial and I had to come out of it not only unscathed but stronger.

The two quotes below that really touched my soul are below.

The first one:

*When you replace "Why is this happening to me?" with "What is this trying to teach me?", everything shifts.* The source for the quote is unknown.

The second one:
(As quoted by Jackson Kiddard)

*"Anything that annoys you is for teaching you patience. Anyone who abandons you is for teaching you how to stand up on your own two feet. Anything that angers you is for teaching you forgiveness and compassion. Anything that has power over you is for teaching you how to take your power back. Anything you hate is for teaching you unconditional love. Anything you fear is for teaching you courage to overcome your fear. Anything you can't control is for teaching you how to let go and trust the Universe."*

# chapter 33

L et me talk about my job change before I elaborate on my health and how I resisted being consumed by it. As I said earlier, I was excited to be in my third role where a tremendous amount of progress in cancer research and drug development was happening. But I was now convinced that I had to be in a job where I interacted with patients. I started to look for such opportunities. One such company that caught my attention was a top-notch lab that you would see in most of our counties where we go and give our blood samples.

In one of the Upanishads, ancient scriptures of India, there is a note that says: "Good practices, or Sadhana, and thoughts carry the seeker to his/her objective." I have time and again felt my work is my Sadhana. I indulge in work so sincerely, I am led towards my destiny gracefully. As if my hand is held by an angel who directs me toward the right path.

The same happened with my fourth role. I reached out to the medical director of the company via LinkedIn and expressed my interest in working for them. To my great surprise, the vice-president of the company called me almost immediately and, after a brief chat, he scheduled a job interview in an upscale restaurant—I liked his creative approach. As is my habit, I arrived at the destination early and, this time, an hour early. Even as I entered the mall, I was wondering if I was doing the right thing as my current job was good for me in every way. Was it right to quit the company because my priorities had changed? And, as you know by now, I have always interpreted signs from the Universe while making major decisions. This may sound a little trivial, but opposite

the restaurant we were to meet at, I found my favorite store, Charming Charlie's! I began to relax instantly. I was sure the Universe was telling me that this    quest was the right choice for me at that time.

Charming Charlie's is a store that sells girls' and women's fashion jewelry accessories. The entire store is beautifully decorated and it is all color coded and the store always fascinates me with ideas to enjoy life in your own unique ways with a dash of color. Most scientists you meet do not care too much about their attire and care much less about accessorizing themselves. But I am unique! I love jewellery, colorful clothes, and I am a great fan of pearls and white stones. Many of my friends call me "Blingy Kamala" and "Bubbly Kamala" for my smiles. Of course, I was also called "Crazy Kamala" for my philosophy and spirituality in science! I entered the shop determined to only window shop but ended up buying quite a few earrings. Since I still had more time on hand, I wore a pair of new earrings and went in for the interview feeling very pleased with myself!

The VP was at the restaurant waiting for me. Before starting the usual interview questions he asked me if I found the place of the interview all right. I laughed and explained to him my shopping spree at Charming Charlie's and even showed him the new earrings I was wearing. While in many countries, including India, talking about something so out of the way with your future employer might be frowned upon, it is not so in the US. People here assess you not just for your qualifications but also for the personality. After my animated description of Charming Charlie's, we laughed and he laughed. "You are a great business tycoon, Dr. Maddali! You have sold Charming Charlie's to me and I will recommend the place to the girls in my family and friends from a lifelong customer!"

With that, we started the interview. His first question was why I was changing my job since my prior company and the company I am interviewing were almost doing the same kind of work. I explained to him how my earlier company had zero patient-and-physician interaction while we worked on the most innovative and lifesaving drugs. Hence my quest for the new role to connect with the patients and understand the impact of healthcare innovation in the community. With my luck, he was an MD with an MBA. His journey was a bit similar to mine! He too was passionate about the healthcare sector helping patients and he was not the usual VP, being keen only on expanding business.

He was very open, too, in expressing how he felt. "I can see a leader in you, Dr. Maddali. I appreciate that, despite being at the business end of healthcare, you haven't lost your passion as a clinician and lifelong scientist as well as an avid learner." And he ended the interview saying I was hired and he would do everything in his capacity to help me at the company.

My fourth role was a diagnostics and clinical laboratory but they collaborated with hospitals and clinics across the globe. They offered testing in several health segments—cancer, neurological disorders including MS (my health battle), virology, immunology, and cardiovascular diseases to name a few. Out of 900 MDs who worked at this company, I was the only one with a veterinary background, linking scientific insights in the most creative manner into the human medicine world. People loved the new perspectives I was bringing in. It was a very healthy atmosphere where I was welcomed with open arms. I again played a dual role—I interacted with the research team about the available tests and trials and I conveyed the same to the clinics and physicians. It was the most satisfying experience to see the research reaching the patients indirectly through the physicians and hospitals. The

oncologists (cancer doctors) were very receptive when I talked to them about the better alternatives available from a testing perspective which would personalize better treatment options for cancer patients. The business expanded enormously, making the top management quite pleased with me.

At the same time, when I spoke to the researchers, I gave them news from the world of pharma and how their innovations were being developed. The research team loved hearing how their work impacted the end-users. All in all, I felt like an earth angel chosen to help the world I was a part of. I learned so much every day, I felt like the dedicated disciple Arjuna before his teacher, Drona. Here I was the disciple and the world was my teacher. I offered my gratitude to the Universe every single morning. I silently thanked every researcher, business head, and physician who interacted with me and taught me. And, most of all, the VP MD, I started calling him—who let me choose my work and layer it with my passion. He trusted me to do the right thing and never interfered with what I was doing. I was driven by my desire to make the world a better place and that very desire has always steered me to the right people and places.

Drug development is an elaborate process and business in healthcare. Only now, with the Covid vaccines making the headlines, people are realizing the enormous amount of research and trials that go on in developing a drug. But it is the same grueling process with every new test and drug. The sad part is only about a small percentage of the patients benefit from this. I had to change that. I had to make sure every patient had access to the right drug, right test, and right clinical trial.

# chapter 34

While my professional life thrived, my health kept deteriorating. My paralytic attacks were more frequent and my stride was unconfident. It was now five years since my first attack and no drug cured me. I hadn't slept properly for years now and I began to hallucinate, seeing ghoulish forces surround me. I was too scared to fall asleep because I imagined supernatural forces dragging me into a paralytic state. Most nights, I felt some unseen force lift me and leave me hanging in the air.

One such night, when I woke up sweat-drenched, an inner voice spoke to me or maybe I paid more attention to my inner feelings. Again, call it God or the Universe or my inner voice, but the message was clear: Wake up, Kamala. Your struggles are that of a seed trying to germinate. Rise above the mud and unfurl another petal. Fight until you are at peace with your pain and yourself.

When that vision passed, I was fully alert. I stayed up all night and the next several nights thinking about that voice and my condition that had debilitated me for years. The more I thought the more convinced that my neurological condition might be because of the stress; I had gone through being a warrior student, miscarriages, new mother, family life, homemaker and full-time career. The point here is not to point to any phase of my life but it is a reality in all our lives that we are running our bodies like machines and we do not take time to repair and recover. I was well aware of how the cells in our body need to be in a state of equilibrium, but I had gone and over-fired my neurons—and those specialized cells

of the nervous system and several types of cells in the immune system and various body parts like muscles, heart cells, etc., which control our day-to-day responses and reactions. True that I can't prove this theory medically but sometimes you just know what has caused your debacle. It is not as easy as a "cell in a petri dish" as discussed in my earlier chapters.

Once it was clear to me that the cause of my condition was extreme anguish, stress, and sadness, I decided to change that part about me. I began thinking about all the women out there especially, being a fascinating force of feminine power. If an educated and employed woman like me could be put through life stress, how about those less fortunate ones who do not have either the knowledge or infrastructure as Melinda Gates captured in her book? I had to help women with my knowledge. I wanted to shout to the world of women, asking them to take care of their minds, bodies, and emotions. I wanted to speak to every young girl and tell her how nothing in this world mattered other than empowering herself mentally, physically, and financially. But before I embarked on educating others, I had to test this knowledge on myself.

The author of the bestselling book, *You Can Heal Your Life*, Louise L. Hay reiterates the fact that we are all capable of healing ourselves. I will not elaborate on her teachings here, but the above-mentioned book is worth a read. Through her books, she teaches how to put together broken pieces of yourself and become whole again. Quoting her, "When we create peace and harmony and balance in our minds, we will find it in our lives." That was what I wanted to do. But I had to find a way to bring in an everlasting change in me, not a temporary fix. I could no longer trust medical science to heal me. I had to find my path to recovery.

If I was controlled by negative forces, be it stress or hallucination, I could neutralize them and eventually overpower

them by bringing in abundant positive energies, right? A simple law of nature! I methodically chalked out a spiritual solution to problems. I began to make a list of things that made me feel positive, in no particular order.

Power of Prayer or Meditation,
Power of Knowledge,
Power of Memories that made You and only You,
Power of Empathy,
Power of Gratitude,
Power of Forgiveness,
Power of making mistakes into blessings.

One of my many favorites, mantra/prayer—"Sarvesham Svastir Bhavatu (Peace/Shalom Mantra, India)."

An ancient Sanskrit prayer related to the biblical vision of shalom, beloved by Hindus including Gandhi and used by a few Christians. The source of the prayer is the Brihadaranyaka Upanishad, written about 700 BCE. Gandhi, father of India, led his people into freedom from colonialism at great cost—the Indian Independence Movement spanned ninety years. One of Gandhi's favorite song-prayers was this ancient Sanskrit text. It has been set to multiple musical forms, and I really liked the one sung by Tina Turner, who has been involved with Buddhism since 1971, in addition to the traditional way it is sung in India. A multicultural group of children repeat the lyrics back to her and the video absolutely touched my heart like a similar stage performance I directed in my second year at vet school with people from diverse groups. Every prayer might sound unique but the intentions matter the most like the one I was blessed with.

Sanskrit version:

Om Om Om

- Sarvesham Svastir Bhavatu
- Sarvesham Shantir Bhavatu
- Sarvesham Poornam Bhavatu
- Sarvesham Mangalam Bhavatu
- Om, Shanti, Shanti, Shanti

English translation:

- May there be happiness in all
- May there be peace in all
- May there be completeness in all
- May there be success in all
- Peace, peace, peace

Alternate translation:

- May good and well-being come to all
- May there be peace for all
- May all be perfected and made complete
- May there be success and prosperity for all

That was what I wanted and this is the prayer song of my purposeful journey in healthcare and might be what I am learning through my health battle as a rare-disease patient. This awakening of purpose through my prayer bloomed the petal of enlightenment.

The more I explored chanting and meditation, the more I was at peace. I was surprised why such teachings are lost on us and I grew up like most of us thinking prayer was for us only

and it seemed very self-centered. Why didn't anyone teach me to listen to the chants when I was agitated? Shanti/Peace Mantras like the above are designed to bring peace of mind and are a universal prayer for everyone and every being in the universe. I was amazed that I had the honor of learning this mantra and it is the mantra of my life!

In the middle of all this, my son was growing up filling me with such joy with his innocence and wisdom. I had a responsibility to protect and empower him too now. The more time I spent with him, the more at peace I was. We have so much to learn from children but we are always bent on teaching them. Their curiosity toward everything around them, their happiness and laughter, their meaningless, yet happy, pursuits, their energy—we adults have forgotten how lovely it is to be like a child! If you have a child, of any age, please drop everything and spend time with them—listening, laughing, and sharing their worldview!

The next bullet on my list was childhood memories. I had such a wonderful childhood. People liked me and vice versa. I had an urge to be a part of that world that I loved. I began searching for my friends online and called them. After the initial surprise, they were all equally happy to connect with me. One thing they all said was that I was always helpful and happy.

I connected with my school teachers who were so touched that I remembered them. I began speaking to my friends from college, my professors, my previous employers—there was a world out there that filled me with hope by viewing me as someone good-natured and intelligent. In the peak of my desperation, I had even begun to question if bad things happened to me because I was a bad person. Then I had consoled myself that I was an average human being—neither good nor bad. But now, listening to people from my part of

the world, I did not want to be average anymore. I wanted to be a good person like they remembered me.

# chapter 35

We are trained to believe that once you start your own family, self-care is not an option. It is even truer in case of Indian families living in India and outside of India; at least, for a part of the vocation. But I decided to break that norm as I needed to nurture my inner-self and visited my home towns Kurnool and Nellore. I wanted to visit my cousins, my friends scattered in different parts of Andhra Pradesh and took a trip alone.

My parents were of course ecstatic to have me all to themselves. The long lost relatives, friends, my uncles, aunts, and cousins—I was filled with joy every single day of my month-long visit. Surprisingly, I did not have any major attacks when I spent time with my joint family and my childhood friends. So, I did not want to alarm my parents with my condition but it made me think if I had such hidden stresses when I lived in the US that caused the attacks. Up till now, I don't have an answer for why, when I traveled alone, I had no major paralytic attacks except fatigue and all other signs. Did I feel free and were my old memories reactivating my happy genes? Did my mind decide when to behave and when to let go? But one thing was sure, I did feel rejuvenated and energized after this trip to India and visiting my hometown. This was my fifth year battling with my health condition and the message of self-nurturing and self-care is very pivotal for any of us. You are not being selfish with self-care, but you are rather being mindful of your body, mind, and soul.

When I came back from my trip, big news awaited me. My previous company and my current company were going

to merge. I was happy since I knew both the companies and loved working at both. But with mergers changes are inevitable. In this case, the change was, the merged company was not going to conduct blood cancer research anymore. That put a huge damper on my spirit. I wanted to learn more about solid tumors, Leukemia, and blood cancer—lymphoma. It was very heart-breaking having to give it up.

I still consoled myself that I had my role intact. In the newly merged company I did not have any physician interactions and insights into how the new tests helped impact patients. If you remember, I had left my earlier company to join this role because I wanted to interact with the physicians about innovation, especially in Cancer. However, the new merger formed a new company that does not have interactions with patients and also physicians who were ordering these tests. Also, the manager who became my mentor moved out of the company and I really missed his mentorship. In all these roles, I learned mentoring is a key aspect of professional development.

Coming back to my five-point process of healing, I became more observant of people around me. Nobody seemed to be even bothered with anything more than a paycheck and whoever I spoke to was burned out. I couldn't blame them either. For all the greatness America offers, life-style is unbearably capitalistic. Basic amenities of life such as healthcare and education have become too premium. This, in turn, is driving people to work mad hours and forget why they even chose that particular career.

Thankfully, I never got sucked into that race. Yes, a good paycheck is important but more important to me was the impact of my work. This gave me the strength to work despite my worsening health. I also became more spiritual and consciously empathetic. Two items on my list were to

empower and help people. The simplest way to help others was to serve them. There is a phrase in Sanskrit that says: Manava Seva Madhava Seva. When you serve people, you serve God.

I began to volunteer at a soup kitchen regularly. Many times we feel philanthropy is doing something big but it is very simple. When you smile at someone genuinely or listen patiently or offer a word of advice, that is philanthropy too. In the soup kitchen, my heart went out to those poor. I made it a point to smile at everyone I served. One of the gentlemen who visited the kitchen everyday looked especially morose to me. I said to him after a couple of weeks to enjoy his food and not be sad at least while eating. I don't know what his story was—he showed up at the kitchen in a worn-out suit and looked like a man once well off.

Taken aback at my words, he paused for a moment. Then he smiled. "Nobody has served me with a smile. Thank you for showing me that there is still kindness in this world." He actually called me "Kind Kamala".

There was another homeless person who looked like Shirdi Sai Baba, one of the gurus I pray to from India. He had a powerful aura around him. At the end of my shift, I stopped by him. "You look like a saint," I told him hesitantly, in case I offended him unintentionally. "You have a divine glow in you."

To my surprise, he smiled very benevolently. "You too have a divine glow, Miss. You have always had it, and remember not to lose it. Have a wonderful life."

It was my turn to be surprised. What did he mean by that? I had heard many stories where my mother Sita used to read out loud about Sai Baba appearing before you at times of the right transformation. In fact, after that meeting, I never met that gentleman in the kitchen again. But his words made me think. Since ninth grade, I was a devotee of Shirdi Baba. Had

he appeared before me to convey a message? Did I have a positive glow about me before? Then, random memories began to flood me. In Tirupati where I studied, a homeless man, who looked extraordinary, sought me out to ask for alms. They demanded a large number too. And despite my friends objecting, I would give the beggars whatever sum they asked. They were not ordinary looking people. They were Sadhus or holy men who indulged in meditation. I felt privileged when they approached me to ask for alms. They would refuse alms from many. They sought people and any temple I went to, at least one Sadhu would seek my help.

In February of 1959, Martin Luther King, Jr. embarked on his pilgrimage to India, a journey that proved to become a momentous turning point for the charismatic leader amid the uproar of the civil rights movement. During King's first press conference in New Delhi, he shared his enthusiasm to embark upon his pilgrimage: "To other countries I may go as a tourist, but to India I come as a pilgrim." My experience in the USA with this episode, I was serving in a foodbank and I ran into a saintly personality, it made me feel I am a pilgrim in America.

Also, despite my glasses and rather unattractive looks, people have liked me since my childhood. One thing, I was called "Kala-Nayak," meaning "Black Leader," by few in my early childhood education because I was dark-skinned and was the school leader. My leadership skills for standing up for a good change made me referred to as "Khalnayak, a gang leader," which is a reference to a famous movie released in the 1990s. But it was all in good jest. Was I born with something positive and do I need to harness that power that is inside me? I take all these experiences as magical and contributing to the blooming petal of transformation in my Kamala.

# WHAT IS LIFE?

What is life without freedom?
Not the freedom of the ego to get what it wants
But the freedom of the heart to go on loving
In spite of fears and vulnerabilities
What is life without courage?
Not the courage to scream obscenities
But the courage to uplift and unite
In spite of divisiveness
What is life without creativity?
Not the creativity that lends itself to fantasy
But the ability to see and realize a better moment
For every one of us
What is life without peace?
Not the peace of hiding away avoiding confrontation
But the peace that comes with the realization
That all souls are truly sacred
What is life without dignity?
Not the dignity that is actually egoistic embellishment
But the dignity that comes from practicing virtues
That begin in non-harming and end in love
What is life without unity?
Not the unity that is an empty word only
But the unity that is found in knowing
There are threads of consciousness binding us together
    purposefully
What is life without love?
Not the love that possesses, exploits and demands
But the love that prompts sincere joy and appreciation
Each and every time a soul awakens to the truth of
    the Self

And suffering of all beings has been reduced
These are the birthright of every living being
Freedom, courage, creativity, peace, dignity, unity,
    and love
Journey toward them and your heart will heal
Walk away from them and your suffering deepens
It is your choice and your choice alone
It is your responsibility to be the person
Your heart calls you to be
Lokah Samastah Sukhino Bhavantu
May all the beings of the world be truly happy.
Om Shanti Shanti Shanti

~ Swamini Shraddhananda Saraswati

# chapter 36

As I began to consciously live a positive life, I began to see a change in people toward me, that included total strangers! People began to confide their problems in me and many said just talking to me gave them solace. I still remember this. Once in an airport, a man walked up to me and looked at me intently. I asked him if he needed anything.

"Can I speak to you for a few minutes?" He asked me. "Your energy is calling me." And I had a spark of a fear for a second but was conscious of the fact that I was in an airport, if I needed any help. But, my heart had a pious feeling while my mind was in a moment of caution.

I was almost spooked! What is this energy I am harnessing? But I smiled at him and agreed. He did not say anything abnormal. He simply chatted for a few minutes and left.

My long lost friends contacted me to chat with me. Every conversation ended with them thanking me, "I feel so much better after talking to you, Kamala," or "I was feeling almost depressed but your energy is so contagious." Or something to that effect.

I was sure I was absorbing positive energy from my changed thoughts and deeds. I felt I had to distribute my positive energy. I continued to volunteer at the soup kitchen. Alongside that, I began to donate to charities generously. Though I began this exercise in positivity to improve my health, at one point I was transformed. I was no longer fixated only on my pains. One day, when I lay paralyzed, instead of panicking, I spoke to my pain! "To heck with you, pain. Bring on as much pain as you want. I will only emerge stronger." Or

do we have an understanding that "I am not with you, but you are with me, the mighty Kamala"?

I understood it is more important to heal your mind. Then the body would automatically obey. I remembered an article about the yesteryear saint, Sri Ramana Maharshi. When he was on his deathbed suffering from cancer, he cried with pain. But he would tell his disciples that the pain was confined to his body, not to his soul. He continued to meditate and talk. I wanted to be like him. Endure the pain without letting it affect me. This attitude toward pain in several neurological conditions like mine, including ALS, is very important as pain cannot be always seen. From then on, whenever I was immobilized, I prayed to greater gods, forces, memories, etc. The Indian scriptures do say quietude and stillness is Shiva, the masculine version of the Universe, and motion is Shakthi, the feminine version of the Universe. What better opportunity than when I lay paralyzed to pray to the Universe as Shiva or Shakti. I would recommend anyone in such battles to pray to whomever you have faith in, let it be a person or thing or an intention you believe in, if not God or Universe or magical forces. Because prayers or positive intentions infuse "hope into your DNA of the soul" of course as told by "Scientist Kamala," that is me.

I have already spoken about how it was very important for me to be in a job that impacted society than a mere paycheck. On the count, my days at the newly merged company had to come to an end. I wanted to further my research on cancer and interact with end-users. An opportunity to make this a reality presented itself when I was an invited speaker at a seminar in Germany. It was March 2015. At the conference, I met a gentleman named Mr. S who was the CEO of an organization that focused on cancer testing. The very name of the company drew me to him and I chose to not disclose

any company names or real people names for a good reason to respect their privacy.

They are the top ten in the US for cancer testing, a business where interactions happened with both pharma companies and patients. That checked my first box for a job! And, their research was on solid tumors and blood cancer. They had their IP or Intellectual Property. In the pharma industry, IP is a highly valued resource. When a company owns the IP, they are free to custom develop tests. In other words, they can develop tests and sell them as products to the healthcare industry. Most importantly it was a highly entrepreneurial organization, though it was a mid-size company. This is my first role working for a non-fortune 100 company.

I was developing so much business acumen in all my industry roles, without a formal MBA, my role had groomed me to be a business and corporate leader. I had innumerable mentors within the company and outside. What everyone appreciated about me was how obsessively I thought about the impact of my job and also the fact that I was a collaborator. During an informal conversation with the CEO in Germany, I expressed my interest in knowing more about the company.

Mr. S immediately invited me to visit him at his New Jersey office. What happened after that visit was pure magic. The position I was offered was everything I wanted in my job, so I took it up immediately. The company was a leader in drug discovery, precision medicine (customized treatment for patients), and clinical oncology (non-surgical treatment of cancer such as radiotherapy). I was the Vice President of Strategic Collaborations. Apologies if this chapter is turning into a crash-course in medical terms but I will try my best to explain every term as clearly as I can.

Mr. S impressed me in the interview when he recommended to me that I should read *The Emperor of All Maladies:*

*A Biography of Cancer*, a book written by Dr. Siddhartha Mukherjee, an Indian-born American physician and oncologist. It was published on November 16, 2010, and it won the 2011 Pulitzer Prize for General Non-Fiction; the jury called it "an elegant inquiry, at once clinical and personal," based on web resources. The Guardian wrote that "Mukherjee manages to convey not only a forensically precise picture of what he sees, but a shiver too, of what he feels." It touched my soul and my observations as a spiritualist in the field of science. I am not wrong to be a "Dalai Lama in Healthcare".

# chapter 37

My travel has been so extensive since 2015 with my new role, I was out of town, at least, eight out of twelve months, which I never expected would be so overwhelming. This lasted for four years, between 2015 and 2019, when I traveled all over the world, including India, Israel, Paris, Spain, Germany, Finland, Canada, etc. In the first year, the travel excited me, exhilarated me, and energized me. I loved meeting people passionate about healthcare and visiting top-notch research organizations in India as well, including "AIIMS-All India Institutes of Medical Sciences," a dream institution for every MD in India. This was a moment of celebration for me as a Veterinary clinician from India and, if you recall my passion, setting up my unique birthmark into the hearts of patients. I was a non-MD in the MD world talking about cutting edge research in cancer with the cutting-edge innovation from the USA.

As I mentioned before, my health deteriorated while I was home but, somehow, my mind and body cooperated while I was away from home. I missed spending time with my son and my better half. Despite the understanding and cooperation from my family, I felt guilty that I was not able to dedicate enough much time to my family. Then I consoled and empowered myself—I am not just a mother and wife. I am also myself. Most importantly, If this job made me feel good as a patient, and also helped many other lives, then I should do so. Guilt is an emotion that sucks the soul, especially of working mothers. The faster you learn to do away with it, the better off you are. Every human being has the right to

their happiness and to pursue their dreams. You will learn new skills and as I said, being a homemaker on top of a job is like getting a PhD in life and we all will learn in our unique ways to strike the balance with its own ups and downs, like seasons of mother nature.

As Winston Churchill quotes, "Success is going from failure to failure without losing enthusiasm."

But by the end of the second year at the new cancer testing company in 2016, I started to feel a burn-out. The travel especially began to get to me. On the work front too, though I was interacting with physicians, I was not talking to patients and understanding the impact of cancer testing, treatment advancements at an individual level. A personal experience in my family has deep rooted my commitment to become a lifelong torchbearer for patient education in addition to my battle as a MS patient. My dad's youngest brother, Sridhar, the uncle who was the most curious about science and innovation and never pursued a formal medical degree, was an inspiration for me in learning. His wife, Latha, my last youngest aunt, was diagnosed with lung cancer in 2014 and it was all so fast that she passed away at the young age of forty-four in 2015. I personally paid a lot of attention to her situation and even sent her samples for any relevant genes and personalized treatment. But, the Universe has taken her soul to the greater skies. I promised to my soul that my learning and dedication to cancer and any health condition will never vanish until my last breath. Also, my commitment to empower communities with education about science and innovation is a "power of hope" to help any person/family/patient in need.

I started interacting with several patient-focused organizations referred to as "patient advocacy organizations". Because every company I was a part of or interacted with was a great innovator, but, honestly, they did not implement ways

to connect with the patient. I also think every employee in healthcare should dedicate a fraction of their time to education of the community about healthcare. This is something I would love to see: "Philanthropy as a community responsibility." It can be on various topics related to health from simple topics, like eating and thinking right, to more complex topics related to genomics. But, that is the true value of higher education in my view, we have to empower communities with education and sow the seeds of knowledge and build the right characters of understanding health.

I started giving several industry invited talks on this aspect and started connecting on Facebook with a few patient-focused organizations. As you might have experienced, life experience is all about good intentions and learning from tough experiences to transform and heal into the best version of yourself. I suddenly got engaged by a patient advocacy group's CEO, an inspiring individual in their seventies, a colon cancer survivor who established an online community of 8000-plus colon cancer patients.

It was a true calling from the Universe to be a torchbearer from the innovation industry to connect directly with patients. My CEO was all for it and he gave me the best freedom and said, "Kamala, you are a butterfly and your destiny is transformation and you are a leader in transformative empowerment." Patient advocacy groups are NGOs that connect patients with healthcare professionals for a particular disorder. This is what I wanted. This time around, I only sent out my thoughts to the Universe and the opportunity came knocking.

According to Upanishads, purity of thoughts (thoughts that are ethical, moral, and selfless) connects one to the Brahman, the supreme human mimicking the greater forces of the universe in simple terms. I started engaging patients in scientific conferences, panel discussions and it was exactly the

sort of collaboration I wanted to see, feel, and contribute to in the path to empowering communities with knowledge. I was in the news for bringing this transformation of "collaborating patient voice into the scientific community". I received a few opportunities to serve on the boards of cancer patient advocacies based in the USA and India. It was a calling to serve on these boards and bring my philanthropic thinking into action. My CEO encouraged me that the community needs a visionary humanitarian driven by science and spirituality like me and no one is better than a woman leader. He empowered me to the core of my soul's heart. I felt so very blessed for a mentor like him who understood me more than I did myself. One board led to another and soon I was serving on several patient advocacy groups. It had an immense healing effect on me. Till then, however much I consoled myself, I used to feel helpless with my health condition. The fact that there was no medical cure for me used to bog me down. But then, being with cancer patients at all levels gave me hope that someday there might be good hope for my condition. The board consisted of not only doctors and researchers but also many cancer survivors. It was a holistic atmosphere where I was helping patients directly by bringing in thought leaders from the industry. I was already involved in philanthropic activities but now I was contributing my knowledge to society. I felt my education and employment were put to use for a worthy cause that was beyond me.

Helping others is highly empowering. My humble suggestion to everyone is to get involved in some cause if time permits. The advocacy roles complemented the stress and burnout I was feeling at. Don't get me wrong. My job was extremely fulfilling but also stressful. Any commercial venture comes with its stresses. But philanthropic empowerment helped me cope. Being with people who were working selflessly towards

the betterment of suffering patients was highly motivating. Also, most of these NGOs were founded by women that inspired me more.

A true moment of triumph when I was awarded a "Healthcare Hero award," in 2017, by NJBIZ, a NJ based organization, for my individual humanitarian efforts in leveraging innovation knowledge about healthcare advancements from women empowerment to patient empowerment. It was not about the award but more about the positive impact that I could feel in that situation—empowerment is a key responsibility for all of us. This was a sign to continue my lifelong mission of being there for patients as a fellow patient and educator, empowering and enlightening humanity.

Inspired by mentors in my life since my childhood and my self-mentoring personality, I decided to launch an organization or affiliate with a women-focused organization that empowers other women and girls in life sciences. The founders wanted to provide a forum for women to come together to celebrate and support each other's success, and in doing so created a dynamic and invaluable forum for the local community. That vision has now become a reality, as they launched twelve chapters throughout North America, led by more than 225 volunteers and a membership base of over 2,600. Thousands of women attend their local events each year, and continue to grow the organization through their ideas, activities, and donations. But, I noticed there was no chapter for the Philadelphia area and I helped co-launch the chapter in 2016. I co-launched the new chapter with another stellar African-American healthcare leader from the pharmaceutical industry.

"Women helping women" is one of the most important features of the organization. I really liked the way we all together could promote inclusion and diversity empowerment strategies across the life sciences field and initiated several

women-to-women mentorships and leadership support through all stages of career development

- from bench to boardroom
- from academia to industry
- from first job to last
- from idea to entrepreneur

A moment of triumph came when Women in Bio, the non-profit, was invited by "NYSE—New York Stock Exchange," in January 2017, for our stellar leadership efforts in the community for empowering women into leadership roles. We all went as a group representing several chapter chairs and co-chairs; with me as the co-chair of the Philadelphia chapter. We were invited to the NYSE closing bell ceremony by the second female president of the NYSE, but the first to hold full leadership of the exchange. Thanks to its founders and past presidents, WIB has become a community that represents one of the fastest growing and most influential organizations for women in life sciences. This experience with patient empowerment, women empowerment, and human empowerment has bloomed several avatars of empowerment petals in my lotus.

My life mission is now to empower people to be in charge of their own health through education, engagement, and support. It is truly wonderful that through this transformative empowerment I could build a community free from judgment that focuses on humanity and the value each person brings. As my dear friend, patient advocate and entrepreneur Dave Fuehrer, a two-time cancer survivor and CEO of Gryt Health, says our mission is to improve quality of life and increase survival for people facing cancer through the relentless focus on patient experience. We have to put patients first and work with healthcare organizations that do the same. We

have to use the patient voice to enhance drug development and access; together, this is the way we truly can help to move healthcare forward.

Today, genomics is helping solve some of the most challenging problems of humankind and inspiring new hope for people around the world. But according to a new survey, more than half (54 percent) of Americans say they are unfamiliar with the term "genomics" and more than one-third (38 percent) of adults report that they do not know what the genome is. The statistics come from a recent survey of 1,004 people, conducted by Atomik Research, and reveal that 54 percent of adults are unfamiliar with the benefits of genomic testing. While the benefits of genomics are still in their infancy, we are seeing incredible cases where genomic testing gives hope to patients around the world, especially in the case of the 350 million people worldwide, many of whom are children, suffering from rare and undiagnosed genetic diseases. This has very personally empowered my health too that the future has hope, which is a true medication for the soul's heart.

# chapter 38

In the meantime, my health deteriorated further. I had symptoms from many neurological disorders, yet my specific condition was undiagnosed. Like in ALS, I began having difficulty walking and felt as though I could trip and fall down any moment. By about mid-2019, I began using a walking stick periodically to keep from falling. It was the same thing with my hands. Especially after I regained movement after a paralytic attack, it started to take me longer and longer to get back to even my daily chores. My son would get very scared when his energetic mother suddenly became immobile. I explained to him my condition and assured him, "You are Simba, the cub of the Mighty Lioness, Kamala."

*Let me take a moment here to tell you the story that I told my son. There is an African proverb, "Until the Lion tells his side of the story, the tale of the hunt will always glorify the hunter." There are many variations of this proverb. Other versions say, "Until lions have their own storytellers, hunters will always be the hero in their story," and "Until the lion learns to speak, the tales of the hunt will always favor the hunter." But they mean the same thing in essence. It is not that hunters kill lions in Africa. No, they don't! The background here is that often when hunters return from hunting, they would tell great stories to emphasize their achievements and hunting skills.*

*The lion in this case is Kamala, the "Kamallion," I said and he giggled with his cute Mickey Mouse face when he was six. The hunter is my health condition. But, what*

*the hunter does not know is that in my case there is a goddess Durga, also known as Shakti or Devi, the protective mother of the universe's energy within me. She is one of the faith's most popular deities, a protector of all that is good and harmonious in the world. Sitting astride a lion or tiger, the multi-limbed Durga battles the forces of evil in the world. This divine force within me that will not give up the battle easily to the hunter disease.*

*He also adorably stated, "No wonder you like lions and tigers as your teddy bears in addition to Mickey Mouse." I gifted my little man a baby cub, which is my university mascot coincidentally called, "Bengal Tigers."*

*In Hindu art and iconography, Durga or Shakti is frequently depicted standing atop or riding a tiger or lion, which represents power, will, and determination. In riding this fearsome beast, Durga symbolizes her mastery over all these qualities. Her bold pose is called Abhay Mudra, which means "freedom from fear." Just as the mother goddess confronts evil without fear, Hindu scripture teaches, so can any being faithfully conduct themselves in a righteous, courageous way. What's interesting is, there is a lotus in Durga's hand, not yet fully in bloom, representing the certainty of success but not finality. The lotus in Sanskrit is called Kamala/Kamal/Pankaj, which means "born of mud," reminding the faithful to stay true to their spiritual quest amid the worldly mud of lust and greed.*

As a "Kamallion (Mighty Lion with the power of mighty Goddess Durga holding Kamala in her hand)" narrated above to my little guy I carry the spirit and faith of a lion and Durga. I refuse to succumb to the deteriorating health condition which is now mimicking Parkinson's disease like signs including cerebellar ataxia, a degenerative disease of the

nervous system. Many symptoms of ataxia mimic those of being drunk, such as slurred speech, stumbling, falling, and incoordination. These symptoms are caused by damage to the cerebellum, the part of the brain that is responsible for coordinating movement. People affected by ataxia may experience problems with using their fingers and hands, arms, legs, walking, speaking, or moving their eyes. In addition to the following latest trends in science and innovation for my health condition, I crafted a healing protocol by blooming the following petals for my health condition.

- Spiritual Empowerment: I practiced more spirituality, both religious and philanthropic as I mentioned through various sections of the book. I organized a group of lions I call them and who were interested in reciting a powerful chant like the peace mantra I shared above. Reciting it with a group of like-minded people healed my soul.
- Scientific Knowledge Empowerment: I am on a path as a patient student to learn lifelong and understand the definition of health from a physical, physiological, mental, emotional, and spiritual point of view. Please note this is for my personal health condition guidance only and not meant to be a protocol that I am recommending to anyone. *Please consult with your medical professional for any guidance with Ayurveda or any other healthcare related topics. This is more of my journey to inspire any reader that might deem it helpful.*

*"The Doctor of the future will give No Medicine, but will interest his patients in the care of the human frame, in diet, and in the cause and prevention of disease."* —Attributed to Thomas Alva Edison

Ayurveda is an ancient and an antique healing art with origins from India. The term Ayurveda is derived from the Sanskrit words ayur (life) and veda (science or knowledge). Thus, Ayurveda translates to knowledge of life. Based on the idea that disease is due to an imbalance or stress in a person's consciousness, Ayurveda encourages certain lifestyle interventions and natural therapies to regain a balance between the body, mind, spirit, and the environment.

Charak Samhita, which dates back to approximately 800 BCE, is a major compendium of Ayurvedic medical theory and practice that Charaka, an internist at the University of Taxila, compiled in Sanskrit. Modern Ayurvedic physicians still use Samhita in their medical training, and the text has been widely translated.

The most widely recommended modern translation is one by Dr. P.V. Sharma, which contains extensive appendices and a rich index.

Another ancient resource is the Sushruta Samhita book by Sushruta. This surgical text, which dates back to approximately 700 BCE, contains pioneering techniques in skin grafting and reconstructive surgery.

I started building a small worldwide network of Ayurvedic experts including an international Ayurvedic expert right in the USA with over thirty-three years of experience including Ayurveda studying and teaching worldwide, since 1982, and has traveled extensively

throughout the world to develop and teach courses. The goal is to learn, educate, mentor, and empower yourself in your personal journey, especially as in my case, where my diagnosis of the condition itself is uncertain.

It is encouraging to see the World Health Organization has launched its Traditional Medicine Strategy 2014-23. According to the WHO 2019 report, traditional and complementary medicine (T&CM) is an important and often underestimated health resource with many applications, especially in the prevention and management of lifestyle-related chronic diseases, and in meeting the health needs of aging populations. With this report, WHO has taken a further step toward an increased understanding of the T&CM landscape at global and national levels. WHO remains committed to supporting Member States in developing proactive policies and implementing action plans that will strengthen the role T&CM plays in keeping populations healthy.

Hippocrates, the famous Greek physician of the fifth-century BC, mentioned in his book, *Ancient Medicine*, that a "full discovery will be made, if the inquirer be competent, conduct his researches with knowledge of the discoveries already made, and make them his starting-point; but anyone who, casting aside and rejecting all these means, attempts to conduct research in any other way or after another fashion, and asserts that he has found out anything, is and has been, the victim of deception." —*Ancient Medicine 1.26.*

This clear universal instruction by Hippocrates is calling on us to collaborate ancient medicine advancements with modern medicine. We just cannot neglect

what is already known about human health and uncovering areas that need further exploration. Modern scientists agree that failure to review pre-existing data can have negative consequences, sometimes fatal.

We know this famous idiom, "I have a gut feeling," or there are several quotes using gut feeling and instincts. Coincidentally, an article published just today, February 3, 2020, in Nature titled, "How gut microbes could drive brain disorders," mentions scientists are starting to work out how the gut microbiome can affect brain health. That might lead to better and innovative treatments for brain diseases. Hence, the scientist in me is never going to lose hope about the power of science and innovation to empower the patient which is me in this case and you if you happen to be or a caregiver for a friend or family. We are at the most transformative time to redefine health by our ancient insights with a modern day eagle's eye approach—Artificial Intelligence is making strides into this understanding of health and wellness.

Education Empowerment: Dr. Seuss once wrote, "The more that you read, the more things you will know. The more that you learn, the more places you'll go." Diving into a good book opens up a whole world of knowledge, starting from a very young age. Studies show stronger early reading skills may mean higher intelligence later in life. When we talk about healthy habits and self-empowerment, reading books is a must.

o *I was blessed right around my fortieth birthday that my doctor uncle, Dr. Venkat Rao, who is my paternal uncle and my Dr. Seuss in real life, gifted me with a life changing book written by Dr. Eben Alexander,* The Proof

of Heaven, *the #1 New York Times bestselling account of a neurosurgeon's own near-death experience—for readers of 7* Lessons from Heaven. *Thousands of people have had near-death experiences, but scientists have argued that they are impossible. Dr. Eben Alexander was one of those scientists and a highly trained neurosurgeon. Alexander knew that near-death experiences feel real, but are simply fantasies produced by brains under extreme stress. Then, Dr. Alexander's own brain was attacked by a rare illness. The part of the brain that controls thought and emotion—and in essence makes us human—shut down completely. For seven days he lay in a coma. Then, as his doctors considered stopping treatment, Alexander's eyes popped open. He had come back. Alexander's recovery is a medical miracle. But the real miracle of his story lies elsewhere. While his body lay in coma, Alexander journeyed beyond this world and encountered an angelic being who guided him into the deepest realms of super-physical existence. There he met, and spoke with, the Divine source of the Universe itself.*

o *Another book gifted to me by a famous oncologist and humanitarian mentor, Dr. Kashyap Patel, is* The Brain That Changes Itself, *by Dr Norman Doidge, introduces readers to neuroplasticity—the brain's ability to change its own structure and function in response to activity and mental experience. His revolutionary new book shows how the amazing process of neuroplastic healing really works.*

*One of my simple goals is to open a "Health Library" in my hometown in India and build "Power Walls of Health Knowledge in the USA" to allow people to gain knowledge and build the best perceptions about life and health.*

*If a good intention is given to the Universe, then some day, some miracle will happen! So build your petals of imagination filled with creativity and good intentions.*

- Personality Empowerment: Now, every morning I also mentally offer the golden intention "gratitude" to everyone and everything I can think of. Practicing gratitude helps one stay grounded and not take life for granted. When we feel grateful for what we have, we also feel an urge to give it back. In Hinduism, gratitude and appreciation play a major part. I grew up with the scriptural phrases—Matru Devobhava, Pritru Devobhava, Atithi Devobhava, and Acharya Devobhava. It means you must treat your mother, father, guest, and teacher as gods. What better way to express gratitude to someone other than elevating them to the status of god. Whatever I recited as a child, in school prayers as well as at home, now showed me the immense power they held. Anyways, I am a "Kamallion" now battling the hunter disease with courage, valor, and faith.

Coming back to my career, my fifth job was connecting me to the entire ecosystem of healthcare. Yet, I was not happy that advancements were not reaching out to as many people as it needed to and I wanted to validate this theory in my mind by real-life patient engagement. When I was in a conference around that time, in 2017, I noticed that there was no patient participation. All of us speakers were from varied healthcare segments and experts in our domain but we were only talking to peers, doctors, innovation, labs, pharma companies, IT sector, etc. I immediately started calling a few of my patient advocacy CEO friends and started inviting them to scientific

conferences. One of the patient advocacy CEOs, Ms. Erika was overwhelmed. "God bless you, Kamala. You are giving us such a unique energy which is bringing patients unique opportunities in life. To listen to the pioneers in the health-care industry and let the industry experts hear the patients' voices."

I was equally thrilled when she brought ten people including patients, survivors, caregivers, etc. I learned that their voices, perspectives, and experiences truly showcased the real-life impact of several treatments, tests, and trials. But, also it showcased several pain points and challenges that need to be addressed. Since a couple years ago, industry has been changing into the similar thinking I had in my little world and it is great to be inspired by like-minded people, compa-nies, and initiatives.

But only ten out of millions of patients could attend the conference; my universal mind was pondering. How do we take these conferences to people?

I am someone enamored by technology. I was in awe of my soda glasses that enabled me to see. Today, I am equally in awe of my beautiful, powered sunglasses by Vogue and DKNY, which I rewarded myself for my hard work and dedi-cation of course. Even a thermometer amazes me for it does. So it is not surprising that I soon found a technology-based solution to bridge the patient-innovation gap. One evening, as I was browsing through my Facebook, a long lost friend of mine from school, Vijaya Vani, appeared on my feed. Facebook suggested that I connect with her. I was dumb-founded. What kind of software do they have that is matching me with my friend from two decades earlier. Then every-thing about the Internet began to appear magical—Google suggested restaurants near me that served the cuisines I liked. Twitter and LinkedIn suggested people and articles that could

be of interest to me. Spotify introduced me to new singers I liked and Kindle to books I loved. And most often they were correct! Why not use this same technology to empower patients looking for information about their ailments?

I started reading up furiously. The more I read, the fascinating world of Artificial Intelligence opened up before me. AI was everywhere! From smartphones to robotic vacuum cleaners to driverless cars. Though I did not understand all the technical jargon, I understood there were several different AI solutions to match people with what they are looking for.

# chapter 39

Simply put, Machine Learning, ML, is a subset of AI that uses the available data to learn rather than being programmed. For machine learning to work, people should be willing to share information. However, the further I read, it became apparent to me that ML is still in its incipient stages when it comes to healthcare. This is largely because healthcare is a highly regulated industry. There are stringent guidelines that drive the industry and also there is always the lurking fear of a lawsuit for technical innovators.

Patients share their information in a privacy protected environment. On such platforms, patients can interact with and educate each other. When I started looking on LinkedIn for anyone providing such a platform, I stumbled upon one organization called Grit. The organization worked toward a cause that was dear to me—connecting patients with treatments. The company is run by cancer patients, survivors, and caregivers. It has an app that provides private groups where caregivers are provided counseling and patients can discuss with other patients the illness and cures. They do the wonderful job of connecting cancer patients and survivors.

I contacted Dave, the founder and CEO, and expressed my interest in collaborating with him. Dave is a two-time cancer survivor. He and I understood each other, both having experienced grave ailments. Pain understands pain and empathy builds strong and meaningful relationships. That was how Dave and I bonded.

It was my first time working with medical technology, and needless to say, I was highly excited. In one of our conversations

I asked if patients are up to date with trials and treatments. He simply shook his head and said it was nowhere near where it should be. There you go, the transformative collaboration started and I joined as an "Advisory Board member" to bring the change I wanted to see. My CEO, Mr. Super, applauded me for my vision and always mentored me on women, human, and patient empowerment. I sometimes think it is a male version of me talking to me as that is how collaborative our mindsets were.

A business that is run compassionately thrives. An important concept in Hinduism is Dharma, which roughly translates to principled living. When an organization is run in Dharmic ways, profitability follows automatically. With the mentorship and leadership of Mr. Super, that was what I was doing. Alongside my job, I was working for causes that were larger than the organization.

Around July 2019, my health started declining and the cancer testing company went through organization-wide changes. Since the company with the new changes could not afford to keep all of its top management, it gave me a chance to step down with a good severance package. For the first time in years, I felt good with this change and I wasn't scared anymore of not being left with a job; I am on a path to transformation. Career is not just a job but a commitment to my dharma or values as a human, patient, woman, and scientist. I had just turned forty and it felt like the right time to take a mindful sabbatical. I took a two-month healing sabbatical after 60-70-hour work weeks for the previous four years. I encourage anyone regardless of age or sex to take a mindful sabattical as it is a mental and emotional wellness strategy. A spa retreat for your mind, body, and soul for two months!

I established my advisory company called Health Collaborations. I have made it my life's mission to drive

transformational change in healthcare bringing cutting edge
research to organizations and individuals. I continue to serve
in several advisory roles that are non-profits focused on
patient education in cancer and neurodegenerative disorders.
A quarter of my work is non-profit and empowering commu-
nities as a "Healthcare and patient champion."

I was in a life-altering paralytic attack a year ago, just
before my birthday dinner. My parents were devastated at
seeing their own daughter in such a condition, right in front
of their eyes. The episode started off dramatic. Before heading
out for my birthday dinner, I was talking to my mom and had
a terrible attack, which was one of the worst in the last twelve
months. I was paralyzed in bed for more than six hours with
my eyes shut, and my voice stopped functioning. Despite the
fact that I could barely communicate with my right thumb,
they knew that I was listening. Over a year has passed since my
parents left for India and I eagerly await to hug them again.
Since they left, I have been experiencing episodic ataxia, and
a few signs to share:

- Unsteady walk and a tendency to trip or stumble
- Change in speech, including slurring, weak voice,
  and loss of voice in episodes lasting many minutes to
  several hours
- Poor coordination and extreme fatigue
- Severe neuropathic pain makes it impossible to always
  see
- Difficulty picking up objects, eating, or doing activi-
  ties that require fine-motor skills
- Fast back-and-forth eye movements
- Trouble swallowing, loss of taste
- Stiffness and Paralytic attacks in the face, neck, arms,
  legs, or whole body from a few minutes to hours

A lot of the things going on in my body are silent monsters hidden underneath me. Friends and family can sometimes fail to recognize my health problems because they cannot see certain signs.

My son, Venky, who has been witness to me fighting this disease since he was three, deserves the credit for bringing comic relief to my battle. He would laugh innocently when I used to get twitches in my face and body, thinking I was playing a comical role. "When you smile, Mummy, you are like Mickey Mouse, the cartoon you love and if you are making these funny faces, you must be Donald Duck." Growing up, those were my favorite cartoon buddies. When I was a kid, I sketched them a lot. Even now, when I suffer from spasms and twitches, I still recall these characters, which makes kids smile and gives me joy as I cope with pain.

I imagine Harry Potter's powers within me due to my latest signs, which present themselves many times since the past two years; which compel me to use a walking stick. My son thinks I have a Harry Potter magic wand as I play with the cane a lot and use it like a wand.

Whenever I walk, I chant the most powerful spell from the Harry Potter series, Expecto Patronum. My son, Venky, who is about to turn twelve, is consistently surprised whenever I express my gratitude for my battles in life.

In JK Rowling's fantasy fiction series, I read about the significance of this powerful spell. With all its power, the Patronus charm is also deeply personal to you. Your Patronus is unique to you and you conjure it by focusing on the most happy memories of your life. When fully formed, a Patronus takes the form of an animal or magical creature and serves as a protection shield against dark magic, specifically Dementors as depicted in the movies. It is a tough spell to master, but

because it is so powerful, it comes from a place of joy and love, much like Rowling's message.

I tell my son, in my imaginary creatures, the animals I select are my favorites like elephants, eagles, horses, peacocks, hawks, hummingbirds, and butterflies. These animals each have a different spiritual significance across eastern and western cultures, given their specific physical characteristics.

My son inspires me to seek out more legendary characters or fictional characters. I believe it is crucial that we stop perpetuating illusions and attitudes about people with disabilities, especially coming from a community that hasn't been so open-minded about such situations. The marginalization of the disabled is common in the developing world. Sometimes, we hear people talk about treating persons with disabilities as if they weren't even real. This is a compassionate gesture because I grew up as a visually handicapped child and also appreciate the challenges of many rare diseases in modern times and chronic diseases that creep in. To build empathy and confidence, we should share any historic heroes who have been disabled but powerful in their unique abilities to battle life.

To my astonishment, during my spiritual growth, I have only read about great kings, queens, and gods without disabilities. Recently, I have been searching for some inspiring mythological figure representing disabilities that are unique and inspirational. Ashtavakra, the Great Vedic Sage with eight deformities, is regarded as one of the most inspirational characters.

The legend says that when Ashtavakra was a developing fetus in his mother's womb, he heard and learned the correct pronunciation of the Vedic Mantras, the most ancient holy recitations being taught by his maternal grandfather and Guru of his parents. So, one day when his father was practicing chanting those mantras he made eight mistakes in

pronunciation and intonation of the mantras. The fetus from his mother's womb requested his father to correct those mistakes. The egotistic father could not bear this and cursed the unborn child with eight deformities for pointing out eight mistakes. Hence, Ashtavakra was born with eight deformities in his body. But, this person despite being born with physical deformities went on to become a respected sage in society. Of course, he had to face some humiliation at the hands of some members of society. But, he ultimately gained the position of *Brahmrishi* (the highest position for a sage or holy person) with his intelligence and knowledge. He was the official Guru of king Janaka, father of Goddess Sita. He has written Ashtavakra Samhita to pass on his acquired knowledge to the world.

By August 2020, nearly nine years have passed and I have been classified as an undiagnosed rare disease neuro-degenerative patient. I am actively seeking answers about human health through cutting-edge research by building the spirit of "Ashtavakra" who was an avid learner right from his mother's womb. In fact, my curse as a rare-disease patient has turned out to be a blessing to become an avid learner in my later part of my life.

In the ten years after diagnosis, it took me time to find the balance between the experience of being under a beastly curse and loving and empowering a wounded lion within myself. I named my inner lion "Kamalion," which has the spirit of a Kamala, and opened my petals of knowledge to perceive pain as a pathway to positive goals, and this spirit needs to be tamed by being grateful.

I believe that telling stories about mental battles openly and sharing positive learnings from these experiences are important to fighting the growing mental health pandemic in our modern world. It was very evident when Meghan Markle shared with Oprah Winfrey openly about her battles

with suicidal thoughts and feelings. That is the necessary way of educating society, community, and individuals to recognize that pain comes in various forms in every person and we ought to build our positive stories of battles to make it a magnificent epic of modern history.

I hope you noticed my first chapter, where I wrote about my experience with suicide and outlined the learnings I have been continuing to do to not let myself or anyone I come across take that road by teaching them self-empathy and storytelling. I would not be a storyteller today if I didn't choose to gain knowledge from my horrific experience of suicidal attempt. At the time, my most excruciating struggles were after that incident, and I wouldn't be a responsible storyteller now. Let us persevere with the intentions of helping others continue to hear our stories of life experiences. Bloom your petals of resilience and protect your mental health. Imagine the infinite effects that will be generated if we build a circle of Kamalas with such petals to combat mental health even in the most cherishing and advanced eras of humanity. There is a "legendary genetic element" to our human culture when we hear stories such as Ashtavakra or HarryPotter. Call me imaginative or fanciful or fictional, but I would rather take all the positivity from my visions and build the right perspective to take for my life's battles. It is interesting how the tree of life was one of the oldest of all mythological symbols. Yet, who hasn't realized that the "Tree of life" is actually the greatest educator in life. I would encourage every reader to research the "Tree of life". Simply put, it involves showing inner energy in all your endeavors.

Since the beginning of my education—as a high schooler, clinician, scientist, professional, and now as a patient with a rare disease of unknown diagnosi—genetic research has reinforced my interest in the how, when, and where to utilize

genetic variability in medicine. It has a range of effects, from affecting the eye's color to causing rare, debilitating diseases. Today, targeted gene therapies have become a reality in cancer and some rare diseases, including gene-editing technologies like CRISPR. It is so timely, two female scientists who pioneered the revolutionary gene-editing technology are the winners of 2020's Nobel Prize in Chemistry.

The Nobel Committee's selection of Emmanuelle Charpentier, now at the Max Planck Unit for the Science of Pathogens in Berlin, and Jennifer Doudna, at the University of California, Berkeley, puts an end to years of speculation about who would be recognized for their work developing the CRISPR–Cas9 gene-editing tools. It has swept across laboratories worldwide since its launch in the 2010s, as a way of modifying the genome accurately. The tool has countless uses: researchers hope that it can be used to alter human gene structures to eliminate diseases; to manufacture tougher plants; to kill pathogens, and so on.

In my professional work, I have gained knowledge about new ways of addressing rare diseases, including cancer, in which I am focused. As a patient, I gained a new perspective on clinical trials from the perspective of patients. My work is a launching pad for such innovation including clinical trials related work for these rare diseases, which is why I see my hope not only for me but also for many others who are diagnosed. That is why I am an avid learner and am in the field of "Artificial Intelligence in Healthcare" despite my veterinary and scientist background.

As an individual, I see this idea as augmented, audacious, and authentic, and it can be utilized to find and adapt solutions for the toughest challenges in life such as my condition and many others in need.

Whenever I am engaged in such professionally purposeful conversations in my relationships, it becomes even more crucial for me to embody the definition of a purpose-driven and passionate professional.

My medical condition a decade ago taught me to treasure each day and to start each day with a sense of gratitude. "You are with Kamala, not Kamala being with you," I told my rare disease.

Rare Disease Day, on February 28th, also holds a special significance to me, being an Aquarius also. Our industry raises awareness for the 300 million people worldwide who are affected by rare diseases. Combining professional and personal missions is powerful. This journey has built innumerous "petals of purpose" in my Kamala Lotus. In conclusion, let us be a "Dare to be Rare" family to every rare-disease patient in the universe.

Here are more purposeful petals I'm developing in my Kamala.

The purpose of overcoming challenges with gratitude presented by my rare disease is to give my life the best chance of survival.

A purpose to become a patient trailblazer for many patients like me throughout the world.

A purpose to optimize clinical research as a treatment option for every patient in the community.

A purpose for me is to transform my walking stick into a Kamala magic wand, so I can affect the positive change I am hoping to see.

A purpose to chant this "Prayer of peace" for the prosperity of every human being:

"Lokah Samastha Sukhino Bhavanthu"

Though not a traditional Vedic mantra, "Lokah Samastah Sukhino Bhavantu" is a Sanskrit prayer that invokes compassion and peace.

It simply means, "May all beings be happy and free, and may the thoughts, words and actions of my own life contribute in some way to that happiness and freedom for all."

By chanting this mantra, we can move away from the self and radiate a prayer of love for the world around us. It reminds us that we are surrounded by the Universe and also we are a part of it. The mantra is inherently inclusive of all living creatures, simply reminding all of us that WE ARE ALL ONE and we must care for one another.

In terms of my health condition in 2021, I will shortly be celebrating my tenth year of being a beautiful and bold Kamala instead of fearing being totally paralyzed, and overcoming all my fears pertaining to becoming completely paralyzed.

A Harry Potter wand has become my walking stick, and I have named her Trishul, the historical Hindu mythology trident held in the hands of Lord Shiva and Goddess Shakti. Shul means problems or suffering. Trishul means that which destroys all kinds of suffering.

Three types of pain that arise in life:

1. Aadibhautik (physical)
2. Aadhyaatmik (spiritual)
3. Aadidaivik (ethereal)

This Trishul, mythological trident is so mesmerizing to learn about how it relieves your suffering and all the problems in life.

I will use my "Trishul" appreciably and with faith in the same way my two heroes in my life did.

- A moment of gratitude and tribute to my first teacher, my beloved grandfather, Mr. Venkat Gupta, the lion principal, for his passion and the manner in which he lived his life. He passed away on my birthday, which will remain a present in my memory forever. I prayed for his blessings, energy, and strength in his struggle as a paralyzed patient who had no definitive diagnosis for more than two and half decades. My grandpa is known for reciting the Rama Chant one million times, as well as naming my father, Lord Rama, in Ramayana with his left hand. I regard him as a spiritual teacher whose wisdom is captured in his chant book. I chant Om and Om mantras with my left or right hands as often as I can to train my brain and boost its capabilities due to episodes of paralysis. Every letter I write is a blessing from the Cosmic energy of the Universe.
- I am honored to pay homage to Dr. Stephen Hawking, scientist, spiritualist, and model hero. He is known for his ALS (or amyotrophic lateral sclerosis) and his cosmic intelligence and theory on black holes. He became a positive role model for individuals with disabilities because he was an example of positive living despite having a disability. Intriguingly, the disease stripped him of his voice, which gives me some hope as I deal with voice problems intermittently and hope for the day when I can live gracefully like he did. He was writing a book when all he could do to communicate or write was to blink and I also had this experience from time to time in 2020.

  Eventually, a college friend presented him with a revolutionary new computer. The computer was connected to his wheelchair and was able to speak for him. He wrote papers and gave lectures to classes.

Despite struggling with fear for years, he overcame it. I admire his ability to leverage innovation to combat challenges he faced in life, as I described in this book. I started getting enlightened on similar technologies including a voice amplifier, text to voice softwares or voice to text softwares, robotic arm and hand so I could graciously be planning for the future battles with my health. The same sense of humor is evident in Dr. Hawkings and me, despite our battles with our health and visions of the wonder and mysteries in life.

I have recently been told by friends within the industry that I am the living example which inspires others to achieve their goals, like a Lady Stephen Hawking did by writing this book, *Becoming a Kamala*.

There is a scripture story in which Kannappa is a great devotee of Lord Shiva. He is unaware of how to worship Lord Shiva properly, but Kannappa takes care of him as if he were his own child. He sprays water in his mouth on the Shiva Linga and decorates it with the flowers found in the forest, but Shiva does not seem to mind. I am like Kannappa. While I never know what path to take, I always know that my purpose is to live my life as a Kamala and build circles of Kamalas along my journey through Petals of:

Empowerment,
Education,
and Empathy.

The "Circle of Kamala" is the strategy that I intend to fight mental health issues in society today. Let's build a kamala together.

Becoming a "Kamala" is our hearts' calling. It is the state of harmony and balance that our life is compelled to live. It is not easy though. The decision to live your heart's truth requires guidance and support, patience and nurturance, and an understanding of what qualities to cultivate, and which parts of ourselves to adapt, adjust, improve, resolve, and change. The person who wishes to nourish their inner Kamala can do so through educational, spiritual, and empowerment programs. One such program is the Spiritual Leadership Certification Program (SLC), offered by Swaminiji Shraddhananda Saraswati. Such programs, and others like it, explore what it is to be human, exploring the roles suffering and healing play in our life experiences and our worldviews. We must understand how to cope with fear and uncertainty as well as our ability to choose courage and openness in order to realize our inherent wholeness. Initiatives like Swaminiji's SLC offer us the unique opportunity to do this often challenging but deeply inspiring work in the company of a skilled and knowledgeable teacher, and in an environment that is conducive to honoring mud, muck, growth, blossoming, and struggle.

As we grow through our lives, each of us takes on our individual lotus life and, by inspiring others, we build more Kamalas which each change humanity and make humankind a better place.

If you want the results of this book to be evident in your life, you must first make an effort to change within yourself. It's that simple and that profound. I consider myself a change-maker, a Kamala who lives by the Mahatma Gandhi mantra of love and service of others.

"Be the change you want to see."

Let us "become the change that we want to see."

Bloom the Kamala within you with a thousand blossoms of gratitude.

Namaste!

Ramasita's Kamala (descended from my parents) is also a "Kamalion" to me and the rest of the world.

Lightning Source UK Ltd.
Milton Keynes UK
UKHW040630060921
390110UK00001B/16